BUILDING THE MODERN WORLD

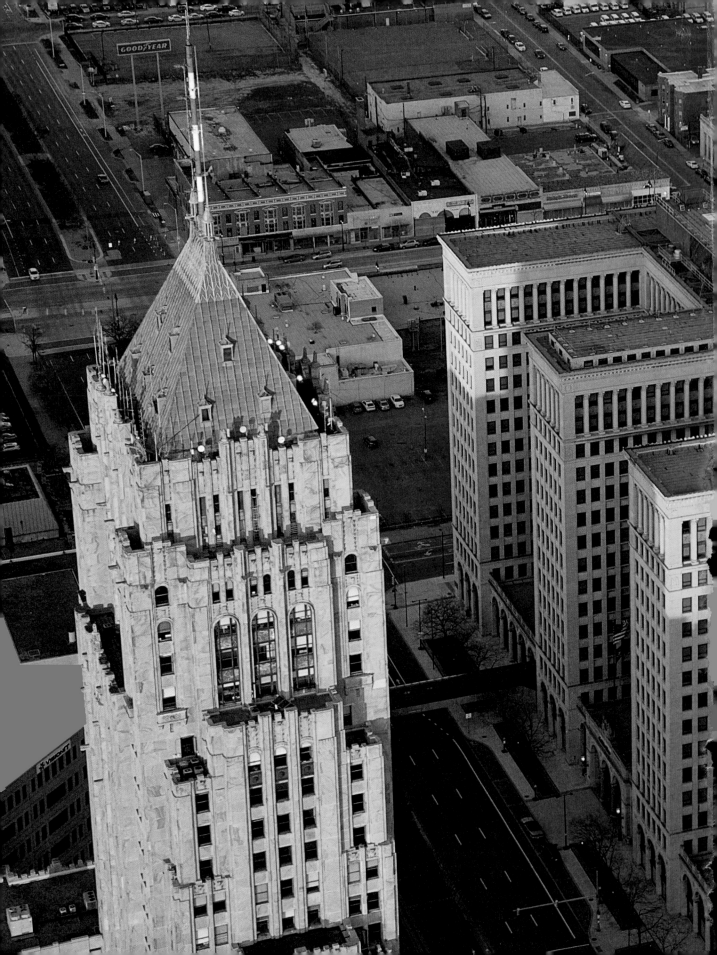

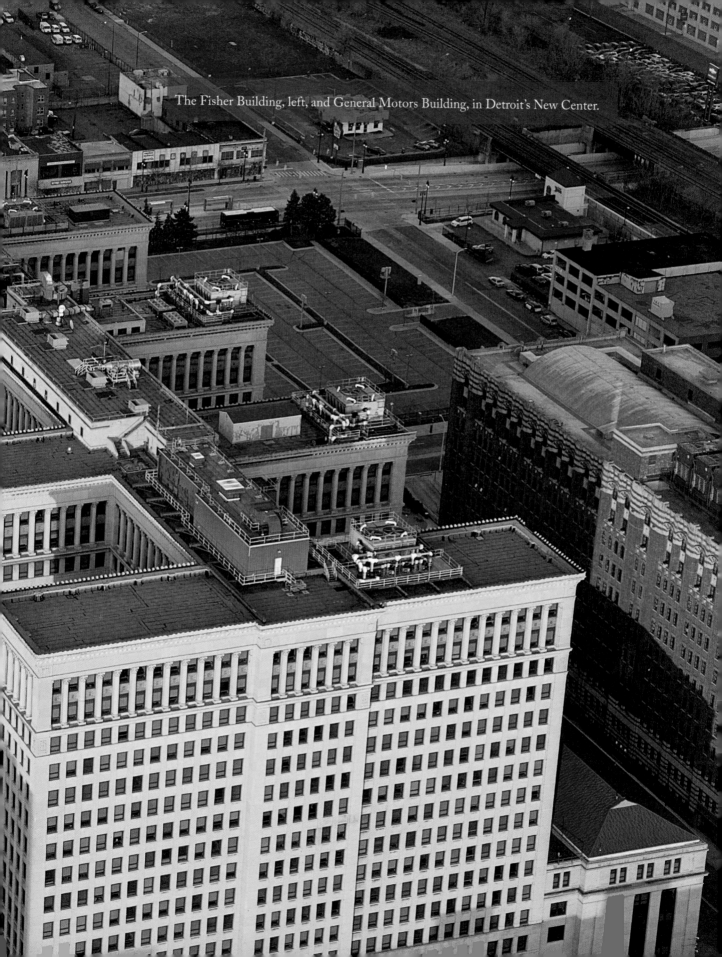
The Fisher Building, left, and General Motors Building, in Detroit's New Center.

BUILDING THE MODERN WORLD

ALBERT KAHN IN DETROIT

MICHAEL H. HODGES

A PAINTED TURTLE BOOK

DETROIT, MICHIGAN

ISBN 978-0-8143-4035-6 (cloth)
ISBN 978-0-8143-4036-3 (ebook)

Library of Congress Cataloging Number: 2017962411

All photographs by Michael H. Hodges, except where otherwise credited.

Painted Turtle is an imprint of Wayne State University Press

Wayne State University Press
Leonard N. Simons Building
4809 Woodward Avenue
Detroit, Michigan 48201–1309

Visit us online at wsupress.wayne.edu

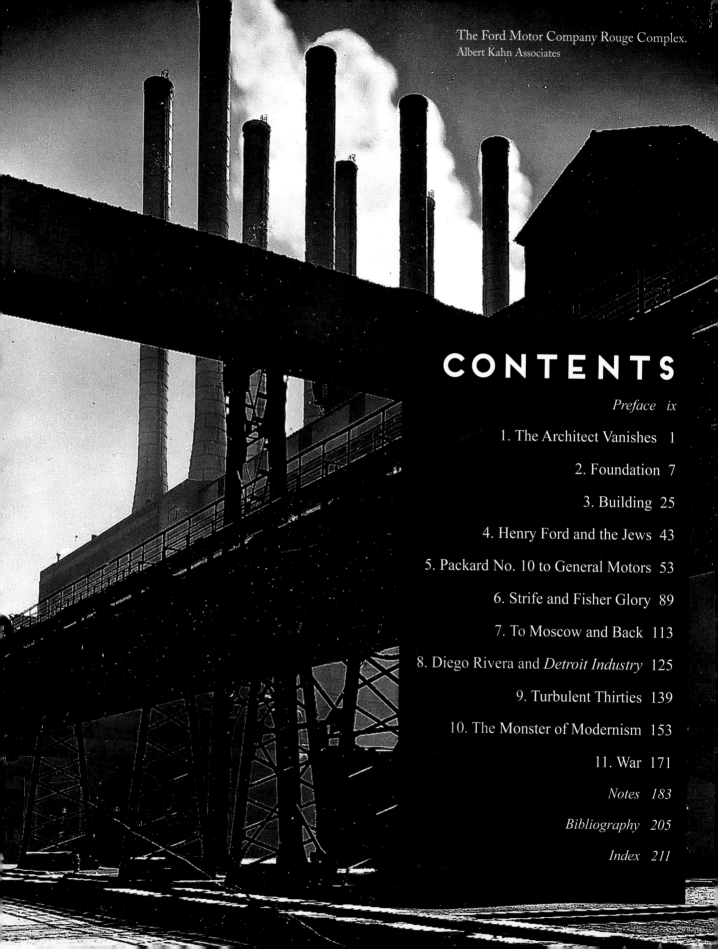

The Ford Motor Company Rouge Complex.
Albert Kahn Associates

CONTENTS

Angell Hall, University of Michigan

PREFACE

I write richly illustrated books about architecture for a general audience. When asked why, I usually say, "So I can pretend I'm a professional photographer," since taking pictures totally swamps research and writing in the pure joy department.

But there's a deeper backstory to my work, beyond the chance to masquerade as a photographer. You could say my books have everything to do with the fact that for one year shortly after college, I explored the possibility of becoming an architect. I read everything about the subject I could get my hands on. I interviewed architects in Seattle, where I was living, and in New York, where I had friends. I was a schoolteacher at the time, so my responsibilities ended in May. I spent the summer of 1981 in New York taking a design course at Columbia University and working in a tiny, remarkably cool little architecture office on lower Fifth Avenue—back when everything beneath Twenty-Third Street had a Detroit-like emptiness to it.

I finally decided that practicing architecture wasn't for me. (I mostly worried I didn't like drawing enough to spend eight to ten hours a day doing it. This, of course, was back before computers.) So instead I became a newspaper reporter, which has been fun and rewarding in equal measure. But I'd be lying if I said architecture hasn't always hovered somewhere out there in the mist as the seductive path-not-taken. So works like this slender volume and my first book, *Michigan's Historic Railroad Stations* (2012), let me square the circle, have it both ways or, to use psychological terminology, integrate the various passions of my life. Composing books has been an immensely satisfying experience, one I'm most grateful to have stumbled upon.

The present work is meant to be an accessible introduction for the nonarchitect, nonacademic layperson to Albert Kahn and

the buildings of Detroit—a city suddenly enjoying a much-deserved second look from the rest of the nation. It's often said that Detroit ranks just after Chicago and New York in the number and quality of its prewar skyscrapers, and it's worth noting that Albert Kahn built a hefty percentage of those that remain. With the Motor City suddenly sexy on the national stage again, at least up to a point, the time seemed right to showcase Kahn's contributions not just to Detroit but to the nation at large.

That said, the world still awaits a comprehensive academic biography of the architect, one that could take advantage of some sources that have become available only in recent years. But in the meantime, I hope *Building the Modern World* will encourage curiosity and further investigation.

A word on the photography: with a little embarrassment, I confess I'm hopeless with Photoshop and other complex systems for adjusting photographs. The pictures in this book are for the most part what came right out of the camera. While I sometimes tweaked the exposure or boosted color saturation across the board, limited tools available on my iPhoto application, there's been no serious diddling of any outdoor images. If the sky in a particular picture is black, believe me—that's what it looked like in real life. Some interior shots, however, have been adjusted for greater clarity.

My introduction to the life and significance of Albert Kahn came from two well-written earlier biographies and one breathtaking work on the genesis of modernism. All three books, however, were mostly aimed at a professional or academic audience. Grant Hildebrand, architecture professor emeritus at the University of Washington, was the first to create a deeply researched analysis of the man, his buildings, and his impact on the twentieth century with *Designing for Industry: The Architecture of Albert Kahn* (1974). It is a marvelous read, full of insight and historical context. Now in his eighties, Hildebrand—who worked at Kahn Associates in the 1960s—proved to be witty, interesting, and generous when I reached out to him several years ago. Federico Bucci's *Albert Kahn: Architect of Ford* (2002) is the other outstanding, if somewhat technical, biography, written by the dean of architecture at the Mantua campus of the Polytechnic University of Milan. Like Hildebrand, Bucci was personally helpful to my project, and a thoroughly pleasant email correspondent. Finally, in his deeply absorbing history of modernism, *Making the Modern: Industry, Art, and Design in America* (1993), University of Sydney professor Terry Smith argued that the modernist movement had its origins not in New York or Berlin, but in Detroit. As a consequence, Michigan, Henry Ford, and Albert Kahn dominate his book's first four stirring chapters.

I have spent a tremendous amount of time over the past three years probing the Albert Kahn Papers at the Bentley Historical Library at the University of Michigan in Ann Arbor and the Smithsonian's Archives of American Art in the nation's capital. I cannot say too much about the good help I got from librarians at both institutions. In particular, the retired Bentley archivist who organized the Albert Kahn Papers (all of which came from the office of Albert Kahn Associates), Sally Bund, was a constant source of direction, support, and good cheer. And I also have to thank Bentley Assistant Director for Reference and Academic Programs Malgosia Myc for her help and good counsel.

Claire Zimmerman, associate professor of architecture and art history at the University of Michigan, probably knows more about Albert Kahn than anyone on the planet—or is at least tied for first place. And despite being one of the university's busiest academics, she nonetheless made time for a series of breakfast conversations that were illuminating and often very, very funny. Like Sally, Claire was a vital support through the three and a half years that this project took. I am deeply indebted to her.

Likewise, I owe much to two of the famous architect's grandchildren—Betsy Lehndorff in Alpena, Michigan, and Carol Rose Kahn of Ann Arbor. A self-taught expert who has widely explored the literature on her grandfather, Carol was an invaluable source and guide through the complexities of Kahn family history. She has become a good friend.

At Albert Kahn Associates in Detroit, which continues to be a major player on the national and international scene, I'd like to thank architects and executives Alan Cobb and Don Bauman, both of whom were unfailingly gracious and helpful. The firm generously gave me access to all its historic images, without charge. I am more grateful for that courtesy than I can say.

The website *Albert Kahn: 400 Buildings in Metro Detroit* by Dale Carlson and Michael G. Smith was another key asset. Not only did it simplify the process of figuring out which buildings were Kahn's, the authors also did the legwork—consulting period newspapers, magazines, and architectural and engineering journals—to justify the attribution of authorship. Additionally, both were engaging interviews, offering sharp and intriguing opinions on the man and his work. In particular, I repeatedly called upon Smith (the author of the 2017 *Designing Detroit: Wirt Rowland and the Rise of Modern American Architecture*) with specific questions, and he was kind enough to answer promptly in every case.

Inevitably, dozens of individuals help an author along the way. With apologies to anyone I'm leaving out, I would also like to thank Louis Aguilar, Sarah Allison, Michelle Andonian, Nancy Bartlett, Laura Berman, Anne Bird, Federico Bucci, Albert Butzel, Leo Butzel, Elizabeth and Antonio Colombo, Peter Cummings, Bill Dobbs, Betty Dorsey, John and Kirsten Dorsey, Katie Dorsey, Kim Doyle, Marty Fischhoff, John Gallagher, Tim Grimes, James Hanks, Felecia Henderson, Kathy Huss, Charles Hyde, Maria Ketcham, John Lapp, David Lynn, Charlotte Massey, Sonia Melnikova-Raich, Kate Montgomery, Tom Mull, Luis Pancorbo, Susan Pollay, Gabrielle Poshadlo, Rebecca Price, Noah Resnick, Ruth Adler Schnee, Charles Shaw, Pam Shermeyer, Kim Silarski, Mary Helen Spooner, Tom Stamp, James Tobin, Ken Voyles, and Gregory Wittkopp.

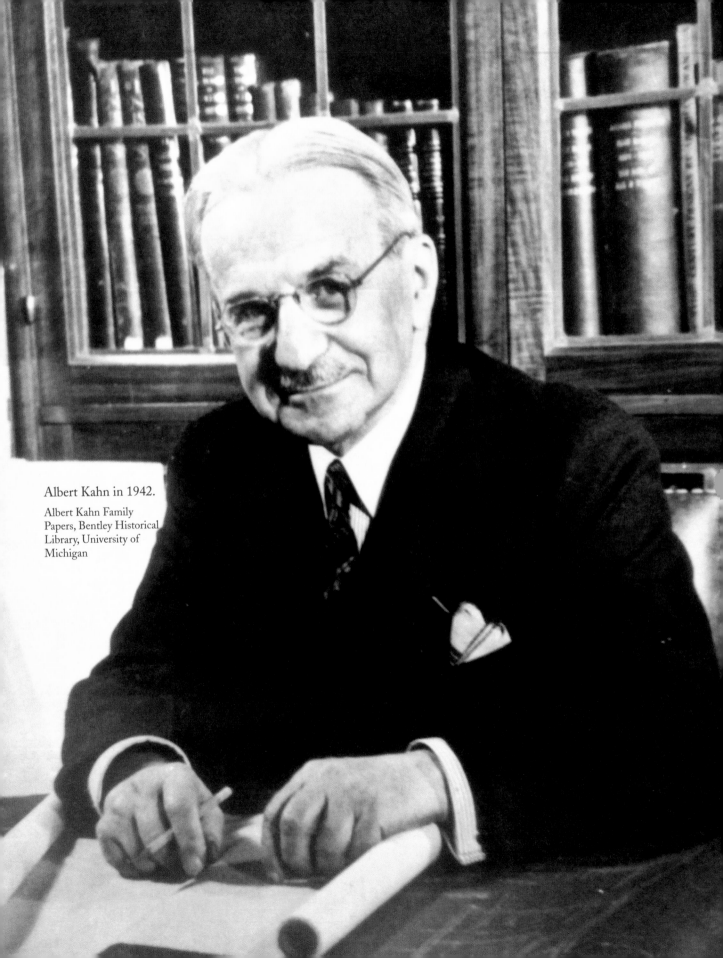

Albert Kahn in 1942.

Albert Kahn Family
Papers, Bentley Historical
Library, University of
Michigan

THE ARCHITECT VANISHES

When he died on December 8, 1942—one year and a day after the attack on Pearl Harbor—Detroit architect Albert Kahn, seventy-three, was knee-deep in equipping the United States to win the Second World War. "Tank plants, arsenals, airplane-engine buildings and giant aircraft factories are all the same to Kahn when he sets his 450 architects and engineers to work," reported United Press International in 1941.[1] The article added that in just seven months, Albert Kahn Architects and Engineers inked 1,650 drawings for new military bases desperately needed in the Pacific and Atlantic theaters.[2]

Indeed, in its obituary, the *New York Times* pointed out that a significant part of all Allied war matériel was produced in Kahn-built factories, "some of them," the reporter added, "such as the new Ford Willow Run bomber plant [in Ypsilanti, Michigan], conceived on a scale undreamed of only a few years ago." Not surprisingly in a year when the war effort was all consuming, Kahn's military contributions dominated his obituaries coast to coast. Not only was he building military bases, his auto plants for Packard, Ford, Hudson, General Motors, Chrysler, Studebaker, and others had all been converted to war production. As for new construction, the speed with which the Kahn firm could deliver a fully built factory was flabbergasting. The *Times* called him "the fastest and most prolific builder of modern industrial plants in the world."[3] Case in point: the vast Glenn L. Martin Airplane Assembly plant outside Baltimore, with its three-hundred-foot-wide, single-span door—at the time the world's largest, built for the wingspans of the future—was open for business eleven weeks after the company

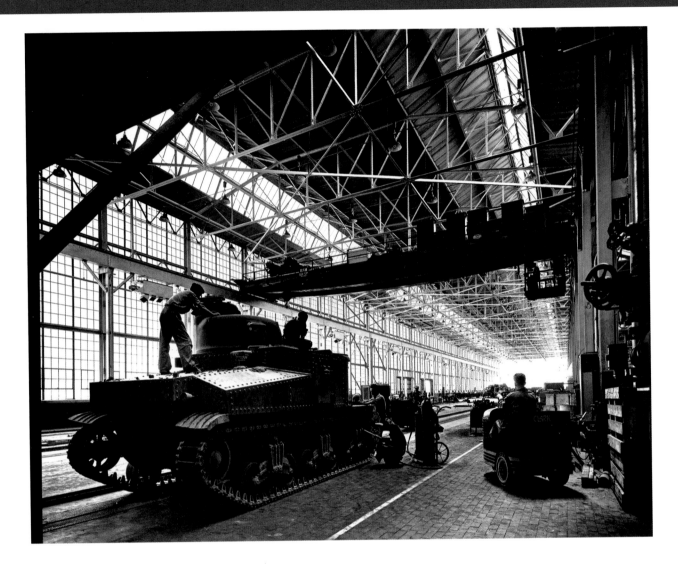

Chrysler Tank Arsenal, Warren, Michigan, ca. 1941.

Albert Kahn Associates

That much-vaunted "Arsenal of Democracy"? Albert Kahn built it.

Nor was Kahn's reach confined to the New World. Obituaries also noted that the Soviet Union's surprising ability to hold Nazi invaders at bay owed everything to the over five hundred—five hundred!—factories that Albert Kahn Associates designed for sites all across the USSR in 1929–31. It was a period when the Detroiter was, astonishingly, the official consulting architect to the Kremlin's first Five-Year Plan. In just a little under three years, Kahn's men laid down the industrial backbone for a country that had been, up till then, profoundly backward.

Kahn was too old to belong to the "greatest generation"—those who actually fought the war. But given the indispensable role his factories played in Allied victory, the Detroiter surely deserves an honorary membership, home front division.

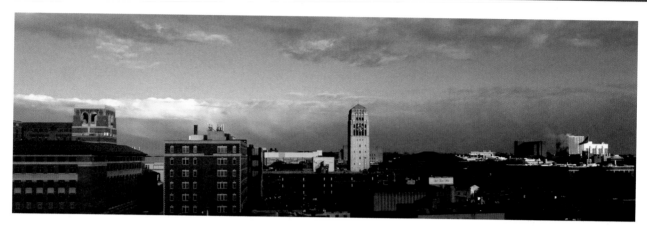

Burton Memorial Tower dominates the University of Michigan and central Ann Arbor.

Albert Kahn was a giant in Detroit's heroic age, the visionary who created the humane "daylight factories" for Packard Motor and Henry Ford, and in the process helped birth both modern manufacturing and modern architecture. His revolutionary early car plants, their walls almost entirely subsumed by glass, electrified architectural rebels in Europe, where grainy, black-and-white photos were passed from hand to hand like sacred texts. In time, these Europeans, with Kahn's factories as the template, would create the International Style, the defining architecture of postwar Europe and America.

Indeed, at the time of his death the architect was world renowned—much praised and mourned from Buenos Aires to London—as an exemplar of American can-do genius. Kahn epitomized the tale of the successful immigrant striver, which meshed perfectly with the nation's hopeful narrative during the war—that the United States was, indeed, a country where a penniless Jewish boy who never finished elementary school could become one of the world's most successful—and richest—architects. If the press reveled in his story of the immigrant boy made good by dint of perseverance and moxie—*Time* and *Life* both ran features on him—Kahn did his best to live up to the role.[5] In interviews, he waxed humble, chalking up his dizzying ascent to good luck and hard work. He was, to be sure, a celebrated workaholic. There's hardly a profile that doesn't cite his habit, when working late into the night, of curling up on a drafting table to nap.

Lost in the obituary accolades, however, was much serious consideration of Kahn's nonindustrial work, which comprised about half the two thousand projects his firm built between 1902 and 1942. Kahn was more than "merely" an industrial architect. His commercial buildings define Detroit, and give its downtown and New Center their sober, masculine, well-dressed look. Nobody built more of what we now consider "old Detroit," whether the General Motors Building, the Fisher Building, the Detroit Athletic Club, or the homes of the city's newspapers. In Ann Arbor, he gave the University

of Michigan's central campus its air of unpretentious dignity, with austere designs like Hill Auditorium, Hatcher Graduate Library, and Burton Memorial Tower.

The pragmatist who famously declared architecture to be "90 percent business, 10 percent art" was a dizzying polymath in a century that prized architectural specialization and scorned the sort of breadth Kahn exemplified.[6] He worked in a range of historical styles on virtually every building type known to humanity, whether skyscraper, factory, town hall, bank, mansion, temple, or lighthouse At home, Kahn was the public-minded citizen *par excellence*, with a civic legacy that extends far beyond his buildings. Detroiters—indeed, the entire international art world—owe the architect a debt of gratitude for his vigorous, but now largely forgotten, defense of Diego Rivera's *Detroit Industry* murals at the Detroit Institute of Arts, a heartfelt endorsement of artistic freedom that helped prevent the sort of cultural vandalism that destroyed Rivera's Rockefeller Center mural in New York.

Kahn lived the life of five architects, and in the process did more to shape the twentieth century than almost any other designer.[7] His ascent from poverty, his outsized influence on both industry and architecture, and his proximity to epochal world events make his life story a tableau reflecting America's rise to power.

But curiously, after his death the man all but disappears. Metro Detroiters still honor him, of course, but Kahn's fame, once global, has shrunk in geographic scope to just the southeast corner of Michigan. Written out of the architectural canon and shelved as just another industrial architect, Kahn's seminal influence at the dawn of the modern era has been entirely overlooked.

Again, Kahn's obituaries in 1942 probably contributed to this eclipse. Written in a year of high war fever, tributes—from the three Detroit dailies to the *Weekly Bulletin of the Michigan Society of Architects*, which produced an entire issue celebrating Kahn—focused on his war-preparedness work to the exclusion of almost anything else. One might have thought the local press would use the opportunity to remind Detroiters of the quality of some of their architectural treasures, from the Century Club to the Livingstone Memorial Lighthouse on Belle Isle. But the architect's nonindustrial work got short shrift, shoehorned into one or two paragraphs. The summary on the front page of the *Detroit News* was typical. Ten paragraphs into the obituary, the article turned to Kahn's commercial work, giving it a total of twenty-three words: "Among the structures to his credit are the National Bank Building, the *Detroit News* Building, the Detroit Athletic Club and the Fisher Building."[8]

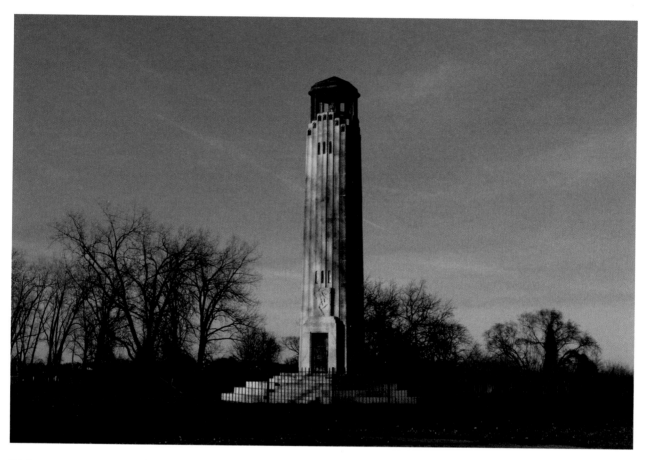

Livingstone
Memorial
Lighthouse,
Belle Isle, Detroit.

Period. A lifetime of work by one of the most influential architects of the twentieth century—the "man who built Detroit," the architect who gave the city its mature face and helped invent the modern world—gets dismissed in half a paragraph, with reference to only four buildings out of the thousands his firm designed and built from the turn of the century on.

And so the architect vanished.

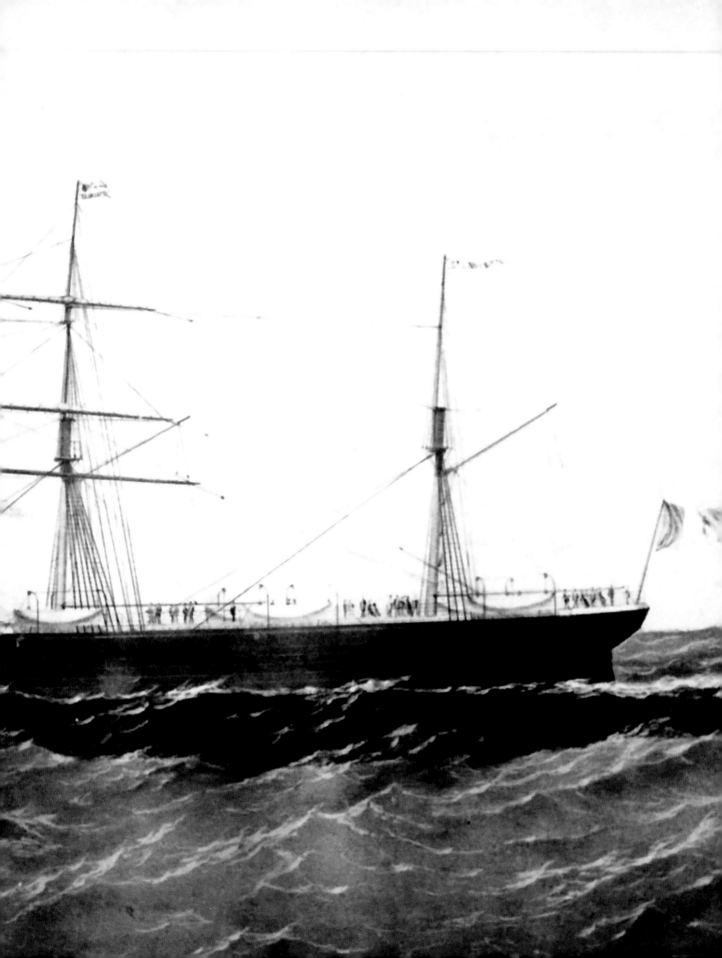

2

FOUNDATION

A yearning for precision and beauty appeared early. At seven, Albert Kahn was so accomplished at the piano that his astonished family came to regard him as a prodigy. Joseph and Rosalie Kahn had moved their large brood from Germany to the Duchy of Luxembourg to live with an aunt the year before, about 1875, and their circumstances in the village of Echternach permitted small luxuries like music lessons and school.[1] The Kahns, from Rhaunen, Germany, some eighty miles west of Frankfurt, were cultured people, never mind their chronic poverty, and encouraged their first-born in artistic pursuits.[2]

The family left Luxembourg for the United States in 1881, before Kahn finished elementary school.[3] "We were not any too flourishing financially," Kahn's younger sister Mollie Kahn Fuchs wrote in a short memoir half a century later. "Father wanted to go to America, encouraged by tales of money growing on trees and everybody becoming rich. He decided to take this step [himself], and if he found it very promising then mother and the children were to follow."[4] And follow they did, sailing on July 21, 1881, on the SS *St. Laurent* out of Le Havre, France, a passage that, according to Fuchs and *St. Laurent* timetables from that era, took about two weeks. (Most printed sources say the Kahns arrived in 1880, but Albert Kahn's passport application in 1890—written in his own hand—clearly says the family came to the United States in 1881, a date he cites a few lines later as the start of his life in Detroit.)[5] Even at this early date, the piano prodigy was already stepping into the role of paterfamilias that would define much of his life. On the steamer, Fuchs wrote, "Albert who was then 12 or 13 years old [he was twelve], took full charge of the family. . . . Eventually we landed in Baltimore where we greatly depended on [him], as he was the only one that could speak a little English. We stayed there a few days," she added, "then went on to Detroit where Father was waiting for us."[6]

FRENCH STEAMER, "ST. LAURENT."

The life awaiting the Kahns in Detroit would turn out to be very different from the relative gentility of Luxembourg. Piano lessons and school, at least for Albert, were hopelessly out of reach for a family whose initial years in America read like a case study in working-class immigrant hardship. It was a grinding, often hopeless fight in which all able-bodied family members had to enlist. In Detroit, Albert—the oldest of seven, soon to be eight children—was put right to work as a barker for his father's first business.[7]

Joseph Kahn was a rabbi by training, but his initial Detroit venture was a restaurant on Woodbridge Street by the old Michigan Central Depot on the Detroit River. The restaurant occupied the ground floor; the family lived on the second. "My poor Mother!" Fuchs wrote. "Besides taking care of her big family, she did all the cooking for the restaurant." She paints an intriguing picture of her oldest brother. "Albert used to station himself in front of the building," she recalled, "and when the trains would come in, he'd attempt to bring the people to our restaurant."[8]

That young Albert threw himself into his assignment heart and soul goes without saying. Virtually all assessments across the years trumpet Kahn's diligence, meticulous

The Kahns sailed on the SS *St. Laurent* out of Le Havre, France, in 1881. The crossing took about two weeks.

nature, passion for order, and determination to get the job right. "I have never known anyone with such an enormous capacity for concentration and study," said his friend and mentor George Mason.[9] Indeed, it's easy to make the argument that it was this wholehearted devotion to the task at hand that got Kahn fired from his first big break, shortly after the boy's arrival in Detroit.

But before that, calamity struck. A fire broke out in the early 1880s and consumed both the family restaurant and the cramped living quarters above. Joseph got six of his children out—all down with the measles, Fuchs recalled—and then had to sprint back inside the flaming building for baby Felix whom, she suggests, her father at first over-looked. The crib was just igniting when Joseph burst into the room. Felix was burned but survived.[10]

Young Albert's big break came after the fire. Somehow Rosalie Kahn wangled her boy a job in the distinguished architecture firm of John L. Scott, who would go on to build the old Wayne County Courthouse, an imposing 1902 Beaux-Arts pile topped by heraldic statuary that looks down on Detroit's Cadillac Square. For dirt-poor parents trying to launch their children into the middle class, the opportunity must have seemed a godsend.[11]

The terms, typical for a youngster being taken on as an informal apprentice in that era, were severe. Albert's new job in the Scott office paid nothing the first year, and only $2.50 a week the second. It was part-time and amounted to little more than emptying wastebaskets, grinding ink, and running errands.[12] But it must have been profoundly reassuring for parents Joseph and Rosalie, themselves cycling through a range of dead-end jobs after the destruction of their restaurant. So when he got fired—and so arbitrarily, at that—it's hard enough to picture the impact on the boy. It's more distressing still to imagine his crestfallen mother and father.

At the time of his abrupt dismissal, Kahn was about thirteen. Years later the architect who would invent the daylight factory, reshape Detroit, and build most of the University of Michigan explained that problems arose because of another job he had. That involved cleaning "a horse or two" at dawn, after which Kahn ran off to the Scott architecture office on Fort Street. Some men in the firm took issue with the little unwashed German. "Most of the men had a very keen sense of smell," Kahn said in a 1926 speech, "and I literally got on their olfactory nerves." But, as he noted, his family's situation was dire. "Extra suits of clothes and bathtubs were not among my luxuries then," Kahn said, "nor had I fully learned that cleanliness was next to

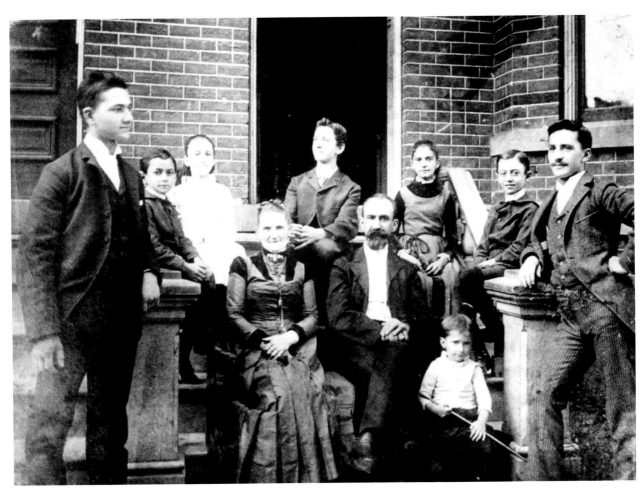

godliness. My appearance, therefore, at the office never brought forward particular pangs of joy. . . . I was not only fired but kicked out by the head draftsman, who since has gone to his reward."[13]

Other factors may have been present as well. At the time Kahn spoke only broken English, according to a 1923 profile in the *Detroit Sunday Times*, "Poor as a Boy, Rich at 54." Still, given how quickly the young man blossomed in a more sympathetic environment, the Scott decision looks to have been a serious error, even if his supervisors didn't think so at the time. His eviction was accompanied, Kahn recalled, by summary judgments on his character: "He lacks vision and initiative! He'll never amount to a hill of beans!"[14]

But, in perhaps the first sign of the remarkable luck that would buoy Kahn throughout his life, it all worked out for the best. While he was still at Scott, Detroit sculptor Julius Melchers had taken Kahn under his wing.[15] In a 1929 profile in *American*

The Kahn family in Detroit, ca. 1890. Albert (*far right*) sports a mustache. Julius (*far left*) would go on to invent the Kahn system of reinforced concrete. Louis, who became the Kahn firm's chief executive officer, is the tiny child by his father's knee.

Courtesy of Albert Butzel

Magazine, Kahn explained that one day he had done something wrong at Scott "as usual" and got in trouble. "I just went outside and bawled. Old Julius Melchers, the wood carver, came out, stopped, and asked what was the matter." Kahn recalled blurting out, "I don't know anything and can't do anything right!" Melchers told the boy to show up at his drawing school that Sunday morning. He would give him lessons for free. "I had always had a bent for drawing," Kahn said, "and despite the fact that at school I got the worst marks in that of anything, my father encouraged me by buying me drawing boards and various materials for sketching."[16]

The boy turned out to have a striking gift for freehand sketching. He let himself dream of becoming an artist—Melchers certainly thought he had the potential. Then disaster struck again. The teacher figured out why his prodigy had no gift for color: Kahn was hopelessly color-blind. W. Hawkins Ferry, a Detroit architectural historian who knew Kahn, wrote that color blindness "precluded the possibility of becoming an artist," and Melchers seems to have felt the same.[17] But again, that luck came to Kahn's aid: the instructor's son, Gari Melchers—who would become a famous painter, with work in the Detroit Institute of Arts—"found me a place in the architecture office of George D. Mason." It was unexpected good fortune, a turn that would set the young man on his life's course. And it all hung on the judgment of a couple adults who could read the promise beyond the rough outlines of an immigrant lad. "In that office I had fair and kindly treatment," Kahn said. "There I passed my first milestone."[18] Telling the story years later, he added, in a puckish aside to his audience, "From that day [forward], of course, begins the real career of Mason and Rice."[19]

The truth is that George Mason and Zachariah Rice were getting far more value than they could have known. "The firm must have seen promise in him when offering the position," wrote William R. Brashear, the Kahn family biographer, "but could hardly have anticipated the quality or potential of what they received. Kahn was not only a superb draftsman, but also a genius with ability to quickly absorb and create, possessing inexhaustible energy and determination. From the outset, he spent hours beyond his expected working time, often well into the night, solving problems he had encountered or just speculated upon, and reading from the firm's extensive library. This would be his only high school and university."[20]

Mason, just twenty-six when Kahn was hired, took a shine to the boy, and there developed a rich, mentoring relationship between the two that Kahn always acknowledged.[21] "What a different atmosphere I found [t]here," Kahn said at a 1926 dinner honoring

Mason, "one of encouragement from the start, for that was Mr. Mason's strong trait. . . . Work was given to me to do other than mere grinding of ink and running errands. I was taught to draw and make perspectives, to make pen and ink sketches, given a chance at working drawings, at details, and presently my salary was raised to $3.50 a week."[22]

The relationship between the two deepened into a bond, and Mason often brought Kahn back to his house after the workday. "How precious I felt the hours when invited to [Mason's] house evenings to help him on the competitive drawings for the Y.M.C.A., which he won," Kahn said, "and the [old] Art Museum which he lost, but should have won. These evenings meant not only experience and practice, but incidentally, a good dinner with a tablecloth and napkins, to none of which I was particularly accustomed at that time." He added, "On these evenings he would often take pains to go through his wonderful collection of photographs with me, and to point out the good and the bad. That proved a large part of what schooling I had."[23]

The *Detroit Sunday Times* profile gave this upward-striving tale a hagiographic lilt. "[The adolescent Kahn] was forever studying," the reporter wrote, "perfecting himself in his chosen calling. He made paths to the library. He borrowed every book he could. He mused and pored and conned over the problems he found encased between the covers. He ground and dug in his self-appointed curriculum—and as the world now admits—*he won*."[24]

By 1888, just four or five years after joining the firm—Kahn would have been nineteen then—he was put in charge of the Gilbert W. Lee house on East Ferry Avenue, since demolished. Thereafter, according to Brashear (who was married to one of Kahn's granddaughters), he became the Mason and Rice "house designer."[25] Speaking with architectural historian W. Hawkins Ferry years later, Kahn was asked whether he was the author of the Gothic carving above the front door on the Gilbert Lee house, which was otherwise Romanesque Revival. "Yes, that's mine," he admitted, and one imagines he said it with a smile. "It looks like a disease, doesn't it?"[26]

Kahn surfaces next in the historical record in 1890, when the twenty-one-year-old applied for a passport after winning a traveling scholarship from *American Architect and Building News*—a $500 prize, or about $12,000 in 2017 dollars. (Interestingly, on passports of that era you were apparently required to pledge allegiance to the U.S. Constitution, which Kahn did in his angular handwriting, promising to "support and defend" the document.)[27] A couple sources suggest Kahn was the only applicant that year, while another says the magazine recruited him for the award.[28] Neither possibility

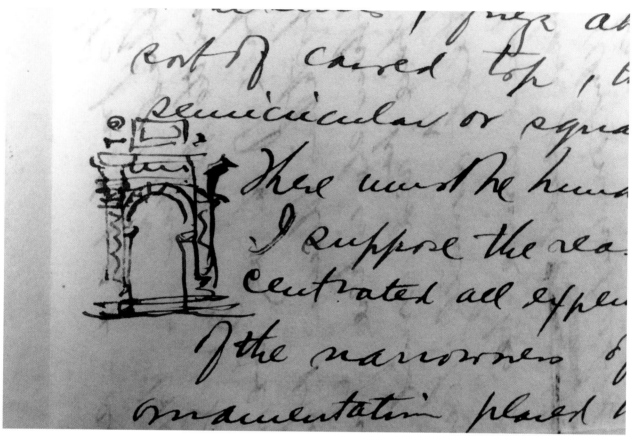

takes anything away from an immigrant boy who, after just six years at Mason and Rice, had mastered enough architectural skill to snag a significant and enviable prize. It also says something about George Mason's eye for talent.

The trip, which took Kahn through England, Italy, France, Germany, and Luxembourg, left a deep and abiding imprint on the young man. Eleven years later, writing his sister-in-law Amy Krolik while she was on the Continent, he could hardly contain the flood of memories, filling both sides of six small pages with vivid architectural observation and suggestions for what she might like to see. "What I liked best in Genoa, perhaps you were struck by them too," he wrote, "were the many exquisitely carved entrance doorways to buildings of minor importance. Nearly all follow the same motif—the delicate pilasters at the sides, frieze above and some sort of carved top, the openings either semicircular or square. You remember! There must be hundreds of them. I suppose the reason they concentrated all expense here was, because of the narrowness of the streets, no ornamentation placed higher up could be seen." Words were not enough. On the left margin, the rising architect sketched out a delicate portrait of just such a doorway, one inch tall—the type of grace note included in many of his letters, particularly during

his courtship of Ernestine Krolik, whom he later married.[29]

Kahn landed in Genoa on Christmas Day, 1890.[30] By February, he was in Florence, where the same beneficence that led him to Mason's office steered him to a wealthy, well-educated young man by the name of Henry Bacon (who thirty-one years later would build the Lincoln Memorial). The North Carolinian was three years Kahn's senior and traveling on a two-year, $1,500 architectural scholarship.[31]

Kahn fretted that he was too poor to make a fit companion. But Bacon reassured Kahn he was almost out of money and needed someone to manage his finances. Whatever the case, the unschooled Detroiter happily agreed to join forces with Bacon. "We strapped on our packs," Kahn said, "and walked from Florence to the next town."[32] The editors of *Architectural Forum* had a little fun at Kahn's expense many years later in a 1938 issue devoted to his industrial work, suggesting that in Italy the young Kahn "was so bewildered by the profusion of masterpieces that he didn't know what to do until Henry Bacon took him in hand."[33] For his part, Kahn always said the four months with Bacon constituted "my real education in architecture."[34] If that seems to challenge similar claims Kahn made on behalf of Mason, it's fair to say his training was shaped by both highly influential teachers.

Kahn's description of Genoese doors, above, also underlines the fact that the man could write. More's the pity, then, that no letters of his from Europe—assuming he sent any—survive. Nor is there any indication that this highly practical man ever kept a diary. What he did keep, however, were sketchbooks from the trip bursting with illustrations of buildings both celebrated and quotidian. These freehand sketches are simply—there's no other word—gorgeous. Kahn's gift for composition and detail was superb, and his technique rivaled that of graduates of gilded art schools.

Albert Kahn was a gifted freehand sketch artist. Credit his early teacher, Detroit artist Julius Melchers.

University of Michigan Museum of Art, gift of the Albert Kahn family, permission courtesy of Albert Butzel

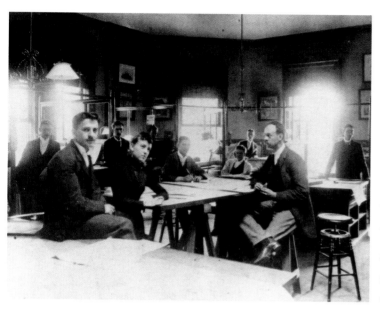

Albert Kahn (*left*) in the Mason and Rice office in the late 1880s.

Albert Kahn Associates

Nor did Kahn focus only on the master-pieces of European architecture, as biographer and architect Grant Hildebrand pointed out. He was also drawn to the vernacular and out of fashion. In this, Hildebrand reads independence and a constitutional antielitism starting to coalesce into an aesthetic point of view. "The taste for less popular but nevertheless vigorous and dynamic work," Hildebrand wrote, "toward which so many of Kahn's sketches were oriented was in all probability Kahn's own [as opposed to Henry Bacon's suggestion]. Even at that time [Kahn] was recording certain attitudes toward architecture that set him apart from his professed guide," attitudes that anticipated the leap Kahn would make with his "beautiful factories" in the early twentieth century.[35] Kahn always disdained the role of prima donna artist-architect, the narcissist who served himself rather than his client. Federico Bucci, the dean of architecture at the Mantua campus of the Politecnico di Milano (Polytechnic University of Milan) and author *of Albert Kahn: Architect of Ford*, noted that the Detroiter saw his role as "a technician at the complete disposal of the client"—an "unprincipled" flexibility later European modernists would scorn.[36]

Kahn returned late in 1891 to the Mason and Rice offices on Griswold Street in downtown Detroit.[37] Mason had kept in touch with his protégé during Kahn's travels via letters that the younger man called "kindly, helpful, instructive."[38] While Mason made no notes in his professional diary when Kahn left for Europe, there are two entries upon his return: On November 27, "Albert Kahn returned home from Europe this a.m.," he wrote with typical brevity. Four days later, Mason added, "Albert Kahn commenced work this a.m.—first day since his return from Europe."[39] One imagines that on his return the young man was bursting to show off the drawings he had made in Europe. The sketches received "rather gratifying comment," Kahn noted years later, and "no one was happier about the results than Mr. Mason." Shortly after he started back at the firm, Kahn was named the firm's chief designer. He was just twenty-two.[40]

Kahn's first commission after his promotion was the Watson M. Freer house (since demolished) on Detroit's aristocratic East Ferry Avenue, next door to the Long Island

Shingle style mansion architect Wilson Eyre built for Watson Freer's brother, aesthete and art collector Charles Lang Freer. (The latter's astonishing collection of Asian art and ceramics would eventually form the core of the Smithsonian Institution's Freer Collection.) Hildebrand, not always complimentary of Kahn's nonindustrial designs, praised the Watson M. Freer house, finding it

> rigorous, non-picturesque, and austere. It has little in common with the era of Richardsonian (Romanesque) influence then drawing to a close, or with the classicism and eclecticism that were just beginning to gain in popularity. The overall form of the Freer house is crisp and clear—openings are cleanly incised within the simple mass. The brick has been handled with hardly a trace of romanticism and with great respect for its ability to create a precise wall plane. The house is a personal and original work, sufficiently distinct from previous Mason and Rice designs to have occasioned some office discussion.

Regrettably, the house was torn down after World War II to make room for the modernist (and admittedly good-looking) Merrill-Palmer Institute for childhood studies (now the Merrill Palmer Skillman Institute at Wayne State University).[41]

Word of the young architect's talent got around. In one of the great what-ifs of architectural history, in 1893 the celebrated Chicago firm of Adler and Sullivan apparently made Kahn an offer—interestingly, to fill the seat recently vacated by Frank Lloyd Wright who, depending on whom you believe, was fired or quit of his own accord.[42] There may have been a personal link as well that brought a young Detroit architect to the attention of such an illustrious firm. Partner Dankmar Adler's father was rabbi at Detroit's Temple Beth El, which Kahn's family attended. As a boy growing up in Detroit, Adler also studied drawing with Julius Melchers, albeit a couple decades before Kahn. Within the congregation, Kahn was likely discussed as a young rising star, notable for his success in a heavily Gentile profession—intelligence that may have been passed along to Adler.[43]

In architectural terms, an offer from Adler and Sullivan was a bit like Harvard offering you a full scholarship. The firm was one of the most famous in North America. Its 1892 Wainwright Building in St. Louis was celebrated far and wide as a great leap forward in skyscraper design—progressing from "layered" interpretations to a unified whole that celebrated the powerful red-granite behemoth's upward-thrusting lines.

Key players in the Chicago School of design, Adler and Sullivan would end up creating much of turn-of-the-century Chicago's "modern" look. Moreover, Sullivan was reaching for a specifically American architecture—an ambition that always intrigued Kahn as well.[44] Sullivan's provocative Transportation Building at the 1893 Chicago World Columbian Exposition, with its massive, concentric entrance arch, was the talk of architects and critics everywhere. Apart from Boston's H. H. Richardson, titan of the Romanesque, or classicists McKim, Mead, and White in New York, there wasn't a more famous architecture firm to be found.

But the young Kahn, just twenty-three, turned down the gilded offer.[45] The explanation most commonly cited is that Kahn had a family of nine to support, what with parents and younger siblings, and couldn't take the risk of a new job in a new city.[46] And perhaps Detroit already felt charged with potential, ten years before the incorporation of the Ford Motor Company, and thus every bit as promising as Chicago. Or perhaps Kahn didn't want to break so soon with George Mason, who'd promoted him to chief designer just two years before. Unfortunately, Kahn doesn't discuss the episode in any of the surviving archival documents, so we are left to guess.

Or alternately, as the timing suggests, perhaps he was falling in love with a Detroit girl. In 1893, Kahn was working on a new house on Adelaide Street on the city's east side for the Kroliks, a well-to-do Jewish family with a daughter named Ernestine, whose photos show an angular, pretty young woman with large searching eyes. She was one of the few women graduates of the University of Michigan in those years, getting her BA in 1892, just before meeting her future husband.[47]

Ernestine's letters reveal a literate, highly intelligent personality—and one with undeniable spirit, even as a teenager. After her father suggested she ought to pen two or three letters a day to relatives back home while visiting family in Minnesota in 1885, she pointed out that a well-composed letter took two hours to write, and three would consume six hours a day. "As I like to go around a great deal," Ernestine added, "and in fact came out here for that purpose, I hope you won't require me to spend half my time writing, now that you know the facts of the case."[48]

Ernestine and Albert appear to have made an excellent marriage, but even before the wedding, the young woman learned that her husband-to-be's work took precedence, which over the years would upset plans for dinners, concerts, family gatherings, and trips to Europe. When Mason sent Kahn to New York to help partner Zachariah Rice in the summer of 1894, the news came as the first of many blows to his fiancée

Ernestine. On vacation at Sand Beach, Michigan, Ernestine wrote her future sister-in-law Mollie Kahn, "You can imagine that I was very much surprised yesterday to get a letter from Albert saying that he was going to New York. I am very glad for his sake for it certainly is a great opportunity. But oh, how I shall miss him when I get back! I had been counting the days till next Friday," she added, "but now I don't feel so eager."[49] In what appears to be the earliest Kahn communication in the public record, the young architect sent a note to his fiancée a few months later, begging off lunch: "My dearest Ernestine—I find after all that if I want to finish up today I must stay down here for dinner this noon, so Sweetheart excuse me just once more. I'll be up for supper and will stay until about 8 instead. Yours in haste and so much in love with you, Albert."[50]

Happily, as long as he was working on the Krolik project, Kahn was frequently obliged to be near Ernestine. And his Ernestine wasn't the only one who was occasionally bereft. "I think the contractor and the mechanics at your house thought me a little out of sorts this noon," Kahn wrote his fiancée in early June 1894, "but I didn't see Ernestine and knew that I wouldn't, and that was the cause."[51]

In an August 4 letter that summer, Kahn summarized a trip to the old Detroit Public Library at Farmer Street and Gratiot Avenue (the predecessor to Cass Gilbert's 1921 library on Woodward Avenue), where he'd hoped to find new journals from Paris's École des Beaux-Arts. Instead he stumbled upon *Henry Hobson Richardson and His Works* by Mariana Griswold Van Rensselaer, sometimes described as the first female architecture critic. The young man went on to describe another architect in love. "I ran across a number of letters of [Richardson's] from Paris to his Love—a Miss Hayden of Boston," Kahn wrote, "and what nobility, what grandeur of intellect and honorable pride and love for his profession [you find] in some of them. Such loftiness and bigness all through them. . . . Oh dearest Ernestine, how I do wish that I were a Richardson." But the young man stepped right back from that fantasy. "Believe me nevertheless," Kahn added, "though I am not a Richardson, the same love and reverence for his profession, that made him the master he was, will make me what I am capable of."[52]

For a young architect who never attended a day of college, the Detroit Public Library played an outsized role in Kahn's education, and he freely noted the help he'd found within its walls. Amusingly, the four-story Second Empire building (on which a very young George Mason may have worked) also seems to have played a supporting role in his marriage proposal to Ernestine, which apparently took place while he was walking her home from Gratiot Avenue and Farmer Street, where the Skillman branch library

stands today. "Do you know of one thing [the library] proved an assistance to me in, my Darling Ernestine? Do you remember . . . a walk back home from it and its outcome? I feel now like lifting my hat when I pass by," he added. "I feel—I don't really know how—when I step in."[53]

According to Hildebrand, who spoke with two of Kahn's daughters, now both dead, the couple revealed their engagement to their parents in the summer of 1894 but didn't make a public announcement for some time. Kahn in particular seems to have struggled under the burden of concealment. "But some day," he wrote, referring to his sisters, from whom he had trouble keeping the secret, "I'll be able to tell them and then I can babble openly all I want to, and yell when I feel like it, and dance and sing." He added, "But the latter, I fear, they'll gladly dispense with at any time."[54]

As was the custom, it was a lengthy engagement—two years and four months. Ernestine finally set the date in August 1896, scheduling the wedding for September. "You know, of course, that you couldn't make it any too soon to suit me," Kahn wrote his fiancée, whom he called his "kind, sweet encourager." Like many decent young men, he also wondered, standing on the brink of a lifetime commitment, whether he was up to the task. "I am such a crank they tell me," he wrote, "that I fear at times that you are taking great chances. But I'll try my very best to make you happy, just as happy as you can be. Four and a half weeks more and we'll be one—I can hardly believe it. I can hardly imagine myself a husband and the proud possessor of a wife. I do hope that I'll be equal to it all."[55]

If the young man was smitten with his bride, he was equally besotted with architecture, and one of the pleasures in reading his love letters is the way one passion reinforces the other. Building commentary floods Kahn's letters before and after his engagement, and not just to Ernestine, but to a range of family members as well. You get the sense of an ambitious intellect that just can't contain its excitement. "In my last letter I mentioned some of the buildings I thought you might not [want] to miss seeing and especially noticing," he wrote in 1895, while Ernestine was visiting New York. "Of course I mentioned only a few. There are so many. There are however [also] many lessons there of what *not* to do," he added, "and sometimes such are as interesting as their opposite. But if you want to see a really exquisite little structure, just notice the other Vanderbilt house on the N.E. corner of Fifth Ave., and I think, 45th Street. It is a gem built some years ago by the great R. W. Hunt, but I doubt its having been excelled in this country since. That too is a sort of French Renaissance of the 16th century, but cast

in a mold entirely its own." The design, he added, displayed "a knowing disregard, and courage, and self-consciousness, which stamps it as the work of a genius, a thoroughly trained man."[56]

That Kahn's education never went further than elementary school might, with many couples, have presented an obstacle—even if the 1890s were still very much the era of the self-made man who triumphed over poverty, a college education not necessarily required. But by 1894, never mind his early privations, Kahn was already a successful young man—chief designer at one of Detroit's most important firms—and that likely helped dampen any concern about status and formal degrees. And to judge by his clear and literate letters, there was nothing to suggest a fellow who never made it through seventh grade—-all the more remarkable when you recall that when Kahn first made landfall in Baltimore, he spoke only the most rudimentary English. Or perhaps it was Ernestine's broad sensibility that put the education question to rest. (Her son Edgar called her the calmest person he'd ever known.)[57] Family biographer Brashear argued, "Ernestine had the intuitive power to grasp the scope, if not the operations, of her future husband's mind and the fact that he required no formal education."[58] In addition, Ernestine's own parents had bridged an even greater gulf. Her mother, Sarah Ewell Krolik, came from Protestant blue bloods with Revolutionary War connections; Ernestine's father, when young, had peddled dry goods from a horse-drawn wagon. (Edgar called his grandmother "a real liberal in her time," noting her work on behalf of discharged prisoners, immigrants, unmarried mothers, and others among the downtrodden.)[59]

Ernestine and Albert were married by his father, Rabbi Joseph, on September 20, 1896, in the Krolik drawing room. It seems to have been a small, elegant affair. Decorations were pink, green, and white, and a mandolin orchestra played behind a screen of flowering plants.[60] The union appears to have been highly successful, producing four children and lasting forty-six years until Albert's death at seventy-three.[61]

What sort of man did Ernestine take as her husband? Albert Kahn was small and compact—just five feet five inches, according to his 1925 passport.[62] He was a handsome fellow with a high forehead and dark, thick hair parted just off center. He favored bowties and owlish horn-rimmed glasses. For most of his adult life, Kahn sported a short, carefully trimmed mustache. He spoke with a light German accent.[63] From the start, he radiated confidence, seemingly sure of his place in the world. In a family portrait taken around 1900 when Kahn was thirty-one, the eight siblings surround their

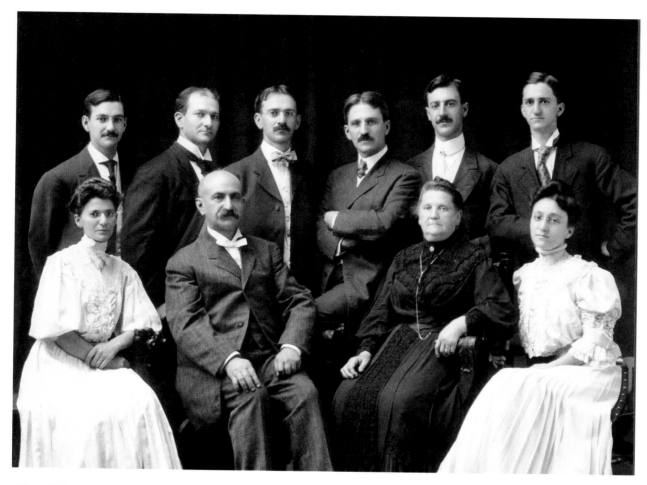

Albert Kahn (*center with arms folded*) and his seven siblings surround parents Joseph and Rosalie.

seated parents, Joseph and Rosalie. Albert, half a head shorter than any of his brothers, stands at center with arms folded and one leg thrust forward, gazing with easy authority at the camera.[64]

As a young adult, Kahn liked biking ("my wheel," he called it), and he wrote his fiancée an enthusiastic letter detailing a ride from Detroit to Utica to Mt. Clemens and back. But his youngest daughter, Rosalie, said he was no athlete: "*Once* he tried to learn to ride horseback," she wrote in 1967, "but he was [by then] a round, short-legged little man, and he almost rolled off. That was his first and last try." Kahn was also a devoted Tigers and Wolverines fan, attending University of Michigan football games and, when his son Edgar was varsity hockey captain, those games as well.[65]

He almost never stopped working. His daughters remember him coming home for dinner at 7, taking a short nap, and then continuing to work in his study.

Kahn was not particularly religious or observant, but he nonetheless sat on the Temple Beth El board and chaired its Choir Committee for many years.[66] The Detroit

Historical Society calls him a "founding craftsman" of the 1906 Detroit Society of Arts and Crafts, the hugely influential arts club. From 1918 to 1942 he sat with Edsel Ford and other luminaries on the City of Detroit Arts Commission, which oversaw the newly created city-owned Detroit Institute of Arts.[67] In 1918 Kahn built a handsome summer house filled with windows on Walnut Lake in Oakland County, and he joined the Bloomfield Hills Country Club and Bloomfield Open Hunt. He also belonged to the Detroit Philosophical Society, the YMCA, and the Bohemians, a Detroit "musicians' club."[68] Kahn was generous with his time. In 1935, he invited members of the arty Torch Club to his restrained Arts and Crafts home at John R Street and Mack Avenue to hear him speak about Impressionism, surrounded by a personal collection that by then included one work by Alfred Sisley, one Mary Cassatt, one Camille Pissarro, and two Edgar Degas.[69] He was also much in demand to speak on architectural and urban-planning topics, both in Detroit and around the country. In the early years, Kahn's speeches had considerable personality and were often punctuated with mild ethnic jokes—all of which would sadly disappear as he gained fame in the 1930s. (One such aside concerned a Scottish minister who always gave credit where credit was due, even to the devil himself. "Well, we must admit," the pastor reportedly said, "Auld Nick has great energy and perseverance.")[70]

Kahn had a consuming passion for buildings and beauty, but he was no starry-eyed idealist, never mind a 1908 *Detroit News Tribune* profile that styled his engineer brother Julius "the doer" and Albert "the dreamer."[71] Albert's discipline and drive quickly became the stuff of Detroit architectural legend. After a flattering profile underlining the architect's hyper-kinetic nature appeared in 1929, a friend wrote to say, "I can just

Kahn belonged to two of the best private clubs in Oakland County.

Albert Kahn Papers, Archives of American Art, Smithsonian Institution, courtesy of Ernestine Ruben

picture you chasing from one office to another with your coat-tails flying, and pepping up everyone in the organization."[72]

Kahn's attachment to buildings went far beyond mere ambition—they had a grip on the young man's heart. McKim, Mead, and White's 1894 Metropolitan Club in Manhattan didn't just excite the young architect, it sent him into reveries. Kahn was already familiar with the New York firm, having seen its Agricultural Building at the 1893 Chicago World's Fair. But the Metropolitan Club made a particularly deep impression. "Mr. Rice and I stood and stood and couldn't satisfy ourselves," he wrote Ernestine. "It looks just what it is and I know of few modern buildings that have impressed me so. These men are simply great."[73] The firm's neoclassical, Beaux-Arts brand was dubbed the "American Renaissance" and would later form the template for any number of masterworks, including New York's late lamented Pennsylvania Station.

Kahn had an artist's appreciation for excellence in other crafts. He loved classical music and was a regular at the Detroit Symphony Orchestra. At a performance or listening to the record player at home, his daughter Rosalie said Kahn would sit rapt and oblivious to all else around him. "He was just as absorbed in listening to music as in working," she wrote. "He would sit with his mouth open, apparently drinking in the sound more fully in this manner, and he would hardly move a muscle. At some particularly pleasing passage he would murmur to himself, 'Beautiful, beautiful.'" Despite his workaholic nature, he almost always left the office Saturday afternoons in time to catch the Metropolitan Opera radio broadcast at home with Ernestine. But despite his early promise with the piano, Rosalie could never recall her father touching the instrument. "I don't know when or why Father stopped playing the piano," she said. "He was not willing to do anything to which he could not give his best effort; he had to choose, and architecture was it."[74]

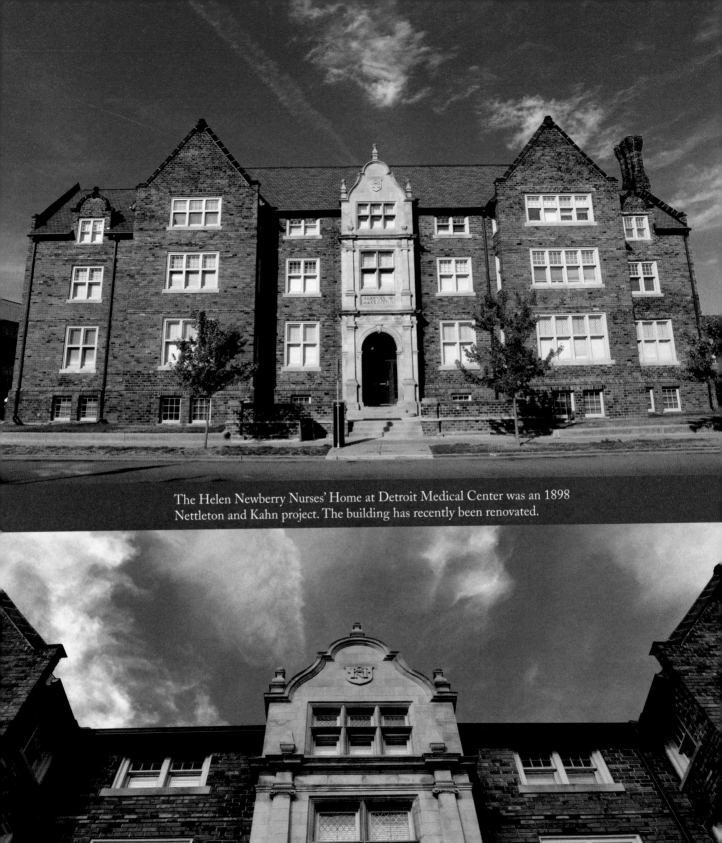

The Helen Newberry Nurses' Home at Detroit Medical Center was an 1898
Nettleton and Kahn project. The building has recently been renovated.

3

BUILDING

The year was 1896, a season of upheaval and change for both Albert Kahn and Detroit. The first experimental cars appeared on city streets, while James Vernor inaugurated his new downtown plant to produce his signature ginger ale.[1] For his part, in January, Kahn stepped out with two older colleagues from Mason and Rice, George Nettleton and Alexander B. Trowbridge, to create Nettleton, Kahn, and Trowbridge. And in September he got married.[2] The parting with Kahn's longtime mentor George Mason appears to have been amicable—the latter must have recognized that at some point his young prodigy would want to be on his own. In any case, Mason steered work he couldn't handle to the fledgling office. Nettleton, Kahn, and Trowbridge snagged some important commissions, like Detroit Children's Hospital, but in general business was, to use Brashear's word, "lean."[3] The firm designed what Ferry calls the "English Jacobean" 1898 Helen Newberry Nurses' Home (now part of Detroit Medical Center) and the long-gone library and art gallery at the home of *Detroit News* founder James E. Scripps.[4]

In 1897, Trowbridge left the firm to head up the architecture department at Cornell. Three years later, the remaining partner, Nettleton, died of tuberculosis—which had to have been awful for Kahn on a personal basis as well as leaving him alone and overwhelmed in a sinking firm. Kind as ever, George Mason threw him a lifeline.[5] The younger man returned to his mentor's office for a little over one year. While Kahn couldn't help but regret the loss of his own practice, he could take comfort in being made a partner in the newly constituted Mason and Kahn. In any case, he needed a steady income. He had a child now, Lydia, born in 1897, the first of what would be four

(*Top, bottom, and facing page*) The 1904 Aquarium and Conservatory on Detroit's Belle Isle. The latter, built a year or two before Kahn's pioneering leap forward at the Packard plant, nonetheless seems to anticipate the coming "daylight factory."

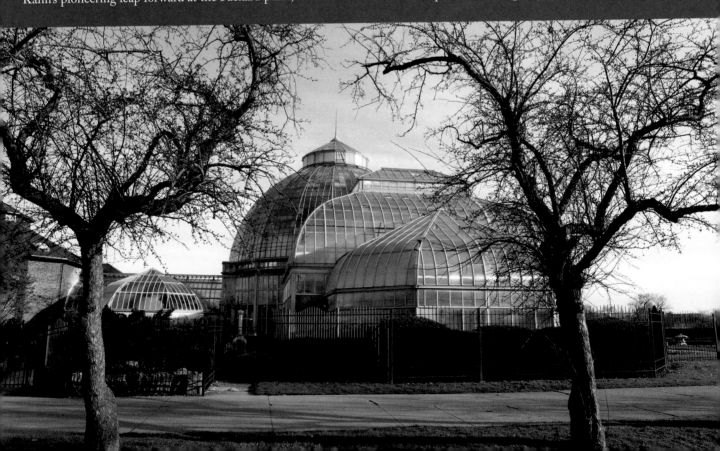

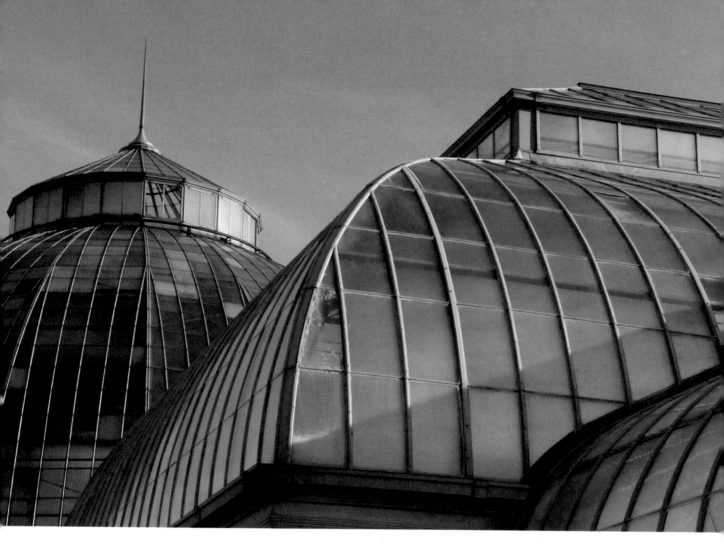

Kahn offspring.[6] Every bit as pressing as his new baby, however, were chronic concerns about Kahn's father and what seems to have been a recurring need to find the old man a job.[7]

It's hard not to tie Albert Kahn's workaholic nature to his father, an "impractical dreamer" who carved out a mostly feckless career punctuated with lots of unemployment.[8] Indeed, if you talked to family members, they would likely have told you that the *Detroit News Tribune* had it all wrong. Albert wasn't the family romantic; that role fell to father Joseph. As an itinerant rabbi, Joseph was first called from Detroit to "minister" in Honesdale, Pennsylvania, where he earned $700 a year. His role seems to have been to get new temples up and running, then move on after several years. Subsequent calls, each for two to three years at a time, came from Trenton, New Jersey; New Orleans; Jacksonville, Florida; Davenport, Iowa; and Leavenworth, Kansas. What this meant, if sister Mollie's timetable is accurate—and regrettably, she offers no specific dates— is that Joseph and Rosalie spent about twelve years away from Detroit, returning for short periods of time in between assignments, when Joseph would scramble to cobble together a living.[9]

After returning from his call to Trenton, Joseph sold sewing machines "in a little store on Gratiot." After his stint in Leavenworth, he took to selling spectacles. The first venture, according to his daughter, "was a flat failure, and so did not last long." He enjoyed somewhat better luck with the eyeglasses, "but Mother, who was our little financier, did all the work." At other times, Joseph gave German and French lessons, which he genuinely seemed to relish. Eventually, he and Albert developed an experimental blueprinting process, the "multograph," which became Joseph's occupation in Detroit for many years. Indeed, the whole point in creating it seems to have been to give Joseph employment. (Mollie Kahn Fuchs would end up taking over the business from her father, in the process becoming a considerable success in her own right.)[10]

Parental finances always seem to have been precarious. As late as 1900, Julius wrote his older brother Albert from New York City to suggest that Joseph and Rosalie move there, where Julius and younger brother Moritz were already living. The former proposed they all cohabit. Julius was pretty sure they could find some sort of work for "Pa," noting that a "Mrs. Kohut, who seems to be one of the best and most influential women among the Jewish people in New York, has volunteered to help." With an engineer's penchant for organization, Julius laid out the proposed domestic economy: "Taking things all around," he wrote, "Moritz and I could grant the family the price of board of about $18 per month. Paula [the youngest daughter] would be saving about $5 above her expenses in Ann Arbor. The extra boarder could pay, say, $6, and if Pa earned anything at all, it ought to be $12 a week [which] would swing the family income to $41 per week on which they might live comfortably and save a fair amount besides. So if all things work well," he concluded, "I do not believe the plan of coming to New York would come so badly."[11] Subsequent letters shed no light on why the scheme never came off, though Albert may have already decided he wanted to bring Julius, whom he'd helped put through the University of Michigan, into the new firm he launched in 1902. In any case, Julius moved back to Detroit in 1901.

In her memoir, Kahn's younger sister Mollie wrote that as early as the family's voyage to America in 1881, Albert—just twelve—was already playing the part of paterfamilias, a role that only grew with time.[12] Brother Moritz, ten years younger than Albert, recalled that if he got in trouble, his father, Joseph, would warn, "I am going to tell Albert about this when he gets home!" Moritz told a reporter in 1929, "Albert was a thin strip of a lad, but he fathered us all. I've seen him give one of the boys a licking, when that boy was a whole head taller and a lot heavier than Albert, and could have licked him with one hand. But he stood and took what he got. Why? Because we looked on Albert as our boss."[13]

The 1903 Engineering Building at the University of Michigan, Albert Kahn's second use of reinforced concrete. His first was the 1902 Palms Apartments in Detroit.

The boss seemed to have a gift for collaborating with his younger siblings. Albert worked with brother Julius, the engineer, on Packard Building No. 10 in 1905, the architect's third design in reinforced concrete, after the Palms Apartments in Detroit in 1902 and the University of Michigan Engineering Building one year later. The collaboration with Julius proved to be a career-changing move. Much if not most of Albert Kahn's early success can be tied to Julius and his experiments with reinforced concrete.

You often hear around Detroit that the Kahn brothers invented reinforced concrete. They did not. They refined a system that dates back at least to 1848 and Frenchman Joseph-Louis Lambot's intriguing experiments with a rowboat exhibited at the 1855 Paris World's Fair. Indeed, France played a major role in the technique's development. Speaking to the American Concrete Institute in 1924, Albert Kahn tipped his hat to a parade of nineteenth-century French engineers—Monier, Coignet, Considère, and Hennebique among them—who, he said, "gave reinforced concrete its real start."[14]

The development of reinforced concrete is one of the great overlooked technical advances in the early twentieth century that helped propel industry into the modern age. Without reinforcement, concrete has limited strength. Embedding steel rods in the wet concrete dramatically boosts the loads the material can carry. Improved techniques like the Kahns' produced concrete that was strong, flexible, cheap, and fireproof.

Small wonder it displaced traditional slow-burning wood and masonry construction. In construction, an entire reinforced concrete floor could be cast at once—slab, beams, columns, and girders. You start with a wooden framework to hold the steel and concrete. Steel reinforcements are set in place and the wet concrete is poured. The whole structure is completed in one fell swoop. Once the concrete has cured, the framework is dismantled and the building's skeleton is revealed, creating a monolith that looks as though it were carved out of solid rock.

But in 1900, reinforced concrete was still an evolving technique in search of perfection, with many different patented schemes hitting the market at the same time. "It is hard today to realize what courage it took to design in concrete," wrote *Architectural Forum* editor George Nelson in a 1938 issue devoted to Kahn's industrial work, with a picture of his futuristic Chrysler Half-Ton Truck plant on the cover. "Handbooks were not available, and formulas were virtually nonexistent."[15] Before the Kahns came on the scene, the system's most successful American practitioner was Ernest L. Ransome, an engineer who got his first patent for a twisted iron (soon to be replaced by steel) reinforcement system in 1884—almost twenty years before the government awarded Julius Kahn patent no. 736,602 in 1903.[16] Interestingly, Ransome at first ran into stiff resistance from the local building industry. "When I presented my new invention to the technical society in California," he said, "I was simply laughed down, the consensus of opinion being that I had injured the iron [by twisting it] . . . in spite of all my references to the twisting of ropes and similar devices." Significant Ransome projects included the San Francisco Academy of Sciences, the Leland Stanford Jr. Museum in Palo Alto, and the Pacific Coast Borax Works at Bayonne, New Jersey. But in terms of architectural history, Ransome's most important commission was doubtless the modern 1905 United Shoe Machinery Company in Beverly, Massachusetts. The Ransome factory was designed at almost the same moment Albert Kahn was working on the Packard Motor Car plant's Building No. 10 on Detroit's east side. It would be the town's first reinforced-concrete auto factory, and the structure that established the Detroiter's reputation as an industrial architect to be reckoned with.[17] The Packard and United Shoe complexes bear a strong resemblance to one another, both in their use of reinforced concrete and their extensive glazing to pull in light. In this respect, each factory was an early harbinger of where twentieth-century architecture was headed.

Reinforced concrete had the great advantage over mill construction of being fireproof, plus its superior strength was capable of much greater spans between columns, with

Although they may seem commonplace today, in 1905 the light and spaciousness of Packard Building No. 10 likely astonished the first workers to get inside.

Albert Kahn Associates

dramatic consequences for interior space. Huge windows to bring in light could be included without undermining the strength of the whole. The resulting airiness must have dizzied the first workers to walk in, accustomed as they were to the dark, dungeon-like nature of early factories. In the case of Packard Building No. 10—originally just two stories, later enlarged to four—columns were spaced at intervals of thirty-two feet three inches. Earlier spans had been half that.[18] Fewer columns not only meant unprecedented spaciousness for auto manufacturers, but also allowed for maximum flexibility, a key asset for a new industry just making it up on the fly.

And as luck would have it, improvements in concrete design came along at just the time that U.S. manufacturing began an epic expansion in scale, with demands for space that dwarfed anything that had come before. "By the end of the 19th century, American industry had outgrown its physical plant," wrote architectural historian and critic Ada Louise Huxtable in 1957. "Traditional wood and masonry buildings of slow-burning construction were no longer adequate to house the new giants of American enterprise. The moment was ripe, near the turn of the century, for the adoption of a practical, versatile, economical material that was to prove to be the workhorse of the new industrial architecture: reinforced concrete."[19]

Julius Kahn joined his brother's new firm in 1902 as chief engineer after graduating from the University of Michigan with a BS in civil engineering.[20] The ambitious young man was critical of most existing concrete methods, which in the worst cases failed with catastrophic results. Concrete could slip from the steel; unreinforced sections could tear from the reinforced. So, in the best traditions of early twentieth-century DIY spirit, the Kahn brothers began experimenting in the basement of the east side duplex Albert had built for his parents. Julius was pretty sure he was onto something big, telling sister Mollie, "If I get this patent [for the Kahn system of reinforcement], we'll all be on Easy Street." As she remembered it, "[Julius] talked constantly about a concrete bar which would be fireproof and used in construction work. How the poor boy did work! The first bar he made was in the basement of our Frederick Avenue house. I remember well how

he would mix his cement, then imbed the bar in it, because I helped with putting in the cement. It became so hard the bar still remains in our old home."[21]

The Kahn system, wrote civil engineer Ryan Salmon and architect Meghan Elliott in *Structure Magazine*, "was unique—it consisted of visually distinctive rolled diamond-shaped bars with flat-plate flanges (or 'wings') that were sliced and bent up at regular intervals at approximately 45 degrees."[22] Julius would spend only a short period in his brother's firm. He quickly established his own company, Trussed Concrete Steel (later called TrussCon), and would go on to market the Kahn system with considerable success. Huxtable called the Kahn system "ingenious, practical [and] economical."[23] Bucci admiringly cited the company's "brilliant commercial management of the patent."[24]

There were detractors. C.A.P. Turner, an engineer with a national reputation and his own patented reinforcement design, "vehemently" denounced the Kahn system in his 1909 *Concrete-Steel Construction* for what he felt were significant weaknesses.[25] For his part, Hildebrand conceded that the Kahn system had an attractive theoretical efficiency "in that its shear reinforcing wings, bent upward at 45 degrees, acted approximately parallel to the forces tending to cause fracture; but the Kahn bar," he added, "was unquestionably difficult to fabricate."[26] And despite praising the Kahn system, Huxtable gave the crown for first perfecting the technique into a reliable system to Ransome.[27]

Building collapses were still distressingly common in the late nineteenth and early twentieth centuries. The Kahn system, Salmon and Elliott noted, was "involved in at least two catastrophic building failures"—the first in 1906 with the Bixby Hotel in Long Beach, California, followed just two weeks later by the Eastman Kodak Building in Rochester, New York. Investigations in each case, however, concluded the blame lay with the contractor's shoddy workmanship, not the design. And the Kahn system was repeatedly put to the test, not least in 1906 with the nine-story Farwell, Ozmum, Kirk, and Company warehouse in St. Paul, Minnesota. Workers piled a floor bay, designed to carry five hundred pounds per square foot, eight feet high with pig iron weighing fifteen hundred pounds, dramatically underlining what the structure could take without flinching.[28] Even more impressive was Frank Lloyd Wright's 1923 Mayan Revival Imperial Hotel in Tokyo. The Imperial, built with the Kahn system, was one of the few buildings to survive the 1923 Great Kanto Earthquake that leveled much of the city.[29]

The 1902 Palms Apartments gave Kahn his first opportunity to build in reinforced concrete, just one year before Julius got his patent.[30] Despite the success of the Palms,

Henry B. Joy, president of Packard Motor Car Company, was Kahn's most significant early client.

Albert Kahn Family Papers, Bentley Historical Library, University of Michigan

however, Kahn returned to conventional slow-burning construction that same year when Henry B. Joy, the new manager of the Packard Motor Car Company, asked him to build an auto plant in a field on Detroit's far east side. Joy, son of the president of the Michigan Central Railroad, was one of many moneyed young men who couldn't resist the pull of the automotive dream. As his biography at Dearborn's Automobile Hall of Fame notes:

Although the Packard brothers founded the Warren, Ohio-based Packard Motor Company in 1899, it was Henry B. Joy who guided the company to become one of the world's foremost luxury car manufacturers. A wealthy Detroiter, Henry Joy, in 1902, chanced to see two Packards start instantly and take chase after horse-drawn fire wagons in New York City. So impressed was Joy that he purchased the only Packard for sale in the city. In fact, he liked the car so much that he persuaded nine other Detroiters to invest in the company, taking majority ownership. When the city council of Warren, Ohio prevented Packard from expanding, Joy persuaded company president James Ward Packard to move the company to Detroit. Joy hired a young architect named Albert Kahn to design a new factory to be located on East Grand Boulevard in Detroit. The result was the world's first [sic] reinforced concrete factory.[31]

Kahn was apparently recommended to Joy around 1901 by Detroit industrialist Joseph Boyer, one of the early investors and officers in what would eventually become the Burroughs Adding Machine Company. Kahn did work on Boyer's house and put a small addition on the Chicago Pneumatic Tool plant (formerly the Boyer Machine Company) on Second Avenue, where Boyer was a director. (It is widely asserted that Kahn built the original Detroit Boyer Machine Company on Detroit's Second Avenue, but architectural historian Chris Meister has cited a range of sources disproving that.) From Boyer's point of view, Kahn was a logical choice when Joy wanted to expand his house. Meister called the architect "the premier remodeling designer at the time in Detroit."[32] Joy was impressed enough to ask Kahn to build his new plant, and later

advanced the architect's name when the University of Michigan (U-M) Engineering Building contract came up.[33]

Never one to oversell himself, Kahn reminded Joy that, apart from a small addition to Boyer's facility, he'd never built a factory. Joy didn't care. Kahn was his man. For an architect who'd spent most of his career in residential design, it must have felt like a leap into the thrilling unknown. "Even in 1903," Hildebrand wrote, "Kahn was able to talk about industrial problems and solutions with an insight and conviction that distinguished him from his colleagues."[34] Meister suggested Kahn lunged at industrial work as a way to save a sinking practice, but that might be selling him short. Rosalie, his youngest daughter, said that "the excitement of the growing industry possessed him."[35] For his part, Bucci saw in Kahn "an impassioned researcher of a new relationship between architecture and industry," an advance that first took shape in Packard Building No. 10.[36]

Through the years Kahn brushed off suggestions that there was anything special about him that attracted Joy's interest. In one of the architect's most-quoted pieces of humble pie, Kahn explained that when he first got into the plant business, "Real architects would design only museums, cathedrals, capitols, monuments. The office boy was considered good enough to do factory buildings. I'm still that office boy designing factories. I have no dignity to be impaired."[37]

Packard No. 10 presaged a radical redefinition of the space within and without the building envelope, one that would end up having unexpected reach in both construction and architecture. It's hard to overstate the influence of No. 10 and the factory type it introduced. "The simplicity and flexibility of the industrial plant," Huxtable wrote in 1957, "[with] its open areas, wide spans, glass walls, unit construction—-the particular emphasis on space, light and air that it introduced—have become basic elements of design; the endless repetition of its standardized exterior patterns has supplanted the classically organized façade and revolutionized the man-made scene. Scarcely a school, hospital, market, office or administration building, apartment house, or large-scale structure of any kind exists that does not bear the mark of the factory style. Commonplace now, these were revolutionary innovations at the turn of the century."[38] Reinforced concrete thus became the indispensable first step in early modernist architecture, one that permitted, as Kahn noted in 1930 to the Cleveland Engineering Society, "a form of architecture quite as distinctive and expressive of our manufacturing age as has been the skyscraper of our commercial achievements."[39]

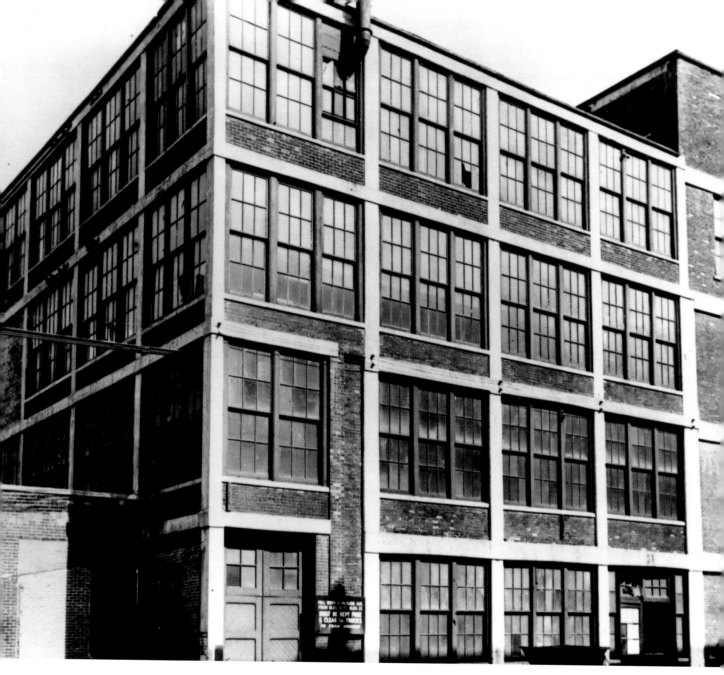

Kahn's 1905 Building No. 10 at the Packard plant—in one fell swoop, the architect invented the airy, infinitely flexible open loft space that would come to define the daylight factory.

Albert Kahn Associates

While a small handful of other reinforced concrete factories embodied some of the same features as No. 10—notably Ransome's plants in Beverly, Massachusetts, and East Rochester, New York—No. 10 was a car plant in a town about to dazzle the world with the sexiest and most liberating technology of the age. Kahn's daylight factory, so called because of the huge windows and skylights, became the template that would be used over and over again throughout the early years of the car industry. With windows stretching from floor to ceiling, at a stroke it buried the factory of the past. Even today, period photographs of the Packard plant when new—its huge windows gleaming—give No. 10 a distinctly modern look, the future sculpted in glass, concrete, and steel.

Building No. 10 was at first fairly small—60 by 322 feet and just two stories in height,

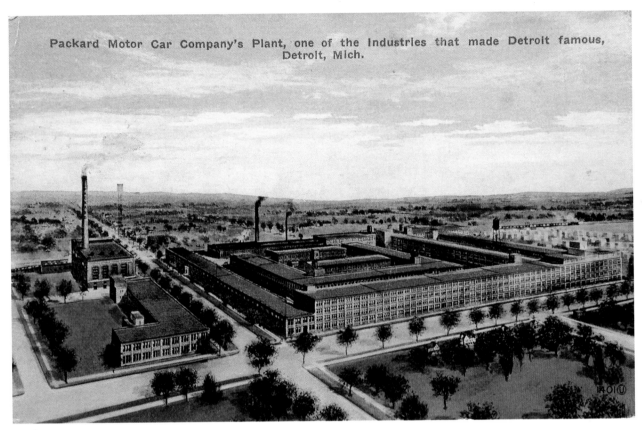

Packard Motor Car Company's Plant, one of the Industries that made Detroit famous, Detroit, Mich.

though it was designed to make additional floors easy to put on. "Columns were located at intervals of 32 feet 3 inches along the centerline of the building," Hildebrand wrote, "supporting a girder on which beams rested at 16-foot 1/2-inch intervals. The opposite ends of these beams were supported directly on columns spaced at 16-foot 1-1/2-inch intervals along the outside wall. Thus no girder was necessary at the outside wall, so that glass could extend up to the ceiling, where it was of greatest importance in lighting the interior."[40]

In *A Concrete Atlantis: U.S. Industrial Building and European Modern Architecture, 1900–1925*, British architectural historian and critic Reyner Banham noted, "It is [to the Packard plant] that one customarily goes to see what Le Corbusier called the 'first fruits of the new age,' the concrete-framed Daylight factory in its first shamelessly naked purity." But after that acknowledgment, Banham savaged Building No. 10 and the Packard plant in general (and this after praising American factory architecture, of which Kahn's work is one of the best exemplars). Banham seemed to have visited the plant under a dark cloud. "What looked so exciting in photographs and magazines seen by European modernists 7,000 miles away looks cheap and nasty in real life," he wrote after a visit to the Packard site in the 1980s. "The inadequacy of the detailing

The Packard plant fronts on Detroit's Grand Boulevard. A brick overpass vaults across the road to connect the two halves of the complex. On its longest side, the plant runs a full half mile along Concord, a tiny side street of burned-out lots and surviving one- and two-story workers' cottages.

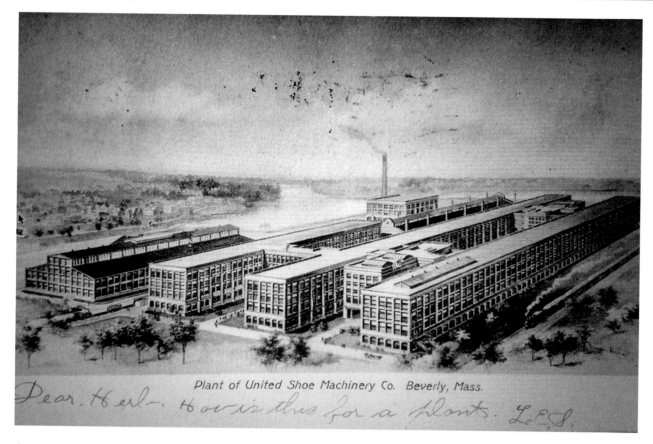

Plant of United Shoe Machinery Co. Beverly, Mass.

Dear Herb— How is this for a plant. L.P.S.

At almost the same time that Kahn was creating Building No. 10, engineer Ernest Ransome, a pioneer in reinforced concrete, designed and built the equally forward-looking United Shoe Machinery Company.

on Building 10 is now very conspicuous. The sharp arrises and exposed corners of the skinny members have spalled off at many points, leaving the corroded reinforcing bars improperly exposed to the weather. Not only is this untidy, but it also contributes to the air of grudging meanness that pervades the whole scheme."[41] But, taking a step back, it might actually be more accurate to say, "What looked so exciting *when new. . .*" The publication date on Banham's book is 1986, so he must have visited the plant at least a year before. And while the half-mile complex at Grand Boulevard and Concord Street hadn't reached the apocalyptic state that prevails today, it was still well into its downhill slide—partly occupied by various small businesses, but shabby, unmaintained, and unloved. It's hard not to suspect that Banham's judgment was affected by his horror at coming face-to-face with Detroit collapse and decay.

Frankly, he goes a little nuts, anathematizing Building No. 10 as "the null-value condition, the zero-term of architecture. Hardly any other architect or builder with a professional conscience could have done it. Few could have brought themselves down (or up?) to this level of cheese-paring economy—-or ruthless rationality, if you prefer—even if they had to affect such an attitude to keep the attention of profit-oriented entrepreneurs whom they hoped would commission buildings from their offices."[42]

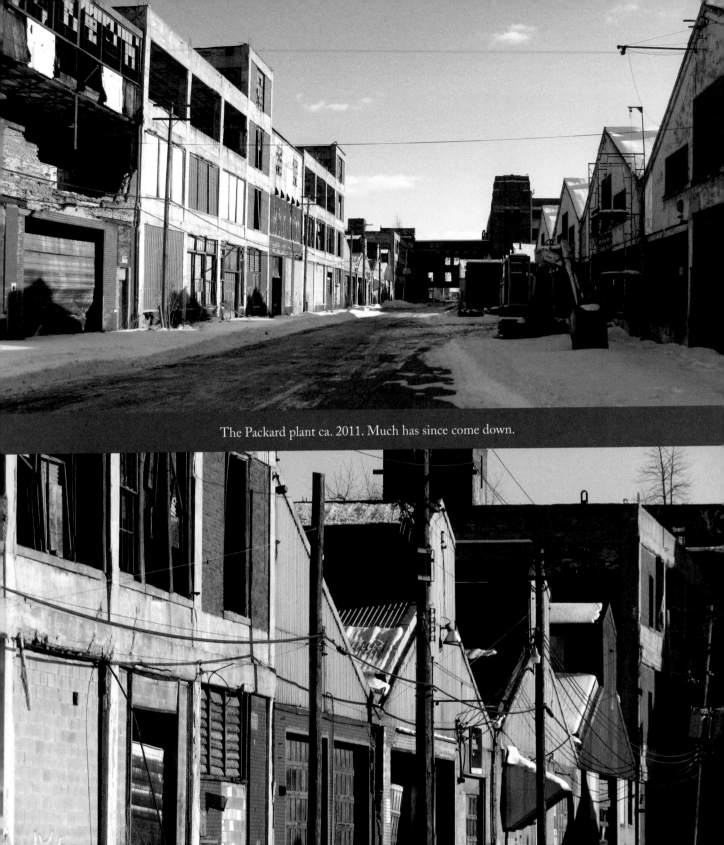

The Packard plant ca. 2011. Much has since come down.

For years, the Packard plant was open to all comers, a particular favorite among urban spelunkers, mostly but not exclusively men in their twenties and thirties, who spent their weekends exploring Detroit's abandoned buildings.

Not all assessments were so critical. Bucci argued there's a lot more going on with Building No. 10 than just the envelope. It's important to recognize, he wrote, that the Kahn brothers were aiming for something big, "the establishment of a laboratory for the research of new construction techniques and new systems for the management of labor; they were less concerned," he added drily, "with exterior design." All in all, Bucci said, Packard stands out as "an early precedent for the Modern Movement to follow."[43] For her part, Huxtable praised the "specialized solutions" Kahn developed for the building "that were to have such an extraordinary impact on the architecture of the world."[44]

Banham noted no impact or architectural precedent in No. 10. Nor did he recognize in its structural nudity the seeds that would flower into Mies van der Rohe's glass curtain walls in high International Style masterpieces like Chicago's Lakeshore Apartments or Detroit's sprawling residential complex, Lafayette Park. Banham was no snob—he celebrated the look of Los Angeles in *The Four Ecologies of Architecture*. Nor was he hostile to factory architecture per se. But in Packard No. 10 he saw an "extreme position, reached so suddenly by Kahn."[45] The use of "suddenly" is interesting. Aren't all cultural revolutions, in their way, sudden and extreme? What Banham misses in No. 10 is the first sign of the quickening of modernism on native soil—and yes, a sudden quickening.

Perhaps Kahn launched a trend, or perhaps the growing might and prestige of modern industry shifted the professional calculus. But a growing number of grade A architects began to include factory work in their portfolios, including Frank Lloyd Wright, Paul Philippe Cret, and Cass Gilbert. So too, of course, did Walter Gropius and one of the Europeans architects Kahn most admired, the German Peter Behrens, often hailed as the father of European modernism. As Hildebrand put it, "If in 1903, when Kahn began his work with Packard, he had been more or less alone in his eagerness to try the factory as an architectural problem, a decade later he was not."[46] The same year as Packard No. 10, Wright built the E-Z Shoe Polish Factory in Chicago.[47] Cass Gilbert

worked up a plan for the U.S. Army Supply Base in Brooklyn and wrote a 1923 article for *Architectural Forum*, "Industrial Architecture in Concrete."[48] Cret—the architect behind the 1927 neoclassical Detroit Institute of Arts—designed an Art Deco locomotive in the late 1930s for the Pennsylvania Railroad's luxury Broadway Limited with Raymond Loewy. The latter would go on to become one of the most brilliant industrial and brand designers of the mid-twentieth century.[49]

Not all Kahn's factories were stripped of ornamentation. The 1914 Murray Stamping plant's cornice gestures toward a Greek temple and a certain spare elegance.

Perhaps No. 10's biggest contribution to modern architecture, however, was that it led Henry Ford to Albert Kahn and to one of history's great, bountiful architect and client collaborations. After 1905, Huxtable wrote, "advances in factory architecture were rapid and revolutionary, largely due to the fortunate concurrence of two exceptional men of the age: Henry Ford and Albert Kahn."[50] Both shared an idealistic vision of the factory of the future—light-filled and spacious—albeit for somewhat different reasons. Ford's principal objective was maximizing productivity, and well-lit open floors allowed men and machines in closer proximity, while Kahn had the humanistic architect's concern for how structures weigh on their users. Hildebrand pointed to what he called the "obvious facts" of the impact of Kahn's designs on factory workers: "Better light, fewer columns, a cleaner floor, more even temperatures, and so forth, seem likely to have contributed to higher morale."[51] Kahn certainly thought so. He told *Detroit Free Press* reporter Malcolm Bingay, in an argument he would make over and over, "Modern industry has proved that it costs no more to plan a building that is beautiful, well lighted, well ventilated and which provides for the welfare of its workers. The old factory building that was once erected without thought of its purpose—to house living beings who were creating things—was ugly because it was built without purpose. Utility, efficiency and beauty are handmaidens."[52]

By contrast, Ford was unapologetically all about the bottom line. "One point that is absolutely essential to high capacity, as well as to production," he wrote in his 1922 *My Life and Work*, "is a clean, well-lighted and well-ventilated factory. Our machines are placed very close together—every foot of floor space in the factory carries, of course, the same overhead charge. . . . We measure in each job the exact amount of room that a man

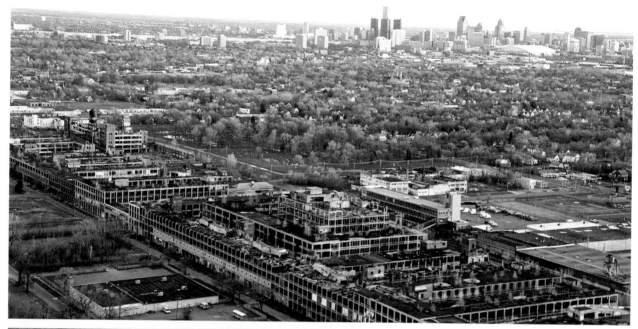

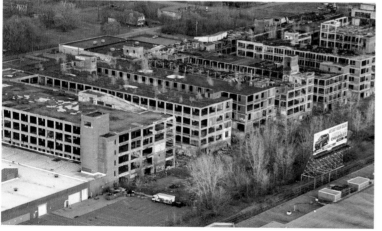

A Spanish developer with a track record of renovating historic properties in Lima, Peru, Fernando Palazuelo bought the Packard plant at auction in 2013, vowing to restore it as a mixed-use complex. But by 2017, work was just getting under way.

needs; he must not be cramped—that would be waste. But if he and his machine occupy more space than is required, that is also waste. This brings our machines closer together than in probably any other factory in the world," he said, adding, "Our factory buildings are not intended to be used as strolling parks." Cleanliness was a vital part of the mix, according to the auto magnate. "Something like 700 men are detailed especially to keeping the shops clean, the windows washed, and all of the paint fresh. The dark corners that invite expectoration are painted white. One cannot have morale without cleanliness. We tolerate makeshift cleanliness no more than makeshift methods."[53] University of Sydney art historian Terry Smith took a more astringent view in *Making the Modern: Industry, Art, and Design in America*, summarizing the result of Ford and Kahn's first collaboration in one damning phrase: "Human space disappeared at Highland Park."[54]

HENRY FORD AND THE JEWS

When and how did Detroit's two rising titans, Kahn and Ford, meet? The historical record doesn't say. Still, it must have been well before September 28, 1908, six months after Ford announced plans for the Model T, when the *Detroit News Tribune* mentioned a reinforced concrete plant Kahn was building for Ford. The reporter didn't name the factory, but it had to have been the Highland Park Model T complex, which in 1908 would have been in the earliest stages of the design process.[1]

At first glance, the two men, architect and automaker, form a peculiar couple. You might ask how the son of a rabbi could work for a man who in 1920 would trumpet his anti-Semitism to the entire globe. But for an ambitious Jewish businessman in the early 1900s, limiting relationships to tolerant and progressive Gentiles in a provincial city like Detroit would mean not much work at all. As his late nephew Bill Kahn told *Hour* magazine, anti-Semitism was rife in the business world Kahn entered. "The prejudice [against Jews] was particularly strong in the auto industry. It was very rare for a Jew to advance so far."[2] Albert Kahn did not discuss his thoughts on the subject in his surviving letters or papers. But it would have been hard to grow up in Europe—or even Michigan—in the late nineteenth century without being aware that anti-Semitism, like bad weather, was a disagreeable force one simply had to maneuver around to get ahead. It seemed to be an issue Kahn resolved would not hold him back. Hildebrand interviewed Kahn's youngest child, Rosalie, and reported, "Her view was that her father wanted to be an American, was thrilled by American industry, and Jewishness was not important to him. That insight is of some value," he added, "but of course it doesn't really take us very far. It's one thing for a Jew to want to be an American, quite

another to serve a viciously outspoken anti-Semite."[3] In *Harmony & Dissonance: Voices of Jewish Identity in Detroit, 1914–1967*, historian Sydney Bolkosky noted that Kahn neither renounced nor hid his religious identity, "but was determined to confine it to religious matters—such as they were for a rather adamant Reform Jew whose religious practice tended to eschew traditional ritualism. Putting aside his paternal rabbinical heritage," Bolkosky added, "Kahn shied away from highly visible public contributions to or support of Jewish institutions."[4] Indeed, his son Edgar appears not to have had the traditional coming-of-age bar mitzvah when he turned thirteen, according to two of his daughters.[5]

When the Kahns first landed in Detroit in 1881, they were virtual pioneers—joining a Jewish community that numbered just 1,000. Twenty years later, the Jewish population had grown tenfold, and by 1914, when World War I ended large-scale emigration to the United States, Detroit boasted 34,000 Jewish residents. The Kahns' arrival came at the tail end of a forty-year wave that brought some 250,000 German Jews to American shores. But Eastern European Jews, newly able to emigrate in the late nineteenth century, would swamp those numbers. "Whether pushed or pulled, from 1881 to 1914, close to two million Jews entered the United States, over 75 percent of them from Russia," wrote Robert A. Rockaway in *The Jews of Detroit*. "They increased the country's Jewish population from an estimated 400,000 in 1888 to 3.3 million by 1917."[6]

For his part, Albert Kahn exemplified the assimilationist spirit so typical of many German-Jewish immigrants. All the same, his connections to the Jewish community were not insignificant. He built both the 1903 and 1922 iterations of Detroit's Temple Beth El as well as Congregation Shaarey Zedek in 1930. As noted, he served for many years on the Beth El board and chaired its Choir Committee.[7] In the run-up to World War II, according to one elderly Detroiter, several German-Jewish children in her neighborhood said that the famous architect had sponsored their families, helping resettle them in Detroit.[8] If Kahn wasn't particularly observant in religion, he seems to have been at ease with his identity and with Judaism's minority status in American society. In a jocular, self-mocking letter to fiancée Ernestine in 1894 from Erie, Pennsylvania, the young swain wrote, "Be it duly recorded in my biography, Erie, Pa., is a town situated somewhere on Lake Erie and has a population of 40,000 when all are at home. Of these, some are white, some black. A good many are black, and the white ones count all sorts of nationalities. Even ours is represented, for didn't I see some noses—oh, such fine specimens?"[9]

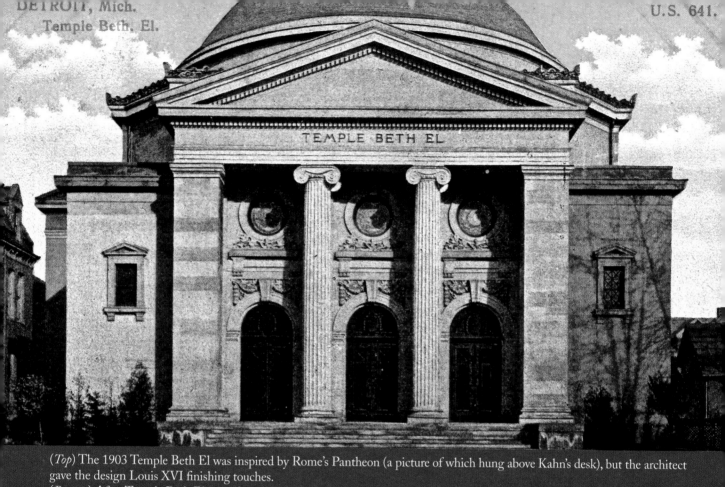

TEMPLE BETH EL

(*Top*) The 1903 Temple Beth El was inspired by Rome's Pantheon (a picture of which hung above Kahn's desk), but the architect gave the design Louis XVI finishing touches.

(*Bottom*) After Temple Beth El moved north on Woodward Avenue, C. Howard Crane—Detroit's legendary theater designer and a former Kahn employee—renovated the façade of the old building in 1925, a change that, sadly, cannot be called an improvement. The Bonstelle Theatre is now part of Wayne State University.

WAYNE STATE UNIVERSITY

BONSTELLE THEATRE

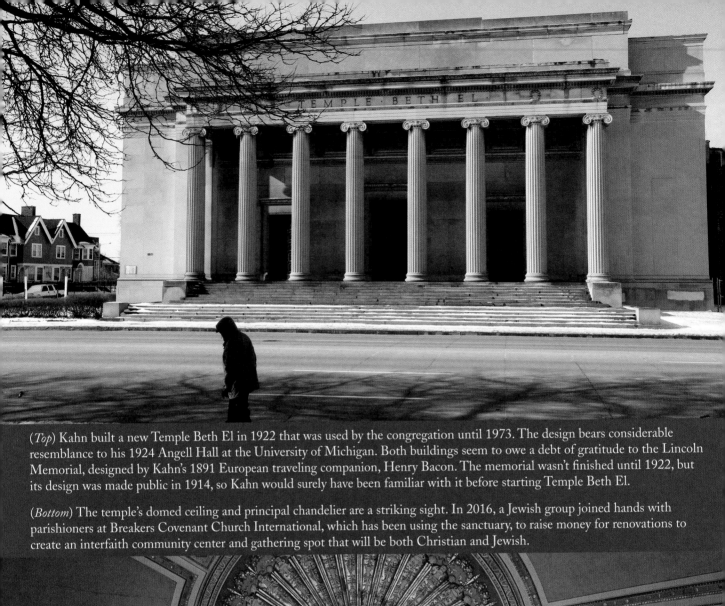

(*Top*) Kahn built a new Temple Beth El in 1922 that was used by the congregation until 1973. The design bears considerable resemblance to his 1924 Angell Hall at the University of Michigan. Both buildings seem to owe a debt of gratitude to the Lincoln Memorial, designed by Kahn's 1891 European traveling companion, Henry Bacon. The memorial wasn't finished until 1922, but its design was made public in 1914, so Kahn would surely have been familiar with it before starting Temple Beth El.

(*Bottom*) The temple's domed ceiling and principal chandelier are a striking sight. In 2016, a Jewish group joined hands with parishioners at Breakers Covenant Church International, which has been using the sanctuary, to raise money for renovations to create an interfaith community center and gathering spot that will be both Christian and Jewish.

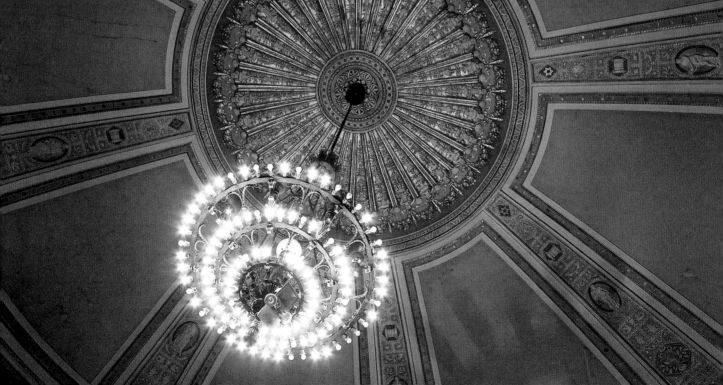

The article that signaled the beginning of Henry Ford's seven-year hate campaign against the Jews. (COLLECTIONS OF THE HENRY FORD MUSEUM, GREENFIELD VILLAGE)

The May 22, 1920, front page that launched the *Dearborn Independent's* attack on Jews, a series that ran nearly two years.

The Henry Ford

It was one thing to work with Henry Ford in the early years, when his abrasive anti-Semitic opinions were not as well known. It was quite another after 1915, when Ford first started publicly declaiming on the topic, attributing the Great War then raging to "Jewish financiers."[10] By this point, Kahn, Detroit's preeminent Jewish architect, had worked with Ford seven years. Once the Ford-owned *Dearborn Independent* (also called the *Ford International Weekly*) launched its twenty-month screed "The International Jew: The World's Problem" in 1920, the auto magnate's visceral disgust was broadcast far and wide. Among other assaults, the series promoted the *Protocols of the Elders of Zion,* a fictitious document alleging a Jewish plot for world domination. It was the talk of the Jewish community, and everyone knew the famous Albert Kahn was Ford's architect. Kahn wasn't the sort of person to dwell on issues beyond his control, but all the same, his association with Ford had to have been difficult at times.

From the architect's point of view, not only was the Ford work a financial lifeline that made Kahn and his extended family rich, the association was also electrifying. Henry Ford was the Bill Gates of his day—a genius, however flawed, in the process of inventing an entirely new world. Ford offered Kahn some of the most satisfying challenges of the architect's career even as his venomous public attacks on Jews presented Kahn with a wrenching, no-win dilemma. By 1920 Kahn was working full steam on Ford's vast industrial city along the Rouge River in Dearborn, and couldn't very well back out without damaging his firm and causing a scandal—and likely souring his relationship with other captains of industry. "There was no telling," historian Bolkosky wrote, "how other industrialists for whom he built would react to open opposition to Ford."[11]

And perhaps there was more binding Kahn and Ford than just good business and mutual benefit. Ford's biases aside, there were deep affinities between inventor and architect.

Like Kahn's interests, Hildebrand wrote,

Ford's interests lay in down-to-earth innova-
tion; his love was for the applicable, tangible
aspects of a problem. A natural mechanic, he
evolved his skills and talents pragmatically.
In his later years, Ford was mercurial, can-
tankerous and obstinate, without any doubt;
but he was also enthusiastic, energetic, and
determined; and the latter qualities he cer-
tainly shared with Kahn. When the two men
discussed a problem, they must have talked
a similar language. . . . Furthermore, Kahn's
meager formal education, which up to now
had appeared to be a handicap, was in this
instance a real advantage. Ford lacked exten-
sive schooling himself and tended to scorn
it in others; in Kahn he had a man with just
the expertise required but with no pretenses
to that erudition which so irritated him.[12]

Henry Ford and
President Herbert
Hoover in 1929.

Detroit News

Indeed, as George Nelson wrote in 1938, "Here was an almost perfect combination
of the time and the place and the men. In 1903 Detroit was predestined to spawn
factories. That it was incidentally to produce a new architecture may also have been
inevitable, but the process was hastened by the men in the combination—Albert Kahn
and his clients."[13] Ford and Kahn, in most respects traditionalists, were also alike in
the revolutionary quality of their works. Indeed, both men were nostalgic for the very
world they were in the process of destroying. Kahn's handsome nonindustrial work
was self-consciously backward-looking and eclectic. And Ford, who more than any
other individual helped destroy the traditional American small town (and big city),
nonetheless in his old age assembled a faux pre-automotive town: Greenfield Village in
Dearborn, Michigan.

And Kahn had an uncanny gift for translating Ford's vision into brick and mortar.
"The Highland Park and Rouge River plants were built as a result of the drive and
money of Henry Ford," noted historian Neil Baldwin, but "it required the consummate

abilities of one equally driven man to make Ford's often-inarticulate vision into a reality: his architect, Albert Kahn."[14] Yet for all the intellectual connection between the two men, it's worth recalling that Ford did not hire Kahn to design his Dearborn mansion, Fair Lane, on the banks of the Rouge River. Whether the automaker thought Kahn good enough for factories but not for the finer things is unclear. In any case, the initial company working on Fair Lane, Frank Lloyd Wright's firm, was hired just as Kahn was wrapping up the Highland Park factory, which Ford likely saw as more important. (As it happens, and unhappily for the architecture of Greater Detroit, Wright did not end up building Fair Lane. The celebrated architect absconded to Europe with a client's wife, and the puritanical Ford abruptly fired him and gave the contract to "an obscure Pittsburgh architect," William Van Tyne, who built one of the least graceful mansions in the Detroit area in a choppy English Manor style.)[15]

When Henry Ford's *Dearborn Independent* launched its anti-Semitic series, Kahn was "deeply hurt," according to nephew Bill Kahn.[16] The family story is that the architect never set foot in the Rouge complex again, delegating one of his brothers when an on-site meeting had to take place.[17] Bucci wondered, incredulously, how it was possible that Ford "never considered the possibility of offending Albert Kahn, a Jew, who was at that time designing the colossal plants of the Ford Motor Company on the River Rouge."[18] Still, Ford appears—hard as it is to swallow—to have believed he wasn't harming "good" Jews like Kahn, or the automaker's onetime neighbor in Detroit's Boston-Edison neighborhood, Rabbi Leo M. Franklin of Temple Beth El.[19]

There's little evidence of Kahn's reaction, though he did acknowledge his patron's anti-Semitism in at least one interview, albeit in carefully couched tones. Kahn told the *Detroit Free Press*'s Malcolm Bingay in 1946, with remarkable understatement, "I knew that [Ford] had once had a prejudice against the Jews," but that was as far as he went.[20] For his part, Rabbi Franklin—to whom Ford famously gave a new Model T seven years in a row—was enraged enough in 1920 to return the latest vehicle. An apparently apocryphal story, repeated by any number of Ford biographers, has it that the auto magnate, on getting the cold shoulder from Franklin, "innocently" phoned to inquire, "What's wrong, Dr. Franklin? Has something come between us?" But historian Victoria Saker Woeste, author of *Henry Ford's War on Jews and the Legal Battle against Hate Speech*, pointed out that the quote, cited by Allan Nevins and Frank Ernest Hill in their generally authoritative *Ford: Expansion and Challenge, 1915–1935*, does not appear in the article referenced in their footnotes—though the story of Franklin and the Model T does.[21]

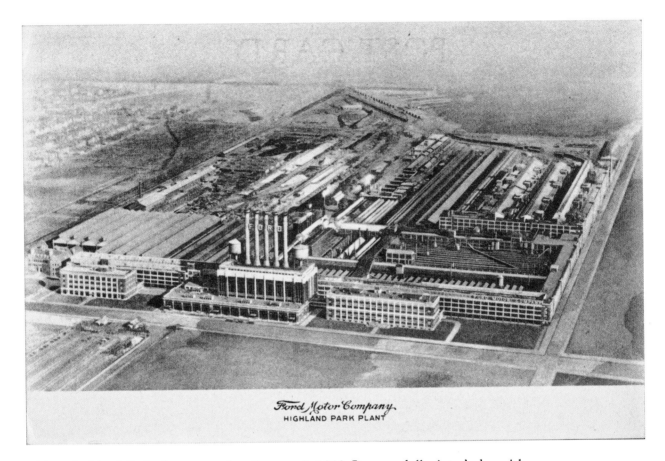

Ford Motor Company
HIGHLAND PARK PLANT

The Highland Park plant opened on January 1, 1910. It was a dull winter's day with a high of fourteen degrees in the township, which six years later would be entirely surrounded by Detroit's explosive growth. Describing the factory's genesis years later, Kahn gave the tale an epic touch. "When Henry Ford took me to the old race course where the Highland Park plant stands and told me what he wanted," he said, "I thought he was crazy. No buildings such as he talked of had been known to me. But I designed them according to his ideas."[22] Some critics, like Englishman Reyner Banham, argued that other plants—Ransome's United Shoe Machinery Company factory in Beverly, Massachusetts, for one—were more revolutionary in design terms.[23] The truth is that the Highland Park Original Building, as it came to be known (aka Automobile Assembly Building), had shorter spans between columns than the Packard plant (twenty feet versus thirty-two and a half feet), and in most other respects was just an elaboration of No. 10 on a very big scale.[24] But what a scale! The four-story Original Building ran 860 feet along Woodward Avenue at Manchester, in what was then the city's northern exurbs. As with Packard, glass covered as much of the building façade as was

structurally feasible. In this case, Kahn used imported English steel sash windows in their first deployment in the United States (an innovation generally credited to Kahn's English associate designer, Ernest Wilby) to create infinitely repetitive, grid-based glass walls that immediately won the huge structure the nickname Crystal Palace.[25] Indeed, it was Highland Park, or rather a photograph of it, that helped inspire Walter Gropius's observation in 1913: "The newest halls of the great North American industrial trusts can almost bear comparison with the work of the ancient Egyptians in their overwhelming monumental power."[26] In time, five towering smokestacks, somber as classical columns, crowned the complex's power house facing busy Woodward Avenue, with the letters F-O-R-D dramatically suspended between them.

The wonder of it all was not lost on the local press. The *Detroit Free Press* ran a laudatory piece, "New Ford Factory Is One Sixth Mile Long—Great Expanse of Glass Affords Splendid Light," complete with two large pictures at the top of its "Builders News" page on July 4, 1909. (The editors seem to have felt this was a fitting lead story for the patriotic holiday.) "Many people passing along Woodward Avenue by the site of the old Highland Park Hotel and racetrack," the article read, "have marveled at the new factory building of the Ford Motor Company, recently completed." The reporter described the walls as "almost one solid mass of glass."[27]

Kahn's paternity in the case of the Original Building is undisputed, but subsequent structures at Highland Park were often designed in collaboration with Edward Gray, Ford's chief construction engineer from 1909 to 1915.[28] Testifying in a tax case in 1927, Gray maintained that plans for the later "Buildings W and X" were worked out by Ford engineers, turned over to the Kahn office only for implementation. "The architectural publications throughout the world gave Mr. Kahn credit for building these buildings," Gray complained, "and he had absolutely nothing to do with it until the time arrived when we, the Ford organization, had the specifications and plans all out in detail."[29]

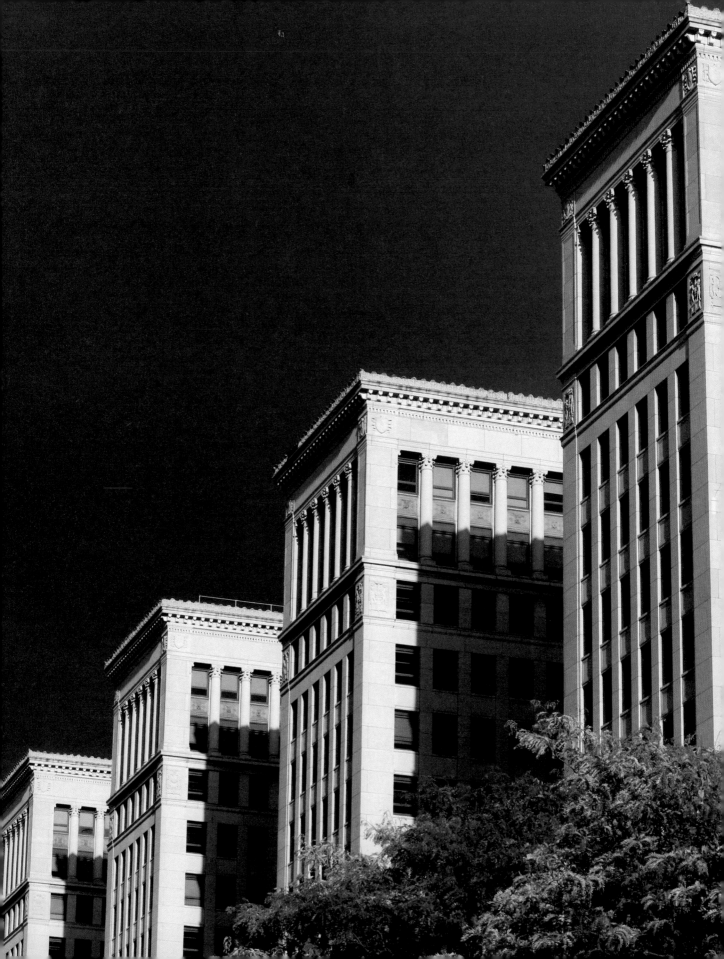

5

PACKARD NO. 10 TO GENERAL MOTORS

Both as youngster and architect, Albert Kahn profited by a talent for impressing powerful men who recognized his remarkable skills and helped him advance. Think of sculptor and drawing instructor Julius Melchers, architect and benefactor George D. Mason, or automakers Henry B. Joy, Henry Ford, and William C. Durant. When Joy contracted with Kahn in 1903 for the first nine buildings at the Packard plant (the revolutionary Building No. 10 would come a couple years later), it had the effect of rescuing what had been a floundering architectural practice. As noted earlier, from 1896 until 1901, when Kahn and Joy crossed paths, the architect's practice relied in large part on remodeling and home building—enjoyable pursuits that Kahn clearly relished, but not highly lucrative ones. There were a few bigger commissions—Children's Hospital in Detroit, for example—but for the most part Kahn's first years in business were difficult When he lost both partners in the short-lived Nettleton, Kahn, and Trowbridge, Kahn took shelter for a year back in George Mason's office. There are signs the relationship got a little testy—not surprising, perhaps, given the step down from independence a return to Mason's firm entailed for the younger man.[1] When Kahn reopened an independent practice in 1902, Joy—who called him "the human steam engine"—was key to the young architect's budding success.[2] Certainly, the reinforced concrete Packard Building No. 10 propelled Kahn into the front ranks of industrial designers. But Joy also appears to have promoted him when the University of Michigan was looking to build its Engineering Building, a commission that launched Kahn on a long, profitable relationship with the school. He would ultimately design over two dozen buildings (or additions) for U-M between 1903 and 1938, structures that give the central campus

much of its personality and visual character. (The Neuropsychiatric Institute, built just four years before Kahn's death, was his last.)[3]

Kahn clearly enjoyed working on academic buildings, and it seems likely that provided an enjoyable contrast to the functionalism of automobile plant design, although he obviously had a passion for that as well. But school buildings provided stimulation of a different sort. In the case of the 1903 Engineering Building (now West Engineering),

The Engineering Arch on the University of Michigan's main quadrangle, the "Diag."

Kahn composed a pleasingly sober building with two Neo-Baroque copper towers and red-brick cladding that masked an experimental reinforced concrete frame. The Engineering Building is an L-shaped structure that defines one corner of the central campus. Its most distinctive feature is the way the building spans an arched passageway that acts as a symbolic gateway between the outside world and the cloistered campus within. While the building's design is unremarkable, the arch transforms West Engineering into a campus icon. For students, thousands of whom pass through it every day during the academic year, the Engineering Arch inevitably becomes one of the most memorable physical features of university life. Hildebrand called the building with the copper cupolas and vast tank for the naval architecture program a "sound work" with "usable and well-lighted interior loft spaces," noting that it formed "a solid basis for Kahn's continuing relationship with the university."[4] (Interestingly, while the building is always credited to Kahn, it must have originated at Mason and Kahn. Mason's professional diary for 1902 has numerous references to checking "specs" on the project.)[5]

Kahn continued to design houses—a practice that would get a boost from industrialists who, delighted with their Kahn-built modernist factories, then tapped him to design their mansions in a range of historical styles. While he also worked in many other idioms, between 1896 and 1918 Kahn built a significant number of Arts and Crafts houses in Detroit and Grosse Pointe, a gracious legacy that adorns many neighborhoods even today. And in 1906, Kahn designed his own large, if understated, house at the corner of Mack Avenue and John R Street. (Early documents list the house on Rowena Street, the original name for that stretch of Mack.) It is a handsome Arts and Crafts structure that's long been home to the Detroit branch of the Urban League.

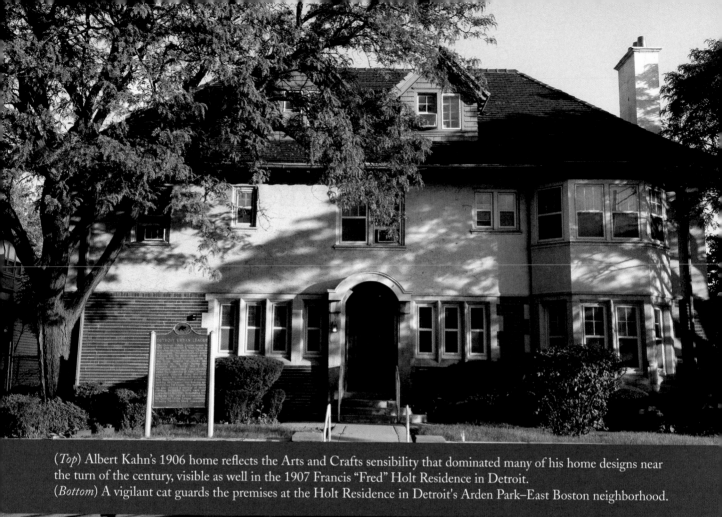

(*Top*) Albert Kahn's 1906 home reflects the Arts and Crafts sensibility that dominated many of his home designs near the turn of the century, visible as well in the 1907 Francis "Fred" Holt Residence in Detroit.
(*Bottom*) A vigilant cat guards the premises at the Holt Residence in Detroit's Arden Park–East Boston neighborhood.

Kahn built houses for the great and famous, like the grand home for Senator James J. Couzens in Detroit's Boston-Edison neighborhood. The architect also furnished the University of Michigan with several of its fraternity houses, including Delta Tau.

Kahn designed in a range of styles, as these homes in Detroit's Indian Village, Grosse Pointe, and Ann Arbor illustrate.

The house suffered considerably with the widening of Mack Avenue, which eliminated most of the buffer between it and the street, robbing the structure of some of its dignity. But the small mansion, enlarged by a Tudor-style gallery in 1928 to house the architect's art collection (with works by Pissarro, Renoir, Degas, Manet, Courbet, and Cassatt), has been lucky in its institutional ownership.[6] The Urban League has done well by it, preventing the dilapidation and abandonment that characterize many of its once-proud neighbors. (Now that there's a Whole Foods grocery store kitty-corner from the Kahn house, there are hopes the other mansions on Mack and streets south might revive.)[7]

Architectural historian Ferry made the useful point that an architect's house is particularly revealing, as it provides indisputable proof as to what he or she really likes. This is especially important with an architect like Kahn, who listened carefully and gave his clients exactly what they wanted. For his own house, Kahn put aside the Tudor ostentation he'd just employed on the 1905 E. Chandler Walker mansion across the Detroit River in Windsor, Ontario. Instead, he opted for the English Domestic Revival much in vogue at the time ("second generation," according to Ferry), which harmonized on many levels with the Arts and Crafts movement.[8] The result is a two-story structure with a dormered, hipped roof, a brick and stucco exterior, and a handsome entryway. Kahn also designed much of the furniture.

The architect worked in a similar vein on a much bigger scale the next year, 1907, when he crafted a country mansion north of the city in Bloomfield Hills for *Detroit News* publisher George Gough Booth, who also founded the 1906 Detroit Society of Arts and Crafts. (Kahn was a "founding craftsman" as well.)[9] "Booth asked Albert

In 1908, Albert Kahn built *Detroit News* publisher George G. Booth an Arts and Crafts mansion in the rolling hills seventeen miles north of downtown Detroit.

George and Ellen S. Booth

George G. and Ellen Scripps Booth in the garden at Cranbrook House, 1915. Booth, who used Albert Kahn's services several times, was publisher of the *Detroit News*.

Cranbrook Archives

Kahn to infuse Arts and Crafts sensibility into a traditional English manor house," wrote the authors of *AIA Detroit: The American Institute of Architects Guide to Detroit Architecture*. "Kahn's own house on Mack Avenue was a prototype for the grander mansion."[10]

It would turn out to be a most unusual collaboration between architect and client, since Booth was a self-taught designer with insight and strong opinions. Indeed, years later, in 1926, the Detroit chapter of the American Institute of Architects (AIA) would grant an honorary membership to the Ontario-born publisher, who rose from relatively humble circumstances to a position of prestige in Detroit, thanks both to his drive and a fortunate marriage to the daughter of *Detroit News* founder James Scripps. At the Detroit AIA dinner inducting Booth, Kahn said, "Too often the interference of the layman with a small knowledge of architecture proves an obstacle to [the architect's] best efforts. With you, however, it is neither the layman nor the man of small knowledge. You have seriously studied architecture and have acquired a proficiency quite the equal of most professional men."[11] Booth and Kahn remained friends for many years—Kahn would also build the 1917 *Detroit News* building—though personal disagreements would cool their relationship in the 1930s.

The Arts and Crafts movement at the turn of the century embodied an artistic rebellion against the modern world that began in Britain and then moved to America. The movement was launched in the 1860s by William Morris and other London designers alarmed at what they regarded as a general coarsening associated with the Industrial Revolution. "Morris looked around Victorian England and decided his duty was to make beautiful objects for everyday use," wrote Joy Hakanson Colby in her book, *Art and a City: A History of the Detroit Society of Arts & Crafts*. "He blamed machines for the ugliness and misery he saw everywhere. For inspiration [Morris] turned to the Middle Ages and the art-guild system of handicraft."[12] By the time Booth and others founded the Detroit Society of Arts and Crafts in 1906, there were about twenty such groups across the United States. The Detroit chapter would go on to become one of the most influential, due in no small part to the spreading fame of Mary Chase Stratton and the iridescent glazes produced at her Pewabic Pottery studio on East

Jefferson Avenue. (Kahn, like most Detroit architects of the era, used Pewabic tiles in any number of his commercial and residential projects.)

Cranbrook House, as Booth's 1908 mansion is known, might be far grander than Kahn's home, "but the same restraint in design and materials prevailed."[13] Set on three hundred acres of rolling woods and meadow, the house overlooked "a landscape panorama as beautiful as any in the region."[14] The house was to be the first set piece in a sprawling, architecturally distinguished campus now known as the Cranbrook Educational Community. Kahn's contributions were limited to the mansion and one minor dwelling. It's unclear whether Booth considered him in the 1920s when he decided to build several schools in the woods and fields of Bloomfield Hills. (In any case, at that point Kahn was far too busy building the Ford Rouge complex and some of Detroit's most significant skyscrapers.) Instead the job fell to Eliel Saarinen. Booth's son, Harry, had taken a course taught by Saarinen while studying architecture at the University of Michigan. The Finnish architect's 1922 second-place submission in the *Chicago Tribune* competition had caused quite a stir, with many contending the modern design was superior to the neo-Gothic tower that won. The generally accepted

tale is that Harry introduced his father to Saarinen, though Kahn disputed that many years later, claiming that he was the one who first brought the two together.[15] In any case, Saarinen moved to Bloomfield Hills, where the design and construction of the three intricate Cranbrook academic campuses would consume the rest of his career. The architect created a remarkable ensemble. Today, just a short walk across a valley from Cranbrook House are Saarinen's Prairie-style Kingswood School (critic Wayne Andrews called the sandstone, copper-roofed ensemble "an extraordinarily graceful achievement"), the Arts and Crafts, red-brick Cranbrook School, and the Cranbrook Art Museum, a dramatic exercise in romantic modern classicism complete with reflecting pools and Carl Milles sculptures.[16] Together they form one of the most elegant built environments in the Midwest.

There's a warmth in the design of the Booth house, now officially Cranbrook House, that sets it apart from grander and chillier mansions built by other fabulously wealthy men in the same period.

While the Booth house is grand, there's still a pleasing domesticity to the elite lifestyle of the publishing magnate.

Other significant houses Kahn built before World War I include the 1908 Bay City home of University of Michigan regent William L. Clements, another industrialist who would play a major role in advancing the architect's career. Automaker Horace E. Dodge, who'd hired Kahn to build his industrial plant, also tapped him to design the first Rose Terrace in 1912, a "gabled Jacobean house of rugged red sandstone" on Lake St. Clair in Grosse Pointe Farms. The house, alas—like Dodge—had a short life. (The automaker died at fifty-two in 1920, the same year as his brother John.) Horace's widow remarried and knocked down Kahn's design and replaced it in 1934 with a new Rose Terrace. This was composed in French Rococo style by Horace Trumbauer, a Pennsylvania architect responsible for the Philadelphia Museum of Art and much of Duke University. The second, grander Rose Terrace was itself demolished in 1976 to make way for a subdivision.[17]

Eliel Saarinen.

Eliel Saarinen designed the 1942 Cranbrook Art Museum, sited across a small, picturesque valley from the Booth mansion, in a romantic form of Scandinavian-inflected modern classicism.

Interestingly, Horace Dodge wasn't happy with Kahn's work on Rose Terrace, complaining that the architect failed to adequately supervise contractors and that the furnace was inadequate to heat the house. At about the same time, Horace Dodge and his brother and partner John were also unhappy with work on their Hamtramck plant. Charles K. Hyde reported in *The Dodge Brothers: The Men, the Motor Cars, and the Legacy* that Horace and John sent Kahn 242 letters over thirteen months, most complaining about uncompleted or sloppy work. The Dodges' dissatisfaction stands in counterpoint to the parade of accolades Kahn's work usually earned. Hyde's theory, which sounds credible, is that in 1912 Kahn was so consumed by his work for Ford at Highland Park that he slighted "minor" clients like the Dodge brothers. In any case, from 1912 until the brothers' deaths in 1920, the Detroit firm Smith, Hinchman, and Grylls handled all Dodge factory construction.[18]

One of the handsomest Kahn residences of this period, sadly lost to the wrecking ball, was the 1908 mansion on the gilded shores of Lake St. Clair for Packard's Henry Joy. Hildebrand called it "a very direct, orderly, and restrained two-story brick structure

The 1917 Detroit Golf Club.

with a purely rectangular central portion and wings to either side. The treatment was," he wrote, in one of his highest compliments, "austere." The design depended almost entirely on massing and materials for its architectural impact. Hildebrand compared it favorably to the Watson Freer house of 1895, but added that the Joy residence, Fairacres, was simpler and less ornamented. Kahn would return to something of this style in 1917 with his Detroit Golf Club, another exercise in red-brick, cottage-style simplicity "with slightly more picturesque massing."[19]

In 1917, Kahn built a summer cottage for his family on Walnut Lake, in what is now West Bloomfield, some twenty miles north of Detroit—at the time, way out in the country. (The house was started in 1914, but burned and had to be rebuilt.)[20] In many ways, the Farm, with its low, horizontal lines, was the most modern of Kahn's residential designs—simplified Prairie School married to a traditional white clapboard house. With its unbroken horizontal band of windows on the second floor and the wall of French doors on the first, the house—in theory, if not in precise appearance—bore some resemblance to Kahn's highly glazed auto factories. The cottage would

occupy a central role in the family's social life, though the Kahns returned every fall to their much grander Mack Avenue home in the city.

In 1912, Kahn and Ernestine sailed for Europe, Kahn's first foreign trip since his 1891 fellowship. There's a marvelous picture of the two of them in Venice's Piazza San Marco, hands and hats a-flutter with overly friendly pigeons.[21] But it was the ancient buildings of Siena and Bologna that filled the pages of Kahn's sketchbook. "He made detailed annotations in the margins of his sketches as to the size and placement of the bricks," Ferry wrote in *The Buildings of Detroit*. "Although most of his studies were done in pencil, the arcade of San Stefano in Bologna inspired him to do a watercolor rendering. Only thus could he capture the subtle patina of the reddish-brown brick ornamented with insets of terra cotta. This warm, mellow surface quality was precisely what he needed to humanize the raw concrete skeletons of his buildings."[22]

Albert and Ernestine Kahn in Venice in 1912.

Albert Kahn Associates

Kahn's use of that "warm, mellow surface quality" was most successfully applied with his 1913 Hill Auditorium at the University of Michigan, a satisfyingly grave monument that would prove to be one of the most important designs of his career. Located just outside the main university quadrangle (nicknamed the "Diag" for the Diagonal Walk that bisects it), Hill is sited so as to be visible from numerous vantage points, including the main commercial street nearby, and is thus one of the defining structures on the campus. In many ways, it is Kahn at his very best—a composition at once crisp, masculine, and so clear and direct that you grasp it at a glance. The auditorium is faced in textured dark red brick—St. Stefano imported to southeastern Michigan. Punched into the center is a monumental beige stone colonnade with five entryways separated by huge Tuscan columns. A wide band of the same stone defines the border of the unit, set off against the dark red brick. Just beyond the stone edge, and echoing it, is a ribbon of patterned brick with terra-cotta insets.

The overall design reads like an homage to Chicago's Louis Sullivan, who reportedly tried to hire Kahn away from Mason and Rice seventeen years earlier. "The bold major opening punched into the vaultlike mass and the handling of ornament recalls Sullivan's Getty Tomb or [his] Midwest banks," Hildebrand noted. While only the National

The 1913 Hill Auditorium at the University of Michigan, with Burton Memorial Tower rising over the roofline.

Farmers' Bank in Owatonna, Minnesota, had been built by 1913—the first of Sullivan's astonishing "jewel box" bank designs for small towns—Kahn was likely familiar with it, Hildebrand suggested, as *Architectural Record* ran a feature on it in 1908.[23] Moreover, Kahn had attended the 1893 Columbian Exposition in Chicago, where he surely saw Sullivan's Transportation Building—which involved another backdrop wall surface, albeit a much more ornate one, with a remarkable arched, concentric entryway punched into it. Kahn biographer Bucci found Hill's overall design "a somewhat poorly resolved combination of the classical tradition to which Albert Kahn was inclined, and the local vernacular," but that seems a little unfair.[24] Hildebrand, by contrast, called Hill "one of Kahn's most interesting nonindustrial designs."[25]

With its richly patterned brick forecourt out in front, Hill also represents the first use on the Michigan campus of a plaza or courtyard. Before 1913, wrote longtime university planner Frederick W. Mayer, buildings were connected by hard-surface walkways, but there were no designed "outdoor spaces for assembly and interaction." Kahn, he noted, was familiar with Italy's sociable piazzas, like the Campo in Siena or Venice's Piazza San Marco. After giving Hill a handsome and roomy forecourt, Kahn proceeded

to do the same for the 1920 General Library (Hatcher Graduate Library) and his small gem the next year, Clements Library.[26]

The plaza in front of Hill Auditorium.

Turning to the auditorium interior, it's worth noting that Hill, originally designed for nearly five thousand seats, is widely regarded as having near-perfect acoustics. With sound engineering by Hugh Tallant, the hall is "is one of the finest acoustic spaces of its size in the country. Unlike many other auditoriums, Hill has never required any acoustical remodeling."[27] (At midcentury, Radio City Music Hall would be one of the only halls larger than Hill, with a capacity of six thousand.[28] Detroit's Fisher Theater in Kahn's skyscraper of the same name was built to house thirty-five hundred.[29] The city's 1919 Orchestra Hall, by C. Howard Crane, seats two thousand.)[30]

The lush brickwork on Hill would be repeated, with variations, on two other U-M buildings nearby—the 1915 Science Building (now Natural Sciences) and, five years later, the General Library. Also falling into this pattern was the campus Kahn built for the U.S. Aviation School at Langley Air Force Base in Hampton, Virginia. Of the three at U-M, Natural Sciences, with its huge windows, is the one that bears the greatest

The University of Michigan's 1920 Harlan Hatcher Graduate Library (originally the General Library).

resemblance to Kahn's factories—a similarity that would become something of a hot potato for Kahn in the early 1920s.

A persistent challenge with all Kahn's buildings, Hill included, is pinning down precise authorship. From 1902 to 1918, all work emerging from the office bore the attribution "Albert Kahn Architect, Ernest Wilby Associate." Wilby, who would go on to teach at the University of Michigan, is often credited with the firm's more ornamental designs, as well as the novel use of steel-sash windows at Highland Park. In any large architecture firm—and by 1918, Kahn had a staff of eighty—work will inevitably be delegated.[31] The original idea may (or may not) come from the boss, but the overall design will in almost every case be fleshed out by subordinates. The question, of course, is to what extent designs are guided from the top. With Kahn, that's open to debate. We do know he typically presided over the seminar-like discussions that launched major projects, and compared his role to that of quarterback or orchestra conductor—leading, but not necessarily executing, all work.[32] Sculptor Corrado Parducci, who worked with Kahn on numerous buildings, described an architect intensely involved in even the

The National Theater in downtown Detroit, built in 1910 and shuttered for decades, is one of Albert Kahn's most over-the-top designs.

minutiae of ornament design.[33] All the same, Michael G. Smith argued in *Designing Detroit* that Kahn associate Wirt Rowland (who would go on to do Detroit's signature Penobscot and Guardian towers for Smith, Hinchman, and Grylls) worked on Hill with Wilby and may have had the greatest influence over how the building ultimately took shape.[34] Hildebrand, by contrast—who worked in the Kahn firm in the 1960s— pressed the case for Kahn's own hand: "The theme of mass and void counterplay," he noted, "is just the kind of thing to which Kahn's own abilities were so well suited, and toward which many of his European photographs of the twenties would be oriented."[35]

Still, Smith makes a strong case that you can read Rowland's influence in Hill's relative modernity, as well as the look of the *Detroit News* building four years later. Still, any suggestion that Kahn was a hands-off boss is undercut by the conservative, neoclassical turn the firm took with the General Motors and other office buildings in the early 1920s. Rowland worked on GM, Smith wrote, but bridled under the new restrictions, and left the firm shortly thereafter.[36]

The Kahn office was revolutionary on several fronts. It was an early pioneer in bringing architects, engineers, and other construction professionals all under the same roof and into the same planning meetings. And its internal organization, as a piece in a 1918 *Architectural Forum* pointed out, bore a surprising resemblance to the bureaucratic flow chart at the Ford Motor Company.[37] "Albert Kahn took the lead around 1905," wrote H.-R. Hitchcock, "in developing a type of subdivision and flow of work in his office in Detroit comparable to the new methods of mass-production that his motor-car factories were specifically designed to facilitate."[38] It was all scientifically mapped out. "Departments have graphical progress reports on their work," wrote George C. Baldwin. "At the beginning of any work the estimated progress is indicated by a curve in black ink on coordinate paper, and the actual progress [is] recorded from day to day in red ink. Any marked divergence in these curves indicates serious delay, and daily inspection of the records enables prompt action to be taken to remove it."[39]

Significant commercial work in the 1910s included the cheerfully gaudy Neo-Baroque National Theater (1910) and the 1914 Kresge Building (now the Kales Building) on Grand Circus Park. The first is now empty and shabby. But the Kales Building, a Chicago-style skyscraper with strong vertical lines, was successfully renovated into apartments in 2004 after a long period of abandonment, well before the boom in repurposing Detroit's old buildings that caught fire in the city's post-2008 revival.

Two of Kahn's most significant nonindustrial commissions in the mid-1910s were the 1915 Detroit Athletic Club (DAC) and the 1917 *Detroit News* building. Each reflected the architect's close relationship with the city's power elite—Packard's Henry Joy and Cranbrook's George G. Booth, respectively. Joy had a significant hand in reviving the DAC, with an amusing ulterior motive. According to architectural historian Wayne Andrews, he built the new club "to keep the giants of the automobile world out of the local saloons." Joy likely played a significant role as well in selecting Kahn as architect for the $2 million project (almost $50 million in 2017 dollars).[40] When the club opened, its membership—heavy with automotive CEOs—allegedly accounted for 90 percent of global auto production.[41] Kahn reported in the *American Architect* that the Renaissance Revival club—inspired in part by Rome's Farnese Palace—had a structural steel frame, with floors girded by reinforced concrete beams.[42] (There was no need to do the entire frame in reinforced concrete. Unlike auto plants, nobody here was going to be rolling heavy loads across an upper floor, where concrete's rigidity and stability were key. From the late 1910s on, however, steel frame construction

The Kales Building, on Detroit's semicircular Grand Circus Park, was originally the world headquarters for the S. S. Kresge Company, better known today as K-Mart.

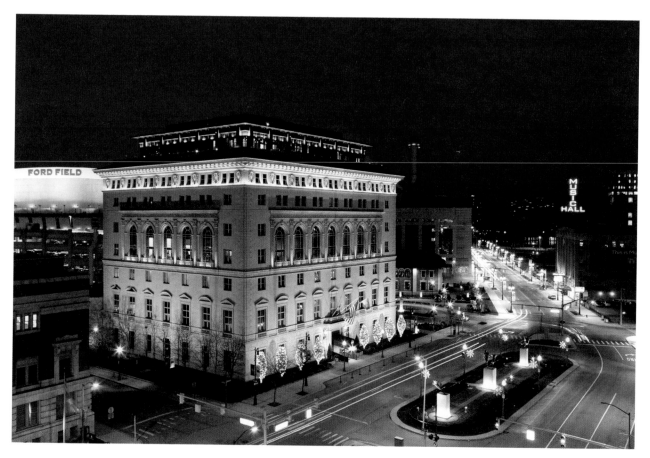

The Detroit Athletic Club, recently renovated, continues to be one of the city's most thriving social institutions.

displaced reinforced concrete for single-story factories.) The DAC exterior was faced in Bedford limestone, while the main foyer on the ground floor has a Tennessee marble floor, with an "interesting" copy of a fifteenth-century Italian mantel, also marble, above the fireplace. The casual Grill Room "was designed after an apartment in the Palazzo Vincigliata in Florence." By contrast, the Dining Room has a plaster ceiling "skillfully done in the manner of Raphael and Giovanni da Udine." Among other attractions was a billiards room, cues artfully concealed behind the wainscoting, a hidden musicians' gallery between the main Dining Room and the Ladies' Dining Room, gymnasium complete with running track, and a swimming pool on the fourth floor that's actually a huge steel tank. The two upper floors boasted 108 "sleeping rooms with bathrooms."[43]

Hildebrand described the club, beautifully maintained and still in use today, as "executed in a rather freely interpreted Renaissance palazzo style in the manner of McKim, Mead and White," adding that it drew not only on Kahn's recent European travels but also on the Manhattan firm's "prototypal and magnificent University Club in New

York of 1900." Praising the DAC's detailing, Hildebrand nonetheless dismissed the design as lacking the "irresistible elegance" of Manhattan's University Club, adding that, unlike Hill Auditorium, "as a totality the building is lacking in vigor."[44] By contrast, Smith argued Kahn's input was slight, crediting the building largely to Kahn associate Amedeo Leone.[45]

A footnote to the DAC project concerns the club's prohibition at the time on Jewish members. Sidestepping this restriction, DAC directors reportedly offered the architect an honorary membership when the building opened, which Kahn politely declined. Some have interpreted the "honorary" stipulation as an insult, and doubtless tied to his being Jewish, while subsequent honorees included the likes of Charles Lindbergh and Eddie Rickenbacker.[46]

The 1917 *Detroit News* building, just two blocks down West Lafayette Boulevard from its arch-competitor the *Detroit Free Press* (built by Kahn in 1925), is an imposing five-story, limestone structure that,

McKim, Mead, and White's 1900 University Club in Manhattan.

with its garage, takes up an entire city block. It was an all-under-one-roof affair, with the printing presses right in the newspaper building. Noting that client and publisher George G. Booth was bent on a substantial civic monument infused with dignity, "Kahn found what Booth was looking for in the solid-looking buildings that had given German cities such an air of prosperity before World War I. In the heavy stone arches, piers and mullions of the *Detroit News* Building," wrote Ferry, "there is something of the character of the work of Messel, Olbrich or Behrens."[47]

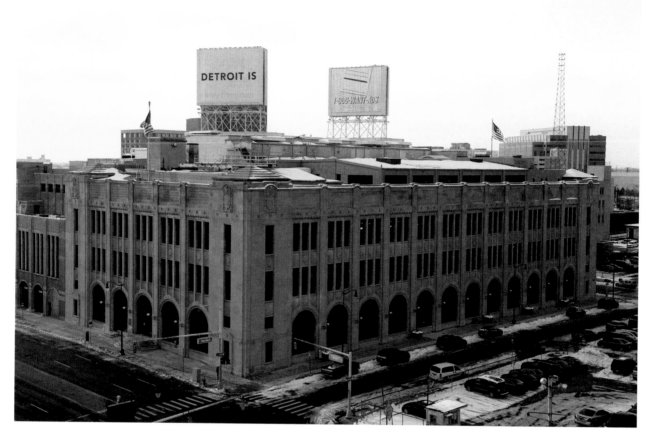

Albert Kahn built the 1917 *Detroit News* building for his client and friend, publisher George G. Booth.

Adding to the *News* building's effect are four oversized statues of publishing pioneers William Caxton, Johannes Gutenberg, Christophe Plantin, and Benjamin Franklin by sculptor Joachim Jungwirth, all of which peer down at pedestrians from niches just beneath the cornice line.[48] Between the great men are panels with weighty (some might say self-flattering) aphorisms carved into the stone testifying to the Fourth Estate's noble responsibilities, lest the journalists within forget. One reads, "Bearer of Intelligence, Dispeller of Ignorance and Prejudice—A Light Shining into All Dark Places." Still another pumps the press as "Mirror of the Public Mind—Interpreter of the Public Intent—Troubler of the Public Conscience." As with the Cranbrook mansion ten years before, publisher George Booth was pleased with the building Kahn gave him. "Dear Mr. Kahn," he wrote in October 1917, "we are about to take up our permanent residence in the new *News* building, and we feel that the moment is an occasion for mutual congratulations. We are convinced that what you have achieved architecturally does you, ourselves, and the city distinct credit."[49] Kahn's old mentor George Mason wrote that the *News* building "is the best thing you have done," adding that Paul Cret, who

would design the Detroit Institute of Arts in 1927, agreed, and he "is a good judge even if he can't always do as well himself."[50]

Kahn's largest commission of this era—indeed, his largest to date—was the 1920 General Motors Building, erected three miles north of downtown Detroit on West Grand Boulevard. It was a site that, by the 1930s, the architect would eventually remake into one of the nation's first high-rise "edge cities." In *American City: Detroit Architecture, 1845–2005*, Robert Sharoff and William Zbaren note that with the New Center Kahn, the "architect of Ford," ironically created "his two most enduring commercial structures—the General Motors Building and the Fisher Building across the street—for Ford rivals."[51] (The Fisher brothers built auto bodies and would eventually be bought out by GM, their legacy visible only in the slogan "Body by Fisher" on GM cars.) The fifteen-story GM Building, originally known as the Durant Building before auto baron William C. Durant lost control of the company (shields near the cornice still bear a large D), is divided into four wings that project both north and south from a central spine. It's a design, as

In a pattern seen in a number of newspaper lobbies a century ago, the *Detroit News* had a globe as its chandelier.
Albert Kahn Associates

The oversized statue of Ben Franklin, one of four publishing pioneers that peer down at pedestrians from the *Detroit News* cornice.

Hildebrand noted, that was common in apartment buildings of the era but rarely used in office buildings, which tended more toward single towers—as with Cass Gilbert's 1913 Woolworth Building in New York. The application to a commercial building in Detroit, however, wasn't unprecedented. Daniel Burnham's much smaller 1910 Dime Building downtown, which Kahn would have known, had two projecting wings

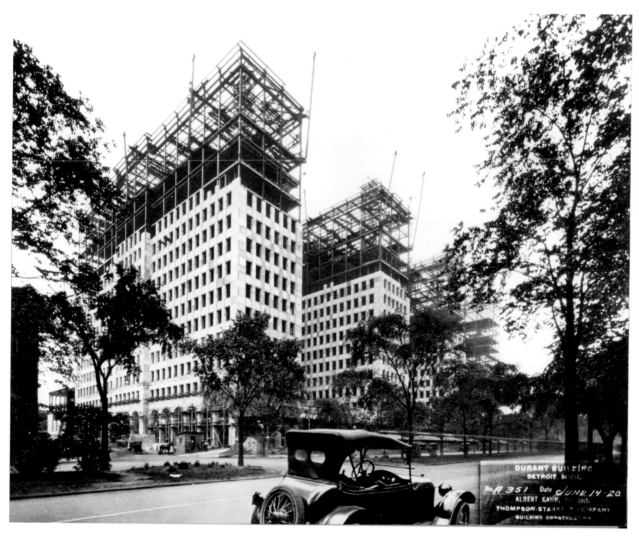

The 1920 General Motors Building was the first skyscraper to go up in Detroit's New Center, three miles from downtown, in what was at the time a residential neighborhood of mostly single-family homes.

Albert Kahn Associates

separated by a large, open light well.[52] In GM's case, the light wells are all one hundred feet square, dimensions that came with distinct marketing advantages. Square light wells (as opposed to ones deeper than they were wide) allowed GM, which rented out floors it didn't occupy, to advertise every office as an "outside room" with a street view, boosting what could be charged in rent.[53]

With 1.3 million square feet (including the attached GM Laboratory), the structure occupies an entire city block and was in 1928 "the second-largest building in capacity in the world after the Equitable Building in New York."[54] It cost about $15 million ($180 million in 2017 dollars) and took just over two years to complete. Thirty-eight buildings, mostly houses, had to be cleared to make way for it. The towering edifice originally housed two large auto showrooms, refreshment lounges, stores, a bank, and

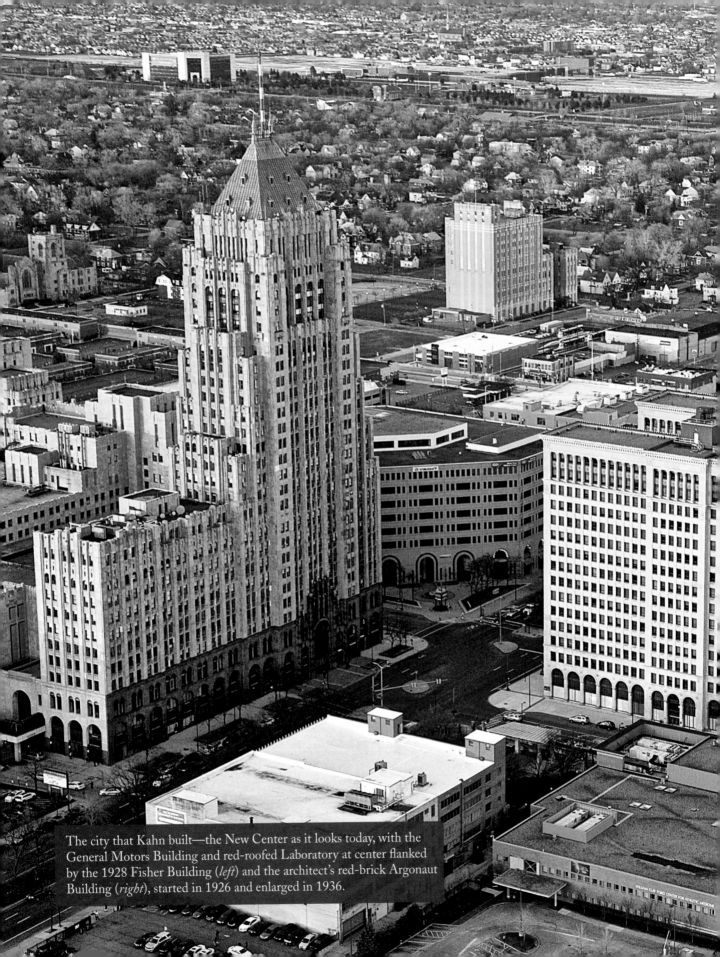

The city that Kahn built—the New Center as it looks today, with the General Motors Building and red-roofed Laboratory at center flanked by the 1928 Fisher Building (*left*) and the architect's red-brick Argonaut Building (*right*), started in 1926 and enlarged in 1936.

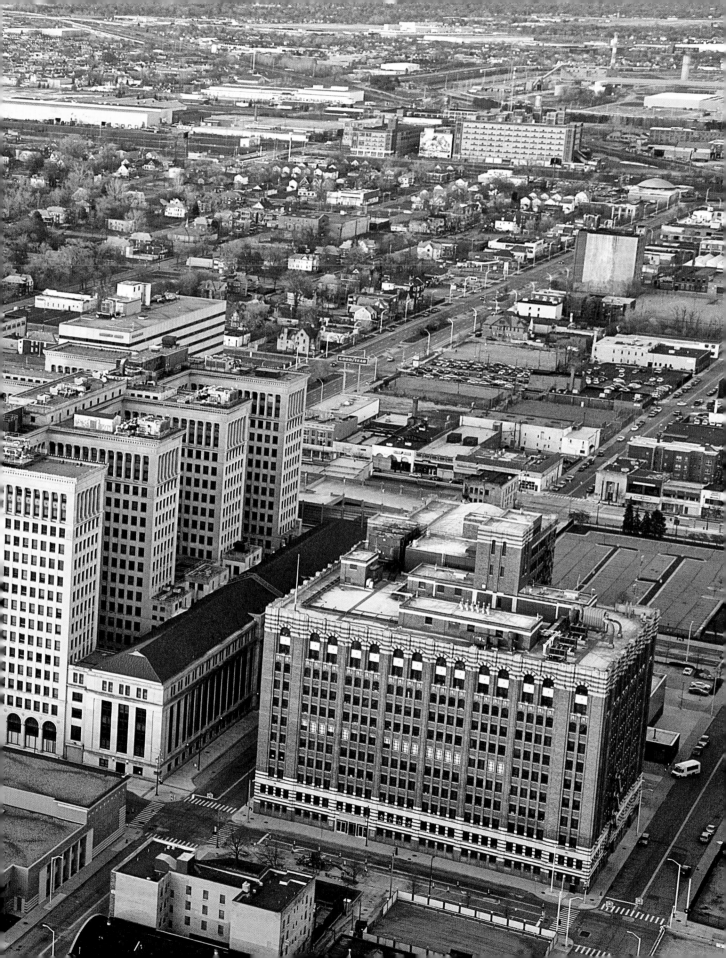

a twelve-hundred-seat auditorium. In the basement alone were "two swimming pools, one for men, one for women, each 25 by 75 feet in size, a gymnasium, 12 bowling alleys, 31 table billiard rooms, barber shop, mail room, stationery supply storage, utility rooms with equipment and locker rooms." Mail zipped around the fifteen stories in an up-to-the-minute network of pneumatic tubes, while workers and visitors had twenty-four elevator banks at their disposal. On the fourteenth floor, the exclusive preserve of company executives, you'd find a general dining room, private dining rooms, "living suites," private barber shop, and a lounge. The fifteenth floor boasted two dining rooms (one for each gender) with cafeteria service "capable of feeding 6,000 people within an hour and 20 minutes," a hospital, doctor and nurse's offices, and—in a nice touch—an employee dance hall. Connecting all this were *four miles* of corridors.[55] The design established a new "typological precedent," according to Bucci: the office building as self-contained city, complete with all the services its residents needed.[56]

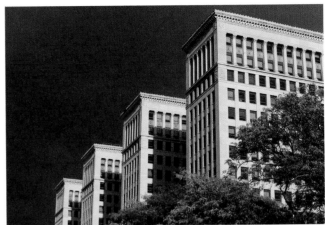

Stylistically, the building is neoclassical, with a ground-floor arcade punctuated by large arched windows divided by Ionic columns. On the upper two stories, Kahn went with Corinthian. In between are twelve stories of severely modern windows, punched into the wall and almost devoid of detailing. "The classic work of Daniel Burnham is instantly called to mind," Andrews wrote, alluding to the tripartite design—base, shaft, and capital—that Burnham favored. "But it is well to recall that in his Detroit skyscrapers—the Dime and the David Whitney buildings for instance," Andrews added, in an aside that flatters Kahn and rather slams the Chicagoan, "Burnham was not offering formidable competition."[57] Hildebrand also admired the GM Building, offering some of his most enthusiastic comments

The General Motors Building is neoclassical at bottom and top, with a severe gridwork of windows in between.

Overseeing the General Motors Building's main entrance are vigilant eagles and two allegorical goddesses.

on Kahn's nonindustrial work. He pronounced the building "a handsome piece of urban sculpture."[58]

Given the staggering number of projects working their way through his office, it's astonishing that Kahn had time for much else in the way of obligations. All the same, in 1918, the same year Kahn and his eighty employees moved to the top floor of the Marquette Building, he accepted an appointment to the new city Arts Commission, whose mission was to oversee the planned Detroit Institute of Arts.[59] It's a position he occupied until his death. In 1919, he also agreed to serve on a committee of three to pick the architect for the Detroit Symphony Orchestra's planned Orchestra Hall.[60] Both these councils were small and elite, and Kahn's presence reflected his standing, not so common for a Jew at the time, with Detroit's industrial and civic aristocracy. Not surprisingly, the man was an unabashed Detroit booster, though not afraid to criticize what he regarded as the city's shortcomings. When James Couzens, an early Ford Motor investor and a progressive Republican, became mayor in 1919, the architect championed his ambitious campaign for civic improvements, including installation of a streetcar system.

Speaking at the Detroit Real Estate Board's 1919 "Peace and Prosperity Dinner," Kahn railed against Detroit's lack of civic ambition. "Where on this continent," he asked, "is there another city of its size with so little in the way of Parks, of Public Playgrounds, of Public Buildings? What could be sadder than our neglected riverfront? Ours is a glorious opportunity to make of Detroit a city not only famous for its industries and millionaires, but for its nobler communal achievements as well." The city had made a good start, Kahn acknowledged, with the new public library by New York architect Cass Gilbert, under construction at that very moment, but it was incumbent upon city fathers to "see to it that sufficient funds are provided to properly maintain the [arts] institution." On the subject of municipal finances, Kahn could be a bit of a scold, contending there was nothing to resent in higher taxes if the proceeds were used wisely for community benefit. The architect had "no patience with these short-sighted calamity howlers," he declared, "whose first and only thought is low taxation and who don't care a fig for what will make for a finer, happier, more enlightened communal life; who, though they owe their wealth to the advance of the city, are yet unwilling to contribute their share toward continuing and extending that advance; who, though they would enjoy all the good things, don't care to help pay for them."[61]

This isn't to say Kahn was unwilling to challenge the government when he felt he'd been treated unfairly, as a dispute resolved by the Federal Board of Tax Appeals in 1928 demonstrated—most interesting for the light it cast on Kahn's income in the late 1910s and early 1920s. The issue involved a real estate partnership Kahn owned with his wife (and brother and sister-in-law). Ernestine claimed her share of the 1919–22 profits on her taxes, not her husband's. Because an obscure Michigan statute prohibited a husband and wife from entering into a commercial partnership together, the treasury in Lansing "corrected" her returns and assigned the income to Albert, where it was taxed at a much higher rate. This resulted in an additional tax liability of $49,832—no small sum today, and huge in 1928. But the federal board ruled in the Kahns' favor, saying Ernestine could claim the money. Here's the intriguing part: quoting tax documents, the *Detroit News* reported that Albert Kahn's total *net* income in 1919—not counting the real estate partnership—was $183,751. Three years later, that would rise to $219,070—or $3.14 million in current dollars, underlining the man's dizzying success.[62]

As significant as the General Motors Building was, the project that consumed most of Kahn's attention in the late 1910s was creation of the River Rouge factory complex for Henry Ford. The automaker had introduced the moving assembly line at Highland Park in 1913, three years after the plant's construction, but quickly realized the system's

limitations in multistory buildings. (Ford, by the way, did not invent the moving assembly line, but he, more than any other industrialist at this time, recognized and harnessed its potential.) Its introduction at Highland Park was the largest and most complete application of the system to date. But within two years, Ford came to the conclusion that Highland Park's multistoried arrangement was obsolete and began scouting about for a replacement site. He found what he wanted not far from his Dearborn mansion, Fair Lane—two thousand acres of flat land along the Rouge River with excellent access to nearby rail lines.

What Kahn would construct there through the 1920s was a vast industrial city, a vertically integrated manufacturing behemoth connected by a single, always pumping circulatory system—starting at the docks, where raw materials were unloaded from Great Lakes freighters, to finished cars exiting the plant on trains. As a leap forward in industrial organization, the Rouge design was unparalleled, and of almost unquantifiable importance in succeeding years to the development of heavy industry both in America and Europe. And because the Rouge buildings were virtually all single story, there were none of the obstacles to complete and total implementation of the assembly line.

The shift to single-story design also had consequences for the material used in the new buildings. After pioneering reinforced concrete in multistory auto factories, at the Rouge, Kahn switched to steel frame construction, which was lighter and easier to put up than concrete. The first building erected at the Rouge was the 1918 Eagle Submarine Chaser factory, built to handle U.S. government contracts during World War I. That plant, later known to Ford employees as the B Building, was another example of the Kahn firm's remarkable speed. Ford got the go-ahead for the chaser contract on January 17, 1918, and the factory opened that May—a construction schedule that Hildebrand pointed out was four times as fast as at Highland Park, mostly thanks to the time savings inherent in steel frame design. The B Building was the largest enclosed structure Kahn had yet built, comprised of five parallel, freestanding "aisles" fifty-one by seventeen hundred feet. While pictures of the B Building suggest it was four or five stories tall, it was completely open inside. The great height was necessary to accommodate the construction of boat hulls.[63]

In just four years at the Rouge, Kahn would design and build the Glass Plant (1923), the Rouge Coke Ovens and By-products Plant (1922), the Job Foundry (1923), the Cement Plant (1923), the Open Hearth Building (1925), and the marvelously named Spring and Upset Building (1925). Of these, the most important—and the most visu-

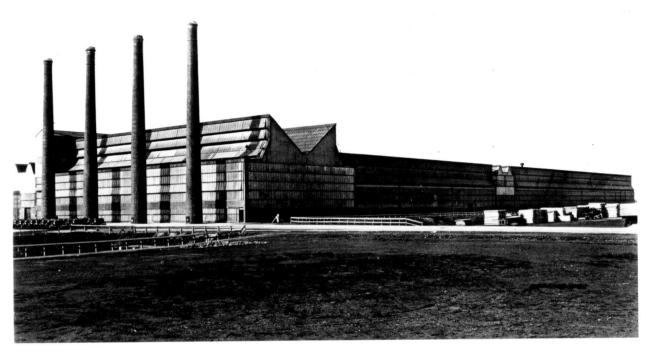

The 1923 Glass
Plant at the Ford
Rouge complex—
an exhilaratingly
futuristic piece
of industrial
sculpture.

Albert Kahn
Associates

ally compelling—was the Glass Plant. According to *Michigan Architect and Engineer*, in 1923 the auto industry suffered from a worsening shortage of plate glass, which was manufactured by an inefficient process requiring a great deal of specialized labor. Under Ford's improved system molten glass was poured from the furnace onto rolls "which flatten it into a continuous sheet." In just seven and a half hours after it was removed from the furnace, the glass could be cut up and stacked, ready for use in Model A's.[64]

If the process within was revolutionary, the Glass Plant's design was equally remarkable. "The steel structural cage was studiously worked out," Hildebrand wrote, "to accommodate precisely the various needs of the manufacturing operation. . . . The materials to sheathe this cage were handled in broad, uninterrupted planar sweeps to simplify the joining conditions, resulting in a simple and economical prismatic envelope. If one were forced to name a single factory that carried industrial architecture forward more than any other," he added, "this would most likely be it."[65] In 1998, the Glass Plant was the only Detroit structure Jonathan Glancey, architectural historian and design editor at the *Guardian*, included in his *Twentieth-Century Architecture: The Structures That Shaped the Century*. "Heat was vented from angled openings in the largely glass roof," he wrote. "The factory was given a strong presence by the row of four chimneys—industrial Doric—provided for the furnaces."[66] Sadly, the Glass Plant is long gone, but in pictures the columns do conjure up a neoclassical solemnity. As with

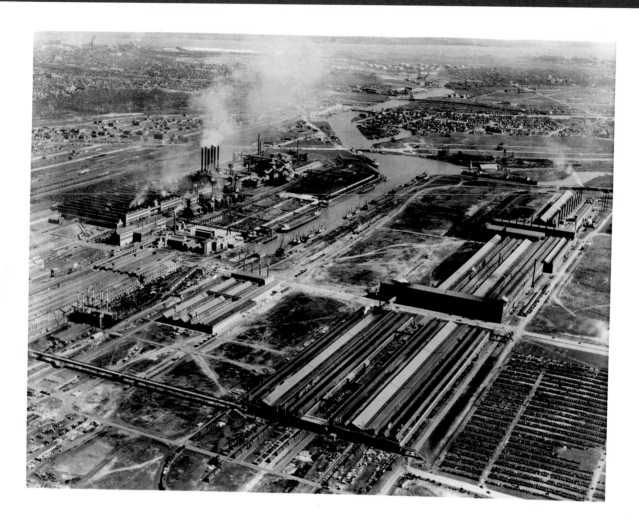

The Ford Rouge plant, a top-to-bottom, vertically integrated enterprise, was built on two thousand acres along the Rouge River in Dearborn. Raw materials arrived on train and ship, and left the complex as fully assembled vehicles.

Albert Kahn Associates

all Kahn's industrial design choices, their location in a row was dictated by simple pragmatism. But their visual power likely pleased and amused the architect.

The steel-framed Glass Plant would become the template for Ford plants throughout the 1920s.[67] It is one of Kahn's most sculptural industrial designs, and while the next decade's factories—the De Soto Press Shop and the Chrysler Half-Ton Truck plant, to name two—were more elegant, even breathtaking, there's little that can beat the Glass Plant's muscular, futuristic profile. It's hard to believe it went up in 1923.

Kahn's spreading fame as an industrial architect worked both for and against him. In 1998, historian Janet Kreger documented a storm that blew up in the early 1920s among University of Michigan alumni. Some felt that Kahn's understated academic buildings, which they disparaged as factory-like, did not rise to the dignity required of a great public university in the Midwest. *The Michigan Alumnus* complained, "It must be acknowledged that whatever advantages Michigan may boast in the university world, architectural distinction has not been her strongest point." While the article,

The University of Michigan's Harlan Hatcher Graduate Library, originally called the General Library when it opened in 1920.

"Speaking of New Buildings," didn't mention Kahn by name, the number of projects he had designed in the previous eighteen years left little doubt whom the authors had in mind. By the early 1920s, Kahn had built the Engineering Building (1903), Hill Auditorium (1913), Natural Sciences (1915), and the General Library (1920). The revolt spread to the faculty. The dean of Engineering, Mortimer E. Cooley, took up the cause, writing university president Marion Burton to complain of "a general feeling of opposition towards the character of buildings that have gone up recently. The University of Michigan is quite as much entitled to have attractive buildings on its campus as any other university," he added, "and quite as able." Cooley cited an unnamed father who sent his son to Princeton over Michigan "simply because of its attractive campus. Were we to build as they do at Princeton, Yale and Chicago," he added, "the University of Michigan would be selected by people who now send their sons to these other places." Cooley claimed several alumni told him they'd donate more if Michigan were more impressive looking. In a direct slap at Kahn, the dean added, "I can hardly imagine a man giving money for a building like our engineering building, chemistry building,

Some say the University of Michigan's Angell Hall (originally the Literary Building) is a deliberate homage to the Lincoln Memorial, built by Kahn's friend Henry Bacon.

natural science building or even our library." Apart from the Chemistry Building, all were Kahn's.[68]

So Kahn was told he had to gussy up his next project, the Literary Building (now Angell Hall). This was intended to be a "gateway" or symbolic entrance to the university. President Burton went out of his way to reassure Kahn in a letter that he admired what the architect had done so far, but suggested that in the case of the Literary Building, perhaps they'd better throw the alums a bone. So the architect presented three alternatives—surface treatments of the same structure that went from plainer to fancy neoclassical. One version even had a campanile in a central courtyard.[69] The regents went with a simple neoclassical design, minus the bell tower. The result is a grand columned building that outsiders on occasion have mistaken for the state capitol. Completed in 1924, Angell Hall looks like an homage to the most famous work by Kahn's 1891 European traveling companion, Henry Bacon, whose Lincoln Memorial was finished at about the same time. But if Kahn yielded to pressure and dressed up the front along State Street, the back of the building reveals what he'd originally

had in mind—a soberly detailed brick building that looks more like his earlier work on the campus.

Another neoclassical building erected at about the same time that was not produced under duress—indeed, one that undoubtedly reassured status-conscious alums—was the university's 1921 Clements Library. The small library houses the collection of rare Americana donated by U-M regent William L. Clements, whose Bay City mansion Kahn built. Like the 1928 Fisher Building, this was a commission with a largely unlimited budget—Kahn could do whatever he liked. Hildebrand espied a direct connection to the architect's heroes, the New York firm McKim, Mead, and White. "Clements represents the closest approach in Kahn's work to the sophisticated elegance of McKim," he wrote, "and it is a close approach indeed." Unusually lavish in his praise, Hildebrand added that the two-story structure "has an almost Brunelleschian quality in the crisp delicacy of its treatment," calling it a "bright gem" on the university campus.[70] For his

Albert Kahn always said that his 1921 Clements Library at the University of Michigan was his favorite design.

McKim, Mead, and White's Butler Institute of American Art in Youngstown, Ohio, is said by some to have inspired Kahn's design for the University of Michigan's Clements Library.

The Butler Institute of American Art

part, Ferry saw echoes in Clements of McKim, Mead, and White's Morgan Library in Manhattan, and both Hildebrand and he pointed out the resemblance to the New York architects' Butler Institute of American Art in Youngstown, Ohio, itself based on the Vignola casino at the Villa Farnese in Caprarola, Italy.[71] It must be said, however, that Clements is considerably more elegant than Vignola casino, and gives the Butler Institute a real run for its money.

(*Top*) Kahn in 1925 built the whimsical Franklin Hills Country Club in suburban Farmington north of Detroit. (*Bottom*) Franklin Hills afforded Kahn the opportunity to indulge in playful Arts and Crafts detailing.

STRIFE AND FISHER GLORY

If the early 1920s were a period of protean accomplishment in Kahn's professional life, what with the Rouge Glass Plant and the General Motors Building, they were also turbulent years with painful crises arising in two key relationships. The anti-Semitic blasts emanating from Henry Ford's *Dearborn Independent* had to have burdened Kahn, though as with most personal matters, he was tight-lipped, leaving virtually no clues in the few candid communications—mostly letters to family—that remain. As noted in chapter 3, family legend has it that after 1920, Kahn never set foot on the Rouge plant, delegating one of his brothers for meetings. He did not, however, break with the automaker. In explaining that, it's worth remembering that Ford, whom Kahn had known since 1908, was a peculiar but undeniable genius who'd given the architect some of the most exhilaratingly innovative work of his entire career. That work made Kahn rich and famous, as his name came to be associated worldwide with cutting-edge industrial design. Also complicating the picture, Kahn genuinely admired the automaker. It had to have been a season of violently conflicting emotions.

Far more harrowing and personally destabilizing was the discovery that Ernestine had breast cancer. She underwent radical surgery, and not only survived but, remarkably, given the state of early twentieth-century medicine, lived another fifty-five years.[1] (By contrast, breast cancer killed her daughter Ruth at sixty, and subsequently two grand-daughters.)[2] Ernestine's surgery complicated plans the couple had to return to Europe. They'd last traveled abroad in 1919 and 1921, but just for short visits. The 1923 vacation was supposed to be a long Mediterranean cruise, and a family affair at that. The couple's oldest daughter, Lydia, now twenty-five, was to accompany them, as was Kahn's brother

Julius. After Ernestine's diagnosis, however, Kahn figured the entire trip would have to be scrapped to give her time to recover from the surgery. But she bounced back more quickly than anticipated, and insisted the overseas trip would do her good. Discussing her illness, family biographer Brashear maintained, "[Kahn] had never neglected his family, which was always his top priority."[3] But Kahn's conduct in relation to the 1923 trip—and subsequent European plans with his wife—is a reminder that the architect also suffered from a difficult and chronic tug-of-war between family obligations and the demands of a hugely successful architectural practice. As the February departure date approached, Kahn convinced Ernestine, Lydia, and Julius to sail without him—he would catch up on a later boat in coming weeks, he said, as soon as work allowed. "I wish I might have gone along but that was out of the question just now," Kahn wrote his middle daughter,

Ruth Kahn Rothman as a young mother with her first child, Phillip. While Kahn was clearly fond of all his children, he seems to have had a special connection to middle daughter Ruth.

Ruth, then a student at the Emma Willard School in Troy, New York. He'd just seen the travelers off, waving good-bye from a dock on Manhattan's west side. "Perhaps I shall get away in March," he added, "and spend 3 weeks over there with Mother and Lydia. We'll see." Turning to a happier subject, he added, "We all had a busy and pleasant time in N.Y., and last night saw a wonderful performance of *Hamlet* with John Barrymore, one long to be remembered. The house is sold out completely for the week but the Old Colony Club helped us find tickets. Uncle Julius & Aunt Margaret were with us. Monday night we went to see the *Old Soak*. We were disappointed and didn't stay it out. It's rotten. I was certainly sorry you could not be with us," he added, in a remark possibly meant as much for himself as Ruth, "but you did the right thing in not coming. It would have cut into your work badly."[4]

As for those family members en route to Europe, a letter from Ernestine on *RMS Mauretania* stationery underlines the Kahns' relative privilege. It seemed Julius didn't approve of the stateroom Ernestine and Lydia had—too much engine noise and, being near the stern, too prone to pitching with every swell. He insisted they move. "The room we have now cost us each $400 more," Ernestine wrote her husband.[5] One

wonders if there was some trepidation behind her admission, even in a family accustomed to significant wealth. In current dollars, she was talking a $14,000 upgrade for the two of them—and to a husband who once chided her extravagance when she wrote a letter using only one side of each page.[6] (Julius, more concerned about the women in his care than his own comfort, kept his original stateroom near the rejected cabin.) Ernestine added on a different subject, "I am wondering how you (just you yourself) are getting along without me. I really can't tell you how much I have missed you. I know one thing, I can't make a trip without you again. Not that Julius and Lydia haven't been just wonderful, but that isn't you. I certainly am looking forward to seeing you in Naples. Now," she finished, "don't disappoint me. Ever your, Ernestine."[7]

A letter from Lydia two days later reported that her mother, despite a touch of seasickness, was doing very well. "She surely was plucky," Lydia wrote, "and while she looked like the dickens for a couple of days and felt a lot worse, still she eats 3 meals a day and managed to keep most of it with her." She went on, "There is a very fine lot of people on board—however I don't think that a group of Americans is as interesting a crowd as a group with a lot of foreigners sprinkled in. We have met some very nice people including Professor Boring of Columbia—who knows your work very well, of course. Best of love to you, father, dear," she signed off, echoing her mother, "and don't fail us at Naples. Lydia."[8]

As it happened, he failed them both. On March 20, Ernestine wrote from Cairo, where the *Mauretania* had put in: "Dearest Albert—your telegram was delivered yesterday morning and it is hard for me to tell you how disappointed I was to receive the word that you were not coming. It certainly was a lengthy telegram," she added, "but I suppose you took that way of softening the blow." The news seemed to sour her mood. "Really, you can't picture what impossible people the majority on this boat are," she wrote. "They have plenty of money and don't hesitate to display it, but when it comes to intelligence and refinement, they are hopeless."[9]

Between business travel and long office hours, Kahn appears to have been an absent father much of the time, but one who nonetheless doted on his children. This comes into sharpest focus in a series of letters he wrote "Ruthie" in 1923 and 1924, first at the Emma Willard School in Troy, New York, and then at the University of Michigan. As noted, by this point Lydia, the oldest child, was in her midtwenties. "Eddie" was just starting medical school at the University of Michigan—and simultaneously captaining the varsity hockey team. (Ah, for those halcyon days of yore, when an ambitious med

student—who would ultimately rise to chief of neurosurgery at the University of Michigan Hospital—had time for both his studies *and* varsity athletics.) Rosalie, the youngest, was eleven. In a February 13, 1923, letter to Ruth, Kahn described the Valentine's gift he'd just given to Rosalie. "This evening I presented it to the young lady, and what excitement!" her father wrote. "She was tickled clean to pieces. It is a mighty cute Valentine, too—a bouquet formed of candies, looking something like this [here he included a small sketch], all done up in tissue paper and in a paper hatbox. . . . She was certainly thrilled, and such hugs I got. She nearly choked me. She is the darlingest thing ever."[10]

Kahn presented his youngest child, Rosalie, with a candy "bouquet" for Valentine's Day in 1923, which he illustrated in a letter to her older sister, Ruth.

In 1986, Lydia told *Detroit Free Press* art critic Marsha Miro that because her father went to work at twelve years of age, "he didn't really understand the idea of childhood. He was not the sort of father who played games with his children." Still, he was attentive to her in his own way. When the young Lydia wanted a doll's house, Kahn refused to buy one of the "fussy" Victorian models found in shops. Instead, he constructed for her what Miro called "a simple white Colonial, with green shutters and large windows."[11] And in his letters to Ruth, who was admittedly his favorite, Kahn appears to be just the sort of father any child would want—affectionate, sensitive to her concerns, and ready to spring to her defense when he felt she was being misused. An issue during Ruth's last year at the boarding school involved the nickname other girls pinned on her, Krazy Kahn. The headmistress—a Miss Kellas—apparently found it offensive but, oddly, seems to have blamed Ruth. Kahn urged his daughter to trust her own instincts. "I got your letter today," he wrote in February 1923. "Don't you worry about Miss Kellas. She is a sad old maid, probably disappointed in love and you must be charitable. Personally I care very little about what she thinks of you, for it means nothing to me. You just do what your conscience tells you is right," he added. "I'd rather take your opinion as to what's right than hers. If you feel good enough to have some fun, you just have it, and if 'Krazy Kahn' doesn't bother you—I care mighty little what she thinks of it. She gives me a pain and I would just as soon tell her so. And as for your studies—if you

have done your best and haven't deliberately or willfully neglected your work," he concluded, "I am entirely satisfied. I would rather have you as you are than a dozen of Miss Kellas' favorites."[12]

The man showed a similar light touch in parenting his only son. When Edgar was fifteen, Kahn decided it might be a good idea for the boy to work in the family business for the summer—despite the fact that Eddie had never made any secret of his keen interest in a medical career. The architecture internship was brief. On Eddie's first day, he was given a piece of tracing cloth and instructed to erase a line. "This cloth represented about 18 hours' work," he wrote in *Journal of a Neurosurgeon*, "but in doing so [I] penetrated the cloth for the line's entire length. I took it to Mr. Bunce, the head draftsman who had known me from my infancy. He did not say a word, but a sad look came over his face. I put on my hat, left the office, and never returned again except socially." That night father and son had a talk. "My father said my ineptness may have been a blessing in disguise," Edgar wrote. "Were I to go into architecture, there would always be the handicap of being the son of an established father. Medicine, he said, was the finest profession in the world—but architecture came second."[13] Again, Kahn seemed to be able to put his children's interests first. "Far from being disappointed in his son's decision to opt out of a career in architecture and an opportunity join his father in business," Brashear wrote, "[Kahn] admired and wholeheartedly supported [Edgar's] determination to enter a profession for which he believed he had a calling. The future was to emphatically vindicate Edgar's choice."[14]

So Kahn was a good, if often distracted, father and a devoted paterfamilias to his extended clan, whom he and Ernestine entertained frequently. Sunday dinners at the Kahn household were famously open to all comers. His onetime employee Wirt C. Rowland (Guardian Building, Penobscot Building, and Buhl Building) wrote a number of whimsical essays for the *Weekly Bulletin of the Michigan Society of Architects* in the 1930s in which he both gently spoofed Kahn ("Kubla Khan") and praised him not only for his architecture but for the hospitality he and Ernestine extended to the wider architectural community. Professionally Kahn seems to have been a gregarious, good-humored sort, at least to judge by the jocular tone of letters from some clients. After Kahn attributed his early success to his work for Packard Motor in the *Detroit Times*, Packard's president, Henry B. Joy, wrote to say, "Well, there you go again blaming me for everything you've done." He added, "I never did anything for you! Never! But you certainly did a lot for me! I never had any more trouble after I 'hooked up' with

you. Nonsense to say I helped you. You would have been just as big as you are if I had never been born!"[15] In 1927, Detroit Trust Company president Ralph Stone wrote to praise the just-completed expansion of his neoclassical bank on Fort Street, but had one complaint: "Dear Mr. Kahn," Stone wrote, "the next time you are in our building, around 10:00 o'clock, will you please come into my office and see how the morning sun sheds its effulgent rays upon my sacred person while I am seated on my throne? Of course, one solution is to stay away until 11:00 o'clock," he added, "but I want to hold my job. To protect it by curtains means putting them all the way up to the ceiling, and our artistic people here shudder at the thought."[16]

A similar impishness cropped up in Kahn's speeches from the 1920s, in which the architect sometimes indulged in mild-mannered ethnic jokes. In a 1921 speech to the Vortex Club, Kahn touched on a Methodist minister, asked to pray for rain. When his exertions produced a deluge, Kahn concluded, "[T]he person who had asked for the prayer was heard to murmur, 'How those Methodists do exaggerate!'"[17] Alas, such gentle political incorrectness vanishes from his addresses in the 1930s, as do his more self-deprecating observations. One wonders whether he wrote his own material in the 1920s, but handed the task to a subordinate thereafter.

Among Kahn's commissions in the early 1920s was a series of handsome look-alike branch offices for the Detroit Savings Bank.

Built in 1921, University Hospital at the University of Michigan, long known as Old Main, was torn down in 1989.

Albert Kahn Associates

Longtime *Free Press* reporter and columnist Malcolm W. Bingay—seemingly one of the few in town to recognize what a character Kahn was—has left the most detailed impressions of the man and what he was like. "Good humor poured from him," Bingay wrote in *Detroit Is My Own Home Town* in 1946, four years after the architect's death. "In a talk with him it was difficult to gauge the stature of the man because of his puckish delight in refusing to take himself too seriously."[18] There are concrete examples of this occasionally self-effacing nature: in at least two instances in Kahn's memory, the architect declined a commission and told prospective clients, "I know a better man." In this way, Kahn may have recommended Paul Philippe Cret for the Detroit Institute of Arts. (He certainly endorsed him. But his exact wording is unknown.) And as Kahn recalled it, he told George G. Booth much the same thing before allegedly introducing him to Eliel Saarinen, who would end up building the entire Cranbrook academic campus.[19]

The 1920s were the high-water mark of Kahn's eclectic career, a decade in which he built the Ford Rouge industrial complex as well as several of his most enduring commercial and academic buildings, including the General Motors Building, Clements Memorial Library at the University of Michigan, and the Fisher Building. Those years, turbulent at times, saw an impressive and highly varied portfolio of buildings go up just before Kahn's practice began to pivot, around 1930, almost exclusively toward industrial projects. His nonindustrial work in the 1920s would be bracketed at one end by the General Motors Building, just discussed, and the Edsel B. and Eleanor Ford House in

1927, which was Kahn's last great residential project. In between we find a parade of significant commissions.

At the University of Michigan, Kahn built the University Hospital (sadly, demolished in 1989), the East Physics Building, the East Medical Building, Psi Upsilon Fraternity, the Simpson Memorial Institute, the Art Exhibits Building, the jewel box Clements Library, and Angell Hall.[20] Despite all these, the project that dominated the decade was the Ford Rouge complex, touched on in chapter 3. Other industrial work included the Studebaker plant, the curvaceous, Streamline-Moderne offices and factory for the Hinkley Motor Corporation, and the warren of five- and six-story brick warehouses that formed the Murray Body Corporation (in recent years known as the Russell Industrial Center and filled with artists' studios). Among important commercial commissions were the multi-winged First National Bank on Campus Martius (which French modernist Le Corbusier would cite as inspiration for his Admiralty Building, a never-built project in Algiers), a new Temple Beth El, Detroit Police headquarters, the *Detroit Free Press* building, the Ford Engineering Laboratory, the Maccabees Building, the

The Kahn firm made something of a specialty of hospitals—indeed, Kahn wrote a thoughtful article on the subject once. Also from the 1920s, albeit built in stages, was the new half of Herman Kiefer Hospital on Detroit's west side, designed in Romanesque Revival style.

Detroit's Russell Industrial Center, formerly the Murray Body Corporation, has housed art studios for many years.

Ft. Shelby Hotel tower, Women's Hospital, a temple for Congregation Shaarey Zedek and, crowning all the others, the 1928 Fisher Building across Grand Boulevard from Kahn's General Motors Building.[21]

The *Free Press* building and Detroit Police Headquarters, both built in the mid-1920s, were two significant additions to the cityscape, and nicely illustrate the range of styles Kahn worked in—from Art Deco to Renaissance palazzo. Indeed, the police headquarters building bears an unmistakable resemblance to Kahn's 1915 Detroit Athletic Club four blocks away, albeit more hard-edged in appearance. Nonetheless, the similarity is striking enough to have given rise to speculation that the police building was designed as a slap at the DAC for its restrictions on Jewish membership—never mind that the club offered to make an exception for Kahn. The theory rests on two assumptions— first, that club members would find the association with a municipal building somehow insulting, which may or may not be plausible. Second, it assumes Kahn was the sort of individual who would engage in deliberate revenge some eight years after the fact. That seems a stretch, not only because the man doesn't seem the type to engage in petty

swipes but also because any number of DAC members were CEOs of automotive companies and his clients. A more convincing explanation centers on Kahn's habit of reusing designs when expedient—an architectural version of mass production more typical of his industrial work but seen with his commercial projects as well. The 1927 Maccabees Building is in much the same mold as the 1925 *Free Press*. Detroit's Northern High School looks a lot like Kahn's Graduate Library at the University of Michigan. Many of his classroom loft buildings on the Ann Arbor campus are all cut from the same cloth as well. Kahn likely chose neoclassical design for the police headquarters for its air of civic authority. Alternately, for aesthetic, city-planning reasons, he may have liked the idea of the visual echo the police headquarters would set up with the DAC several blocks away.

The later 1920s saw a number of important projects, including the handsome Ford Engineering Laboratory (1925), with its modernized neoclassicism, and the Maccabees on Woodward Avenue, kitty-corner from the Detroit Institute of Arts. Ferry called the Maccabees "an imposing three-dimensional composition" and speculated that Kahn had been influenced by Ralph Thomas Walker's massive New York Telephone Building in Manhattan.[22] Like the *Free Press*, the Maccabees was another limestone building with a central tower, echoing the setback laws New York City enacted in the 1920s. (Those encouraged large structures to taper as they rose to preserve sunlight on the street, giving a highly distinctive look to the era's architecture.) In style, the Maccabees is also Art Deco, with strong vertical lines and, like the *Free Press*, a modern, cornice-free top. Of the two buildings, the *Free Press* is the grander

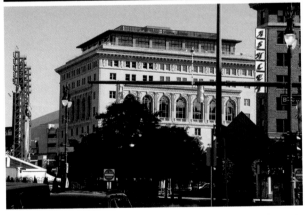

(*Top*) Built on a challenging site, the multi-winged 1922 First National Bank all but enfolds Kahn's 1917 Vinton Building.

(*Middle*) With his 1922 Detroit Police Headquarters, Kahn may have intentionally mimicked his 1915 Detroit Athletic Club (*bottom*) just a few blocks away.

Kahn designed the headquarters for all three Detroit dailies, including the 1925 *Free Press* building.

and more successful—at once lighter and more soaring in appearance. Indeed, it's one of downtown Detroit's most distinctive skyscrapers. George Mason, however, was not impressed, and had no compunction about sharing that opinion with his former protégé. He praised the *Detroit News* building to the sky, but wondered, "Now why didn't you do as well with the *Free Press* and Maccabees temple?"[23]

An even sharper criticism of the Maccabees Building came from a most unexpected source—the Detroit City Council—and it cost Kahn a significant commission. In a front-page article headlined "Admit Fight on Kahn Due to Old Grudge," the *Detroit News* reported in January 1929 that council members rejected Kahn's $1 million proposal for an air terminal and hangar at Detroit City Airport, still furious over his behavior two years before when constructing the Maccabees. Instead the council gave provisional approval to a $2.5 million design by Louis Kamper (who built the Book Tower and the Book-Cadillac Hotel). The set-to concerned Kahn's apparent disregard for well-known plans for the widening of Woodward Avenue, on which the Maccabees fronts. While Detroit's main street wouldn't actually be expanded until 1935, both the dimensions and location of the new right-of-way were common knowledge to architects and planners by the mid-1920s. Despite this, Kahn built the Maccabees' Woodward Avenue façade fourteen feet into the new right-of-way—and at an angle, at that. The architect worked up his own plan for handling the avenue out in front, but the city council was having none of it. Members were particularly incensed at what they called Kahn's refusal to apologize. According to the newspaper, the architect stoutly maintained he "would do the same thing again." That was all the council needed to hear. "I voted against Mr. Kahn in the first place," said Councilman Sherman Littlefield, "because I didn't like the

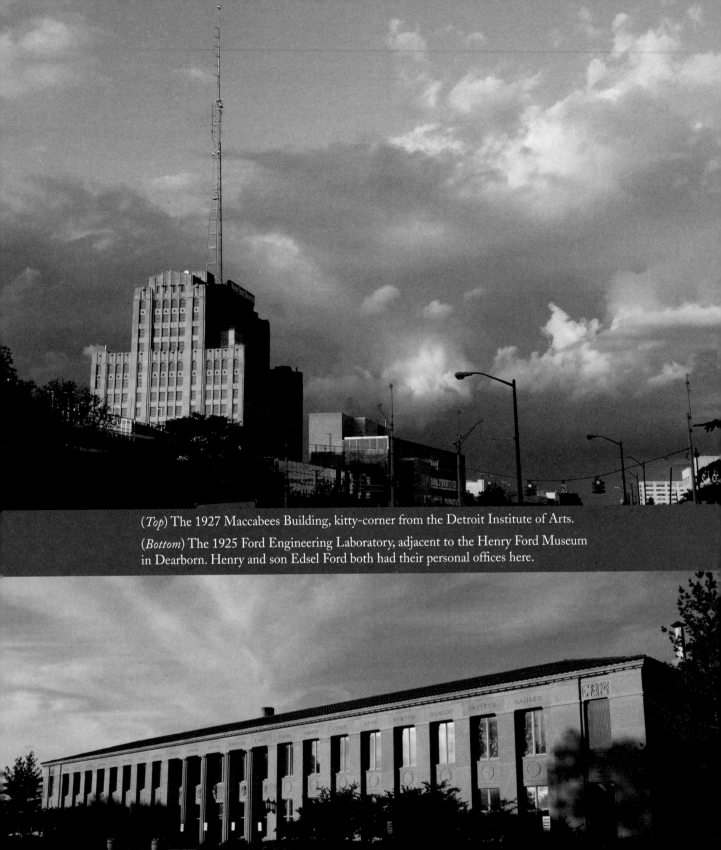

(*Top*) The 1927 Maccabees Building, kitty-corner from the Detroit Institute of Arts.

(*Bottom*) The 1925 Ford Engineering Laboratory, adjacent to the Henry Ford Museum in Dearborn. Henry and son Edsel Ford both had their personal offices here.

Portrait of Edsel B. Ford in 1932 by Diego Rivera, housed in the Detroit Institute of Arts.

way he treated the city in the Maccabees deal." Members agreed the architect should be cut out of future work for the city and, to cope with this intrusion into the Woodward scheme, adopted "a compromise plan that will leave irregular sidewalks at this point."[24]

A couple years before the airport debacle, work was getting under way with the Edsel B. and Eleanor Ford House. This would prove the most spectacular of all the mansions the architect designed for Detroit's industrial barons. "Talk about being important?" Kahn wrote Ruth in July 1926. "Monday morning both Edsel Ford and Mrs. E. spent with me, and Tuesday morning they spent with President Coolidge at his summer camp. The papers have been quite full about the latter," he added, "but somehow failed to record the former. That's always the way. They never get things quite all right." Then, on a practical note: "We turned the first sod for the [Fords'] Grosse Pointe house on Monday. Quite an event."[25]

Despite being twenty-four years his senior, Kahn was unusually close to Edsel Ford, whose relationship with his own father was fraught. Edsel and Eleanor were frequent dinner guests at the Kahn home on Mack Avenue. Edgar Kahn said that for his father, the relationship was exceptional. "[The two] had been close friends since 1917, when [Edsel] was in charge of the Highland Park plant, then making Liberty engines for World War I bombers. Father, I believe, thought more of him than of any other man, with the exception of his own brothers. When he talked to me about him," Edgar added, "it was almost in hushed tones."[26]

On trips to inspect Ford factories in Great Britain, Edsel had spent considerable time in the Cotswold Hills with his father, "who was attracted by the rambling informal stone houses of this remote area."[27] That charm worked its spell on Edsel as well, who fell for the warm, stone-faced Tudor architecture of the region. The auto heir decided

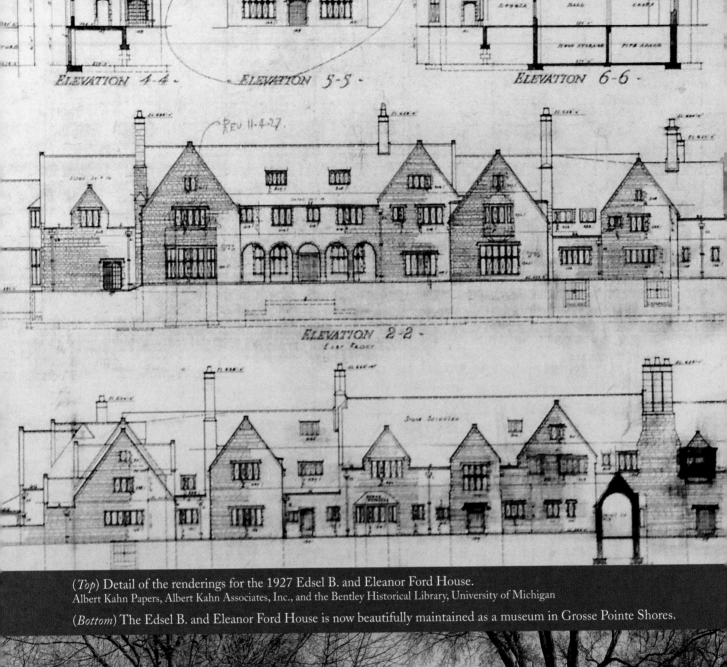

ELEVATION 4-4. ELEVATION 5-5. ELEVATION 6-6.

REV 11-4-27.

ELEVATION 2-2.
EAST FRONT

(*Top*) Detail of the renderings for the 1927 Edsel B. and Eleanor Ford House.
Albert Kahn Papers, Albert Kahn Associates, Inc., and the Bentley Historical Library, University of Michigan

(*Bottom*) The Edsel B. and Eleanor Ford House is now beautifully maintained as a museum in Grosse Pointe Shores.

this was just the ticket for the Grosse Pointe Shores mansion he planned to build on Gaulker Point on Lake St. Clair. Kahn had designed a number of homes in Tudor style, including the original Rose Terrace and the Chandler Walker House in Windsor, Ontario. But the Ford House was to be considerably more elaborate and, as Hildebrand noted, "a good bit more of an archeological adventure." Kahn visited the Cotswold hamlet of Broadway to study the local vernacular and to see what materials could usefully be incorporated into an American house. "Slates, wood, and paneling—in some cases actually from medieval buildings— were brought over, as were Cotswold workmen," wrote Hildebrand. "The house shows thorough attention to historic precedent throughout; the roof, for example, is made up of split stones

Employing traditional Cotswold construction techniques, limestone shingles are organized so that they increase in size as they go down the roof.

hung on oak boarding with oak pegs, with the stones graded from large at the eaves to small at the ridge, in the Cotswold manner."[28] Kahn designed the mansion, which was faced with Briar Hill sandstone, to look as if an old manor house had been added onto several times.[29] Still, Hildebrand found it all "a bit too crisp. It has the quality of metal or marble," he wrote, "rather than of soft limestone."[30] A promotional brochure written decades later when the house was unsuccessfully put up for sale (today the Ford House is a nonprofit museum) claimed, "A proportion of old stones from demolished buildings were mixed with the new stones to obtain the desired weathered effect—just one instance of the infinite detail employed by Mr. and Mrs. Ford to achieve their purpose."[31] The authors of *AIA Detroit* pointed out that the house was "built to last, regardless of context and scale," adding, "Beneath the Ford House's romantic massing are reinforced concrete floors and steel roof trusses."[32]

Kahn's great commercial project at the end of the decade was the 1928 Fisher Build-ing, kitty-corner across Grand Boulevard from his General Motors Building. Nothing the architect built before or afterward ever quite equaled the all-marble Fisher, which consistently wins plaudits as Detroit's most magnificent skyscraper. (Its only real com-petition, in terms both of exterior design and dazzling lobby, would be Wirt Rowland's much flashier 1929 Guardian Building downtown.) The Fisher's fame wasn't just local. The Architectural League of New York judged it one of the best buildings of 1928, a year when an astonishing number of office towers went up across the country, and awarded Kahn its silver medal. "It's a splendid solution of a Commercial Building," the judges wrote, "modern in character and admirable in detail."[33] (William Pope Barney's compact American Bank and Trust in Philadelphia took the gold.)[34] The Fisher has long been used to rave reviews, but few capture its punch as well as former *Detroit Free Press* reporter Dan Austin writing on HistoricDetroit.org: "The building known as 'Detroit's largest art object' has been dropping jaws in the New Center for more than 80 years."[35]

In her living room, Eleanor Ford eschewed ostentation in favor of tasteful simplicity.

The seven Fisher brothers intended their 1928 Fisher Building to be a lavish and enduring gift to the city of Detroit.

Still, George Mason wrote Kahn in 1927, referring to his protégé by name, to say that what he saw in the newspaper struck him as "too common and ordinary for Albert's memorial, and I know he can do better and it may be the final opportunity of a lifetime on so vast a scale." The Fisher Building's design went through any number of iterations, though apart from the late addition of the Gothic roof, the differences from one to another were not that striking. It's unclear which version Mason was referring to.[36]

The Fisher Building was a family affair, financed by the seven brothers behind the Fisher Body Corporation The boys' father had operated a carriage and blacksmith shop in Norwalk, Ohio, and the sons all learned the trade. In 1902, first-born Fred Fisher moved to Detroit to work as an expert carriage maker—a propitious year at the dawn of the automotive era. Fred and brother Charles organized the corporation in 1908, and "Body by Fisher" was born. Their first big order was for 150 closed bodies for Cadillac two years later—the all-enclosed sedan being a Cadillac innovation. In 1926, the company manufactured 1 million bodies, and General Motors bought the brothers out at a price reportedly north of $200 million ($2.7 billion in 2017). Lawrence Fisher became president of Cadillac Motor, while Fred was named vice president and member of the GM board of directors. The year after the sale, the family declared its intention to put up a $35

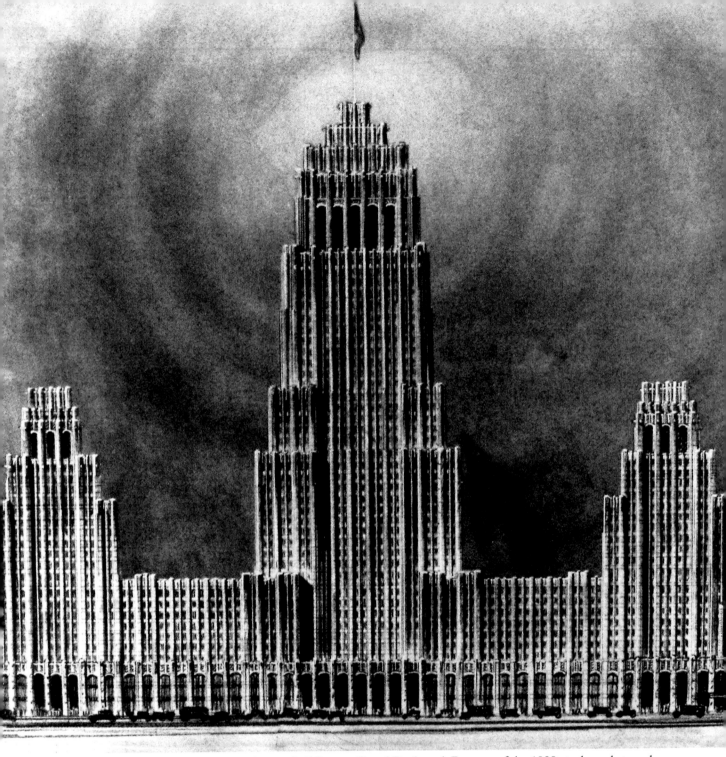

An early proposal for the Fisher brothers' super-building on Grand Boulevard. Because of the 1929 stock market crash, only the right-hand third—today's Fisher Building—was built.

Albert Kahn Associates

million (about $500 million) mega-complex in Detroit's New Center that would stretch the entire long block between Second and Third Avenues.[37] Initial plans called for three towers—two identical ones bookending a massive central tower "some fifty stories high."[38] The stock market crash intervened, however, and ambitions like this scattered

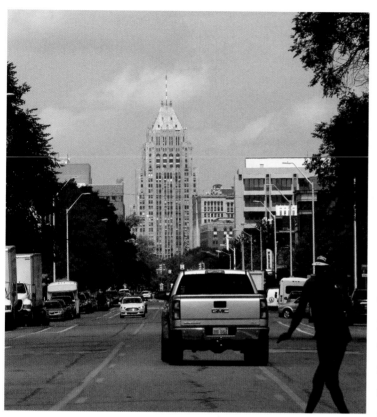

Second Avenue appears to end at the Fisher Building's front door. (It actually does a dogleg to the right at Grand Boulevard.)

to the winds. Only the eastern third of the project—today's twenty-six-story Fisher Building—was built. The 1928 structure is an L-shaped office block eleven stories tall, with a fifteen-story tower—a powerful visual anchor at the corner of Second Avenue and Grand Boulevard.

In discussing the building in the *American Architect*, Albert Kahn opened by noting that both the location and the commission offered rare opportunity. The construction site, at a dogleg where Second Avenue crosses Grand Boulevard, permitted the tower to be built on a line dead-centered on Second, at least for the motorist heading north. The result is that rarest phenomenon in American urban design—an avenue with a satisfying visual terminus at its end. "The Fisher Building's commanding site is an exceptionally happy one," Kahn wrote, noting that it broke the monotony of "the endless straight avenues and streets too common in practically every city in the United States."[39]

The commission was highly unusual in another way. As Kahn noted, "The owners, imbued with a desire to erect a thoroughly high-class building, did not make cost a prime consideration."[40] As he had with his work on Clements Library, Kahn had an almost unlimited budget, though this didn't necessarily make for a happier architect. "A tight budget was a challenge [Kahn] enjoyed, and he did not feel at ease in its complete absence," Hildebrand observed.[41] Indeed, in a letter to Ernestine thirty years earlier, Kahn commented on the over-the-top luxury within New York's fabled Waldorf Hotel. "It is quite a trick," he wrote, "where money is no object, to know just where to stop and not have things run away with one."[42] With the Fisher Building, Kahn appears to have known just where luxury risked edging over into excess. In straddling that line, he created a commercial temple at once magnificent and subdued—never mind the use of forty different types of marble "that would dazzle even the most jaded Roman emperor."[43] (The marble cladding the building's exterior, however, is mostly bluish-gray.)[44]

Inside the spectacular three-story, cruciform lobby—with its gilt, bronze, and ever-changing marble—the architect kept a lid on things by working mostly in a dark palette of black, brown, and gold. The exceptions are found on the barrel-vault ceilings, which were colorfully designed by Géza Maróti, a Hungarian artisan also employed by Eliel Saarinen at Cranbrook. The painter executing the ceiling was Thomas Di Lorenzo, who finished the vast job, astonishingly, in two months.[45] In the *American Architect*, Kahn graciously cited outside contractors who worked on the project. These included "Dr. Maroti" and Di Lorenzo as well as "Messrs. Ricci and Zari of New York," who did most of the exterior ornaments. (They also did the crouching figures atop columns on the University of Michigan's Law Quad.)[46] Anthony Di Lorenzo prepared the models for most exterior and interior bronze work. Kahn also tipped his hat to Detroit's legendary architectural sculptor, Italian immigrant Corrado Parducci, "who furnished models for some of the bronze and all of the plaster ornaments." The lobby's remarkable flared and fluted chandeliers came from New York's Edward F. Caldwell and Company.[47]

The Fisher Building's setbacks are supervised by a small army of leering gargoyles.

The three-story Fisher Building arcade, with its vast painted ceilings—completed in just two months—is one of Detroit's most commanding interior spaces.

The Fisher Building design was revised numerous times. At first, the tower was centered on the Grand Boulevard elevation—until it was moved east to the corner, to take advantage of that sight line up Second Avenue. While the building design was Art Deco, "it was inevitable that such an overpowering masonry mass, with its strong vertical emphasis and soaring silhouette, should [also] have suggested the Gothic," wrote Hawkins Ferry in *The Buildings of Detroit*. "Although the first studies indicated a flat roof," which would have dramatically altered the building's appearance, "there was an irresistible temptation to crown the building with a steep pyramidal roof characteristic of Gothic structures. This was ultimately done," Ferry added, "not without a weakening effect upon the design as a whole." He speculated that Kahn was likely influenced by two of Cass Gilbert's Gothic-crowned Manhattan buildings, the 1913 Woolworth and his 1926 New York Life Insurance Building, whose spectacular gold-leaf roof is one of the great illuminated landmarks on the Manhattan skyline at night. But the Fisher's pyramidal roof also bears a striking resemblance to a 1924 sketch Kahn made of a Gothic gate tower in Moret, France.

Another dissenter was art historian Sheldon Cheney, who sniffed that sloping roofs seldom correlated with "any of the outstanding new buildings" going up in the 1920s. "The immense New York Life Insurance Building has just been all but ruined by one," Cheney said, "and the monumental Fisher Building in Detroit is similarly softened, anti-climaxed. The boldness of the block forms is so much an asset, so clearly an appropriate machine-like element, that the sloping roof can only serve to weaken the effect—if not to make the whole as ridiculous as a naked man under a hat."[48] Most Detroiters would likely disagree. But it is undeniable that without the roof, the structure would be more

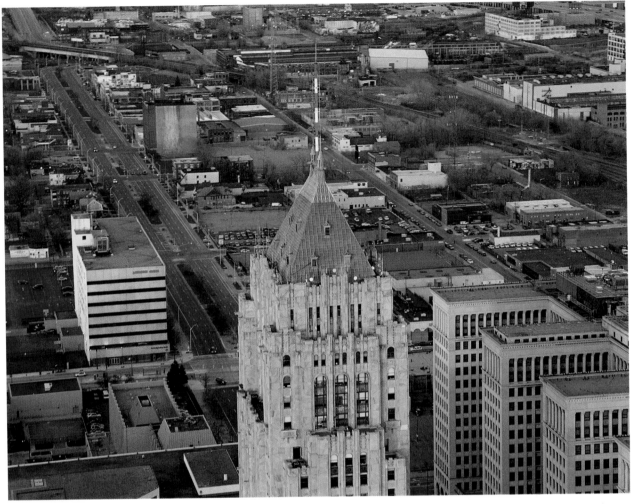

aggressively modern in appearance and its machined quality would be more obvious. By contrast, the National Park Service calls the Fisher "a superbly designed complex which displays some of the finest craftsmanship in any Art Deco style building constructed in the U.S. in the 1920s."[49]

The Fisher's 441-foot tower squares with Kahn's preference for solid, not to say squat, masculine structures. (Another good example, discussed later, is Burton Memorial Tower at the University of Michigan.) Ferry suggested that the Fisher Building embodied a reaction against "packing case" buildings with monotonous, largely flat façades that fell out of favor in the jazzed-up 1920s. "The problem of handling great facades with a multiplicity of windows [at the Fisher] was solved by breaking the planes into panels by recession of the wall surfaces," Ferry wrote. "The transition from the eleven-story wings of the Fisher Building to the twenty-eight story [sic] tower was gracefully accomplished

Looking east down Grand Boulevard at sunset, with artist Katie Craig's abstract *Illuminated Mural* visible just to the left of the Fisher Building antenna.

by a series of setbacks that produced a tapering effect," much of which he attributed to the influence of the 1922 *Chicago Tribune* submission by Kahn's friend Eliel Saarinen at Cranbrook.[50] "In the end," Hildebrand wrote, Kahn "preferred his General Motors Building across the street, but the Fisher Building is certainly an effective foil, and its massing and grand interior concourses are undeniably handsome."[51] The Fisher Building would be the architect's grandest, and one of his last, commercial skyscrapers.

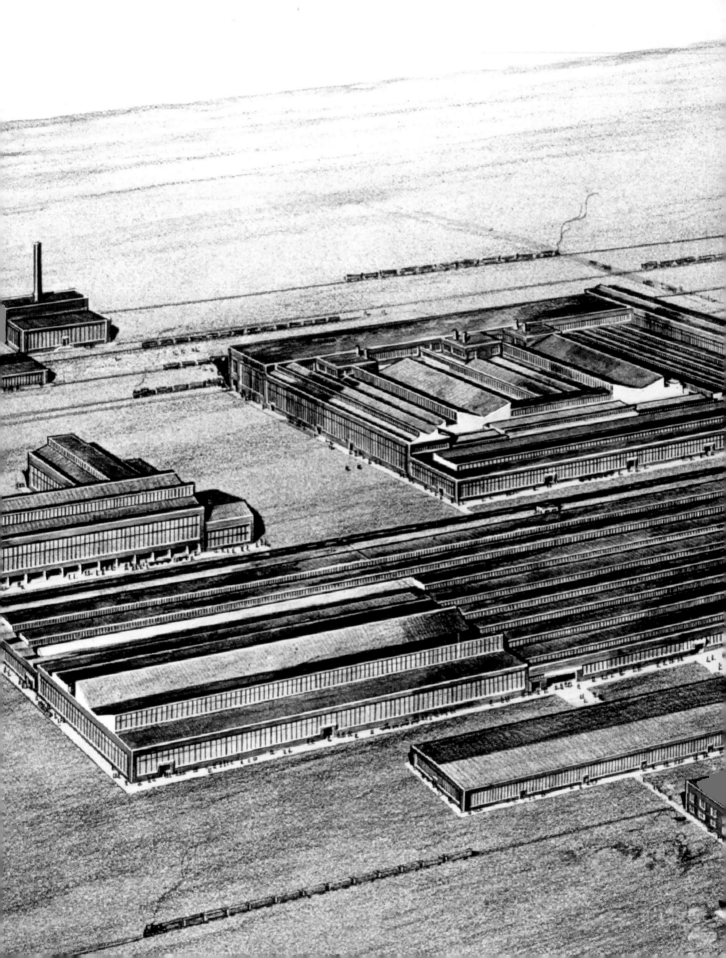

7

TO MOSCOW AND BACK

Albert Kahn's affinity for the lucky break persisted even in a period when many Americans lost theirs for good—the Great Depression. Six months before the market crash on Black Tuesday, Kahn signed a significant European contract that would go a long way toward cushioning the firm from the downturn, at least for the first years of the crisis.[1]

The client was a surprising one—the Union of Soviet Socialist Republics, a rogue state the United States still didn't recognize. The Soviets had sent a team to investigate American industry in 1926, and members were duly impressed with Kahn's work on the massive Ford Rouge complex as well as factories for Packard Motor, Hudson, and other car companies. They also took note of his company's $200 million in World War I construction contracts with the U.S. government. It must have come as a considerable surprise when Kahn first heard that the Soviet foreign-trade company Amtorg was interested in doing business with him. In New York, Kahn met Amtorg chairman Saul G. Bron, who'd apparently invited the famous Detroit architect to stop by for a chat the next time he was in the city.

Sonia Melnikova-Raich, who has done the most penetrating research on this and wrote two papers on the subject for *Industrial Archeology*, noted, "Kahn's trip resulted in his firm being offered a contract for the design of a $4 million [$57 million in 2017] tractor plant outside Stalingrad, which, as it was described to Kahn, was only part of a subsequent building mega-project worth billions."[2] The University of Michigan's Anatole Senkevitch Jr. called the deal, with no hyperbole, "one of the more extraordinary commissions ever given an architect."[3] The day after signing the

contract in May 1929, Kahn gave the agreement a patriotic spin: "The [Soviet] commission simply found that in this country we were producing the best products by the use of the best methods and best machinery. It seems to me to be a fair compliment to American manufacturing."[4]

Kahn was hired later that year as consulting architect to oversee and advise on the entire Soviet industrialization project, becoming a key pillar (or "cog," as the *Christian Science Monitor* had it) in the first Five-Year Plan.[5] The Soviets agreed to pay the American firm $250,000 a year (about $3.6 million in 2017), plus average annual salaries of $10,000 ($143,000) to the Americans who worked in the Moscow office established for this purpose by the state agency Gosproekstroi. The U.S. contingent, which was comprised of twenty-five men from the Detroit office (and their wives), was headed by Kahn's younger brother Moritz. Albert Kahn himself visited the Soviet Union only a few times, and briefly in each case.[6]

Over the next two years Albert Kahn, Inc., designed and built over five hundred factories (the exact number is disputed) on both the European and Asian sides of the Ural Mountains.[7] Almost single-handedly, the Detroit firm created the industrial backbone of the new Soviet state, including three colossal tractor factories, at Stalingrad, Kharkov, and Chelyabinsk. By the late 1930s, all that productive capacity switched over to wartime production and would play an "indispensable role" in the Soviets' ability to hold off the 1941–44 Nazi invasion.[8] (The Soviets faced three-quarters of Hitler's army and therefore are thought by most historians to have been the single most important factor in defeating the Nazis.) Thus, in a marvelous irony, a German-Jewish immigrant in Detroit helped cement Hitler's doom.

Initially, however, Kahn was reluctant to take the "dream job."[9] American economic prospects in late 1928, one year before the stock market crash, looked rosy, and the firm was awash with contracts. Kahn had any number of other reasons for concern, not least the deep antipathy most Americans felt for communism. He was understandably apprehensive about doing business with a government Washington had yet to recognize, and

Albert Kahn signs on as consulting architect to the Kremlin's first Five-Year Plan in January 1930. Signing as well is the Soviet representative, Saul G. Bron. Contemplatively gripping his cigar in the back row is Moritz Kahn, who would head up the firm's Moscow operation.

Albert Kahn Associates

saw particular risk for a Jewish architect in taking on the project. "The enemies of my people echoed what the Nazis were saying, and accused the Jews of fostering Communism," he told *Free Press* reporter Malcolm Bingay. "I wondered what would be said if I took the job. And yet the challenge fascinated me." Deep down, Kahn felt the Russian people deserved a leg up after "all their suffering under the czars."[10] In another interview, he told the *Detroit Times* he was approaching the task "like a doctor approaching his patient."[11]

Henry Ford called Kahn the minute he saw the headlines in the morning Detroit papers—a call that panicked the architect, given that this Jew had just implicitly linked arms with communists. "I knew that [Ford] had once had a prejudice against the Jews," Kahn said with impressive tact. "He wanted to know if it were true that I had taken such a commission. I said yes. I thought that he might then tell me that he and I had reached a parting of the ways. Instead he said, 'That's fine, Mr. Kahn. I want to do all I can to help. You are in touch with these people and I am not. Can you come out this morning and talk it over with me?'"[12] It was a significant about-face. Just two years before, Ford had turned down an offer to purchase a concession and build the very tractor plant in Stalingrad Kahn would end up designing, for fear the Soviets would eventually nationalize it as they'd done in the early 1920s with most foreign enterprises.[13] (It's important to note that Kahn put up no money in the vast Soviet project. The Soviet government hired him—he was not an investor.)

Ford's offer to do whatever he could to help is a good example of the contradictions that confound assumptions about the man. The auto magnate told the *New York Times* the Soviets could have anything they wanted: "our designs, our methods, our steel specifications. The more industry we create," he added with capitalist verve, "no matter where it may be in the world, the more all the people of all the world will benefit. The more industry there is in America or Russia or India, the more comfort and the more profit there will be for everyone, including us."[14]

The famous pacifist who commissioned a "Peace Ship" in 1915 to end World War I put a millennial gloss on his enthusiasm for helping the Russians. "World peace for generations to come depends on the stabilization of the Russian people and their being made self-sufficient by their own industries and farms. If Russia can be put on its feet," Ford said, "and everybody given a chance to work and develop, there may come a time when there will be no more war. Peace will surely come when there are no longer backward people exploited by others." In another elegant display of good timing, two weeks

before the October 29 stock market crash, Ford inked a contract to provide technical assistance in the construction of the Nizhni Novgorod automobile factory, for which he was paid. (The contract also involved Soviet purchase of Ford tractor parts.) Kahn and Ford were not alone in doing business with the Kremlin. Other American firms that followed included General Electric and International Harvester.[15] For its part, the Ford Motor Company had already given the Soviet state and its budding industry unintentional assistance. In 1929 Charles Sorensen, Ford's production director, was astonished to discover workers at a Soviet-built tractor plant in Leningrad assembling a carbon copy of Ford's Fordson tractor, a design they'd stolen and worshipfully replicated.[16]

Kahn's contract for the Stalingrad plant was national news, reported in both the *New York Times* and *Time*. From New York, his old mentor George Mason wrote to congratulate his protégé. "Your remarkable initiative has made possible your connection with the great Russian Enterprise," the seventy-three-year-old said, "and I tender my sincere congratulations for the joy you and your brothers must naturally feel at the result. I can also imagine," Mason added knowingly, "the intensity of the mental strain that must be the price of acceptance. Your work now extends from Coast to Coast and now that you have entered Russia, only the Pacific Ocean remains to conquer."[17]

Strain there doubtless was, but all the same Kahn's men produced quick results. Seven weeks after the Amtorg papers were signed, the first construction engineers arrived in Moscow with drawings for a half dozen buildings. Those included a 1,340-by-315-foot assembly building that the *New York Times* noted was as large as any U.S. Ford plant, as well as a foundry and forge.[18] Complete plans were delivered six weeks later.[19] An Amtorg newsletter praised the firm for its speed, but workers in Stalingrad—perhaps reflecting the triumph of Soviet ideology over practicality—denounced the eighteen-month timetable Kahn initially laid out to complete the tractor complex. The Soviet *Industrial Gazette* claimed that workers at Tractorstroy, as the yet-to-be-built complex was called, were outraged at this "inexplicable delay," charging that both steel construction in the United States and shipment to Stalingrad (renamed Volgograd in the 1950s) could be significantly accelerated.[20] There's no indication this affected Kahn's pace, but as it happened, the main Stalingrad buildings were completed within six months.[21] (One imagines a fair bit of guesswork went into estimating how long construction in a notoriously primitive economy would take.) This apparent grassroots demand by workers for stepped-up production—or greater "tempo," to use the popular Soviet slogan of the day—made some sense. Workers were reportedly concerned to finish as much construc-

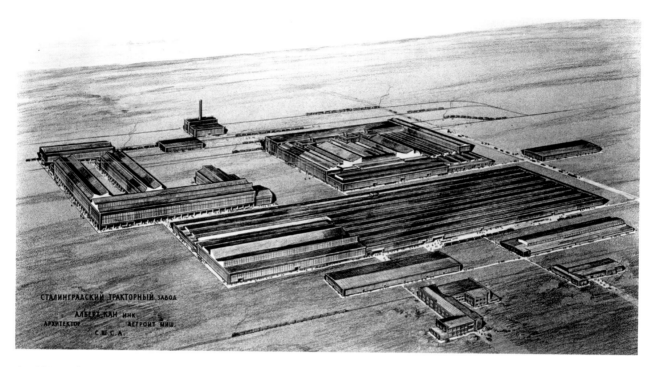

СТАЛИНГРАДСКИЙ ТРАКТОРНЫЙ ЗАВОД
АЛЬБЕРТ КАН ИНК
АРХИТЕКТОР ДЕТРОИТ МИШ.
С.Ш.С.А.

A 1929 rendering of the Stalingrad Tractor Plant, one of three huge tractor factories the Kahn firm would design in Russia. Conditions in Russia at the time were so primitive that camels were used to move factory components, all produced in the United States and shipped overseas, from port to construction site.

Albert Kahn Associates

tion as possible before winter. But the demands also reflect the political grip on industrial production that frequently characterized Soviet economic management; rhetoric often didn't square with reality. For example, at the sixteenth Party Congress in 1930, Stalin demanded that 170,000 tractors be built in 1932. The actual number would turn out to be 48,900.[22]

On top of their daytime duties, the twenty-five Americans on the Kahn staff in Moscow took on the task of bringing Soviet workers, engineers, and specialists up to speed with evening classes. By 1931, the office had trained twenty-five hundred Soviets, a number that rose to four thousand by the time the Kahn firm left Russia for good a year later.[23] There was some friction. Russian architects and engineers were often better educated than the Kahn men, at least in formal academic terms, but relatively unschooled in practical application. And Kahn operations were always, it cannot be said too often, rigorously practical. All the same, the results speak for themselves: by the end of the first year, Kahn employees in Detroit and Moscow had designed buildings worth well over $200 million (almost $2.9 billion in 2017).[24]

The conditions under which the Americans had to work were challenging and, on occasion, wretched. Typhus swept through Stalingrad in the winter of 1929–30, and the housing provided for the Detroiters, like most Soviet housing at the time, was substandard and often without heat—also the case from time to time in the Kahn Moscow

office. Then there were the inadequate local resources the firm had at its disposal. In material terms, the USSR had few factories and lacked the very implements, like pencils and drafting boards, needed to design them. In 1930 there was but one blueprint machine in all of Moscow. "Not only did the plants have to be designed," Kahn told the Detroit Bohemian Club in 1930, "but machinery had to be selected and ordered, process layouts had to be prepared, and the very tools needed to build the plants had to be ordered here and shipped over."[25] Shortages of vital materials were chronic, and the nation's rickety transport system was hopelessly overwhelmed. The firm designed and built short rail lines, but construction crews still had to resort to horses and camels to help move materials from the docks. John K. Calder, a supervising engineer, oversaw progress while swaying around the Stalingrad site from high atop a dromedary's back.[26] (Kahn's son, Edgar, accompanied his uncle Moritz to Moscow in the fall of 1929 and stayed for about a month. "Although the food was poor," Edgar wrote fifty years later, "the fresh caviar was marvelous.")[27]

The Stalingrad plant, the first in the country to employ standardized construction and sawtooth skylights, was just one of three Kahn-constructed Soviet tractor complexes that would eventually churn out tanks and munitions in steadily mounting numbers as the war approached. The remarkable window space typical of Kahn's factories in the United States afforded a quality of light "reminiscent of a painter's studio, a rather unusual aspect in the Soviet landscape."[28] The other tractor giants were at Kharkov in European Russia, west of the Urals, and Chelyabinsk, strategically located on the far east side of the mountains. Both of these initially produced copies of the International Harvester 15-30 tractor. The Chelyabinsk plant would end up dwarfing its cousins, sprawling over more than 2,471 acres and comprising 1,780,000 square feet of covered floor. The assembly building alone was stupendous—1,500 by 650 feet and four stories tall.[29]

Still, there was a perplexing mystery. In building the plants, Soviet officials insisted on what seemed like pointlessly strong foundations and extra steel reinforcement throughout. Kahn was baffled. "I thought the Russians were all crazy," he said, and told his hosts such excess wasn't necessary. "They smilingly told me that I did not know about their weather, that it got awfully cold in Russia. I told my brother Moritz, who was with me in Moscow, that they were insane. How could the weather no matter how cold, affect our buildings?" But the younger brother understood the Soviets' true

KEY OF MATERIALS

AMTORG TRADING CORPORATION
ASSEMBLY BUILDING
STALINGRAD TRACTOR PLANT
STALINGRAD U.S.S.R.

ALBERT KAHN INC.
ARCHITECTS
DETROIT MICHIGAN U.S.A.

Plans for the Stalingrad Tractor Plant. Amtorg was the Soviet trading entity that hired Albert Kahn Associates.

Albert Kahn Associates

purpose. "These people are not crazy," Moritz said. "They are building war production plants and do not want us to know about it."[30] Indeed they were. To take just one example—from 1939 to 1945, Chelyabinsk contributed 18,000 tanks, 485,000 diesel engines, and over 17 million units of ammunition to the anti-Nazi struggle.[31]

The Kahn firm's involvement in the Soviet Union came to an abrupt halt early in 1932. "Soviet Loses One of Its Chief Cogs in Five-Year Plan," the March 29 *Christian Science Monitor* headlined, reporting that the two sides could not agree on payments for future work. The Kremlin raised almost all its foreign currency through the sale of wheat, chiefly Ukrainian. But a disastrous harvest in 1931 gutted grain production by 17 percent and sent national finances into a skid. Millions of Ukrainians, suffering under forced farm collectivization and government seizure of their harvest, died of starvation in 1932–33.[32] "The Soviet Government is short of gold and willing to pay us in Russian roubles," Moritz told the *Monitor*. But, he added, "The Soviet currency is not exchangeable in the West and hence is practically worthless to us." The firm acted with its usual dispatch. All Kahn personnel were out of the country within two weeks. Soviet citizens who'd been working in Detroit also went home (returning to fates that would be appallingly different from those awaiting the Americans). Despite the contractual

rupture, however, Moritz insisted that the firm and the Soviet government still enjoyed "the most friendly relations."[33]

No Detroiter could have known, but 1932 turned out to be an auspicious time to get out, as Moscow started its slide into the lunacy of the Stalin purges and the 1936–38 show trials. Hardest hit were those specialists who'd worked abroad or had significant exposure to foreigners—a deadly contagion that would doom tens of thousands, including many, perhaps most, of the more than four thousand workers the Kahn firm had trained in Russia as well as the Soviet citizens who had worked in Detroit.[34]

Newspapers such as *Toward Industrialization* (*Za industrializatsiiu*) carried articles frankly discussing the extent of the American contribution in the early 1930s—a candidness that would in a few short years morph into a capital crime. Stalin's willingness to seek out Western know-how and investment vanished down a wormhole, with paranoid nationalism and angry xenophobia taking its place. The new mantra, "national industrial patriotism," permitted no acknowledgment that the country's industrial spine had been built in large part by foreigners, much less by Americans. In a sneering response to a 1938 *Architectural Forum* issue devoted to Kahn's industrial work, *Architecture in the USSR* wrote, "There has never been any 'affiliate' of Albert Kahn's firm in Moscow. A group of American engineers was indeed invited in 1928 to Moscow under an agreement with Gorstroiproekt [*sic*] and their activity was strictly limited to technical assistance. . . . Soviet engineers, architects, and workers, inspired by the heroic ideals of Socialism, have themselves created plants which overshadow the best industrial facilities in the USA, and by doing so damaged the commerce of Mr. Kahn, for whom architecture is ninety percent business."[35]

In the wake of this shift came the bloodletting and executions. Disappointing progress under the second Five-Year Plan, 1933–37, was hung around the necks of "spies, wreckers and saboteurs," mostly citizens who'd had contact with outsiders. The show trials that ensued decimated the top ranks of Soviet government as well as unfortunates far down the food chain. In that respect, the dragnet was impressively egalitarian, as befits a communist state. At the Ford-built Gorky automotive complex, 407 specialists were arrested in the first six months of 1938. "It was not a coincidence that so many 'wreckers' and 'spies' were found at the plant which was built with the help of foreign experts," noted Melnikova-Raich, "and where most of the engineers and skilled workers went through training abroad." Tragically, what in 1929 must have looked like a once-in-a-lifetime opportunity—a chance to come to Detroit, the capital of the

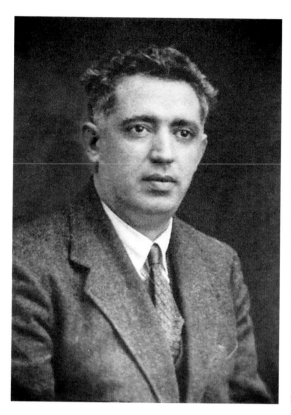

Saul G. Bron in the late 1920s.

Courtesy of Sonia Melnikova-Raich

industrial world!—turned into a millstone that dragged most of the Russians under. "Virtually every Soviet engineer who had any connection with Detroit," Melnikova-Raich wrote, "was arrested, [and] most of them were accused of espionage." Once accused of espionage, you seldom escaped the bullet in the back of the neck.[36]

It's hard to fathom how this hit the Kahn brothers, who'd entered the Soviet venture with such idealistic hopes. We know from their public comments that they saw the enterprise in moral as well as business terms. To then learn that people who had, in some cases, become your friends were killed because of their contact with you had to have shocked and nauseated—if, of course, cause and effect were as visible in 1937 as they are today. That's not entirely clear. It's also worth noting that the political stain of foreign contact applied to contact with *all* Western firms selling technical assistance in those years, not just the Kahns. All the same, the evidence suggests Albert and Moritz may have had some inkling of what was happening. Family biographer Brashear reported that in the mid-1930s Kahn, "who had never felt comfortable with his Russian project and had always harbored a strong distaste for the communist ideology, was now troubled. In conversations with his wife and children, he revealed serious doubts if not regrets, about his work there."[37] In terms of the purges, the Kahns probably got word of the disappearance in 1937 of Saul G. Bron, the Amtorg chairman who first got the ball rolling with Kahn in 1928, which was widely reported in the West. The *New York Times* gave it a terse headline: "Red Leaders Feared Victims of Clean-up."[38] On April 21, 1938, Bron was tried, sentenced, and shot by firing squad—all in one day. The former trade executive was just one link in an endlessly lengthening chain of state-sanctioned murders. In the four months before his disappearance, 704 Soviet citizens were executed for treason. Bron was buried in a mass grave outside Moscow. The purges commonly dragged down relatives of the condemned as well, and Bron's wife died in a Kazakhstan labor camp for wives of "enemies of the people."[39]

It's easy to explain the purges as the product of one dictator's vaulting psychoses, but there was an ugly logic underpinning the slaughter tied to questions of leg-

acy and the historical record, obsessive concerns in the Stalinist dictatorship. Eliminating those who'd worked with Kahn and other Western companies, wrote Melnikova-Raich, was necessary "to conceal the truth about the origins of the early stages of accelerated industrialization in the USSR, which was supposed to go into history as an unparalleled achievement of the brilliant genius of the 'great architect of Communism,' Comrade Stalin."[40]

Interestingly, even in the twenty-first century, Melnikova-Raich reported, the whole question of American contributions to the first Five-Year Plan is still largely unexplored territory in Russia.[41] This is the case despite Nikita Khrushchev's official rehabilitation of Bron and thousands of other victims of Stalin's terror after the Twentieth Party Congress in 1956.

From an American viewpoint, there was always implicit danger in doing business with capitalism's sworn enemies, depending on which way the political winds at home blew. But in 1929, at least, "the American press chose to portray Albert Kahn as a genius who knew how to conquer faraway lands."[42] *Time* ran a short profile the week after the Soviet contract was first signed under the headline "Great Kahn," contributing to the hagiographic treatment of the architect and his work habits: "At [the] office at eight, he often leaves at seven. During working hours, his coat is always off, his hair is always mussed."[43] One thing is certain: had there been enemies waiting to pounce on the Kahns, they could have found much to exploit in politically guileless comments the brothers made before and after their Soviet adventure. On his return from Moscow in July 1930, Moritz Kahn declared that rumors of anti-Christian persecution and desecration of churches were false, and that stories of Soviet citizens being kidnapped abroad and spirited back to Russia to be murdered were "absolutely untrue." (One wants to ask, "How could you possibly know?") Moritz also blamed the continuing U.S. economic slowdown on Washington's lack of diplomatic relations with Moscow, which, he said, gave other governments, like London—which had recognized the USSR—a rich opportunity to capitalize on Soviet trade.[44]

There was blowback, though apparently not right in Detroit. The *Washington Post* ran a long story in March 1930 detailing Amtorg's activities as what it called "an active propagandist agency for the Communist movement." The article conceded that the quasi-public corporation had spent $75 million on American equipment the year before, but charged that among the "several thousand" Soviet engineers brought over for instruction in the assembly and use of the machines were "highly trained

propagandists, whose business it is to plant the seeds of Communism in every factory they visit."[45] More alarming, in September, a few months after Moritz's interview with the *Monitor*, a "former vice-president of the Amtorg Trading Corporation" told the special congressional committee investigating "red influence" that the Russian company's agents had spied on U.S. defense installations and transmitted coded data to Moscow. But the Fish Committee hearing made no mention of Kahn, Ford, or other American industrialists who had recently undertaken significant projects in the USSR.[46]

The night before the Kahn men and their wives set off for Moscow in 1930, a reporter caught the architect as he was leaving the party held in the group's honor at the Bonstelle Theatre in Detroit (originally Kahn's 1903 Temple Beth El). When the journalist asked Kahn what he thought of Russia and communism, he replied that he knew nothing of politics and was approaching the challenge like a medical doctor. "The next afternoon, the headline read: 'Albert Kahn Denies He Is a Bolshevik.' Father was angry," Edgar Kahn wrote. "He phoned the city editor, whom he knew, and protested. The editor said the reporter was a damn fool and he would straighten things out." The paper, never identified, ran a correction the next day that probably only made things worse: "Albert Kahn Denies He Said He Was Not a Bolshevik."[47]

The story didn't have legs, however, and went no farther. Then, in 1931, seemingly out of nowhere, the *Border Cities Star* (now the *Windsor Star*), a daily across the Detroit River in Windsor, Ontario, ran a story quoting a Kahn engineer who denounced the firm's involvement in the Five-Year Plan. Not only did William H. Bruss predict Soviet factories would quickly turn to munitions manufacture—in the early 1930s not a comforting prospect for most Americans—he also charged that the contract Kahn signed with Amtorg "included a clause regarding the promotion of Communism in the United States." The firm responded immediately with what Bucci called a "strongly worded letter from Moritz Kahn denying everything," which the *Star* printed four days after the initial attack.[48] Melnikova-Raich was eventually able to track down the original Amtorg contract—no small accomplishment—and found there's no such clause anywhere in the document.[49] (Interestingly, during World War I when the Kahn firm built numerous army and navy bases for the U.S. government, the architect's wartime military superior, Colonel Goodloe Edgar, received a letter accusing the German-born Kahn of being a German spy. Such was Kahn's standing with the military brass, or at least those in Detroit, that Edgar gave the architect the letter and told him to do what he liked with it. It turned out to be from a disgruntled former employee.)[50]

Luckily for the Kahn brothers, the matter appears to have stopped there. No mention of the issue was made in either the *Detroit Free Press* or the *Detroit News*. The latter was the conservative paper in town, and thus the one most likely to take umbrage at communist collusion. But its publisher, George G. Booth, was Kahn's longtime friend and client. The architect had built Booth's home at Cranbrook and his *Detroit News* headquarters. Whether those connections explain the *News*' refusal to pick up the *Star* story and run with it is impossible to judge. One is almost inclined, once again, to characterize this as yet another example of Albert Kahn's inexhaustible good luck.

8

DIEGO RIVERA AND
DETROIT INDUSTRY

Albert Kahn sailed home in April 1932 after the Russian negotiations collapsed. "My visit to Moscow I'm sorry to say proved useless," he wrote his youngest child Rosalie on SS *Albert Balliu* stationery. "We did not come to an arrangement. I was sorry for I would have liked a new contract but the terms they offered I could not accept." Kahn was not the only crestfallen American on board. The architect ran into three other businessmen returning from Moscow "who also failed in arranging a new contract, and we have had some interesting talks together. Russia is considerably pressed for want of gold," he added. "They would pay us any number of rubles but what use would they be?"[1]

In the same letter, Kahn also described a return to his childhood home in Luxembourg—the first he'd made since his family left for the United States in 1881. "Everything looked just as it used to and I had a most enjoyable 3 or 4 hours there," he wrote. "Queer how I could remember everything and every place, and queerer still the strange feeling in again trodding the old streets and visiting the old haunts." Indeed, oddness colors much in this homecoming. The Detroiter paid a visit to a café in what had once been an uncle's house. But when relatives still living there recognized him, Kahn refused to acknowledge who he was. "The entire household came to the door and windows to gape at me," he wrote, "but I paid no attention. When I asked why they were looking us over so completely, the [waitress]—rather pretty—explained to me that her Father had seen me in the morning and told them all he was sure I was a cousin of theirs from America. I confessed complete ignorance. Then came the Father, who looked me over some more, asked me some questions, whether I was from Detroit

whether my name wasn't Kahn, etc., etc. I told him he must be on the wrong track. He seemed much perplexed and very skeptical. I didn't want a scene, therefore didn't let on."[2]

Kahn and his chauffeur took their time with their coffee. "Time and again the Father and Mother both shook their heads," he wrote. "How could two people look so much alike? Evidently they had pictures of me, for surely they could not know me otherwise, since the Father was only about eight when I left. He is the one to whom I played nursemaid for several years," Kahn wrote, perhaps signaling some of what lay behind his peculiar reaction, "and for whom I was made to suffer considerably—for not perhaps taking care of him etc., dropping him out of his go cart once, and doing other things of the same kind. Well, I had a wonderful time there, but I went away without setting them straight. To do otherwise would have meant spending considerable time," he added, "which I didn't care to do."[3] No word on whether the relatives felt snookered.

On returning to Detroit, Kahn stepped off the train in the hulking Michigan Central Station just days before the Mexican giant Diego Rivera alighted on the same platform. The world-famous muralist, accompanied by his diminutive wife Frida Kahlo, was fresh from a solo show the year before at the Museum of Modern Art in Manhattan and was in the Motor City at the behest of Dr. Wilhelm Valentiner, the first director of the Detroit Institute of Arts (DIA), who assembled the core of its remarkable collection. Valentiner invited Rivera to paint two large murals in the museum's Garden Court touching on "something out of the history of Detroit." The commission was $10,000 (that would ultimately rise to $20,889), to be paid by the DIA's most significant patron and one of the few Detroiters still flush with cash in 1932, Ford Motor Company president and Henry's only child, Edsel Ford.[4]

Kahn, Rivera, and Kahlo found themselves in a city besieged by accelerating financial collapse. Edsel Ford's bank, the Union Guardian Trust, wouldn't fail until early the next year—an event that brought the full force of the Depression slamming down upon the city—but the Ford Motor Company had already slashed its workforce by half.[5] On March 7, a crowd of unemployed workers estimated by the local press at two thousand (recent accounts generally double the number) braved tear gas and freezing water from fire hoses to march on the Kahn-designed Ford Rouge complex, demanding relief. Rivera, a lifelong communist hoping to get back in the good graces of the Mexican Communist Party, had wanted to attend the demonstration, publicized in advance, but couldn't get to Michigan in time.[6] The peaceful protest degenerated into

Wilhelm Valentiner, the first director of the Detroit Institute of Arts.

what the *Detroit Free Press* described as "a fatal riot," though the violence seems to have principally been on the company's side. Four young men were shot dead on the spot by Dearborn police and Ford security guards, while a fifth later died in the hospital.[7]

Valentiner had experienced some difficulty the year before persuading the Detroit Arts Commission to approve the Rivera murals for the city-owned museum. In a 1931 letter to Rivera's chief assistant, the Berlin-born Valentiner complained, "Please assure Mr. Rivera that I am doing all I can to get the Arts Commission here interested in his work, as nothing would give me more pleasure than to have some work done by him in town. But I must confess that from conversations which I have had with several of the most influential people in town, I find that the difficulties are great in this respect, partly on account of the entire lack of understanding of modern art, and partly for political reasons."[8]

All this was brewing as Kahn sailed back to New York, with no way of knowing he was about to trade one communist vexation in Moscow for another in Detroit. Not only were Rivera's politics highly suspect, he'd already painted a Mexico City mural that cast Henry Ford in the role of devouring capitalist. In the Ministry of Education panel *The Billionaires*, Ford whoops it up with other captains of industry, glass of champagne in hand. (One wonders how Ford, famously a teetotaler, reacted.)[9] For his part, Valentiner wanted commission approval fast, fearing a bidding war was about to erupt among top U.S. industrialists for the Mexican's services. He already knew the Rockefellers were bent on a Rivera mural for their RCA Building in the new Rockefeller Center (a work of art that would suffer a dramatically different fate from Detroit's). To gin up enthusiasm among the arts commissioners, who also included Charles T. Fisher, founder of Fisher Body Company, DIA patron Julius H. Haass and, most significantly, Edsel Ford, Valentiner mounted an exhibition of the Mexican muralist's watercolors at the museum early in 1931, shortly after the MOMA show closed. The DIA exhibit seems to have helped. In April, Valentiner wrote Rivera that the arts commissioners "would be pleased

if you could find something out of the history of Detroit, or some motif suggesting the development of industry in this town; but at the end," he concluded, "they decided to leave it entirely to you."[10]

Detroit Industry, a kaleidoscopic work celebrating autoworkers at the Ford Rouge complex, was engulfed in controversy from the get-go. Many Detroiters were leery of Rivera's communist sympathies, an apprehension that would bedevil DIA directors well into the 1950s. Others were outraged that in the midst of an economic crisis a sizable commission was going to a foreigner—and a radical at that. Of greatest concern to Kahn, however, may have been a letter he got late in 1932 from his friend Paul Philippe Cret—the French-born Philadelphia architect who designed the art institute. Four months before the murals' unveiling, a furious Cret wrote Kahn to say he'd only just learned about the project—from Rivera himself, as it happens. The University of Pennsylvania professor was exercised because he'd designed the central Garden Court, where the murals would go, as a reflective, semi-sacred space free of visual distraction apart from a few marble masques, terra-cotta roundels, and a stepped fountain with live fish and tropical vegetation. Just two paintings graced the soothing off-white walls—*The Dancers* by Arthur B. Davies and Maurice Prendergast's *Promenade*.[11]

In a December 19 letter "from one architect to another," Cret conceded that the Arts Commission could do whatever it pleased with its institute. But a work of architecture, Cret argued, is really no different than a painting or sculpture. Altering a significant element of a building "is like having a painting refinished by one other than the artist." It was hard for him to take this as anything other than a slap in the face. "If, for some reason, the attitude of the Commission toward me has altered since the time of the dedication," Cret wrote, "do you not think that I ought to have been given a chance to know about it?" He didn't want to make "an unnecessary fuss" about the affair, and he acknowledged Kahn's role in championing his appointment many years before. "Your very friendly support in the past is a matter of which I have always been proud," he wrote. All the same, Cret noted, "I can tell you that I feel that I did not deserve this kind of treatment."[12]

Kahn was stung, and just after Christmas wrote institute director Valentiner, who was on unpaid leave in Europe (in large part to save the museum his salary during the economic collapse). "I am very much afraid that we erred in not keeping Mr. Cret advised of what was to be done," Kahn wrote. "I had a letter from him a few days

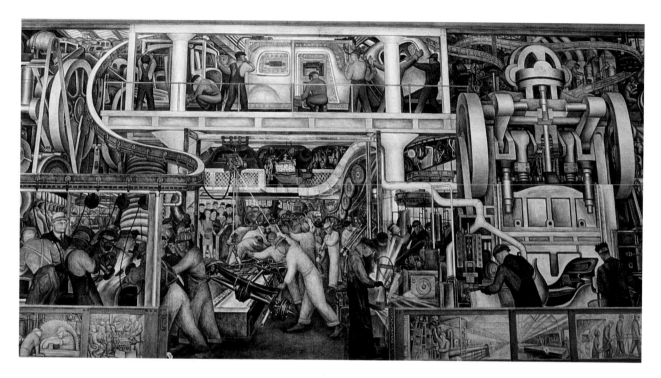

Rivera's mural on the south wall seems to present life at the Rouge as it really was—blank-faced men, all white; a mean-faced overseer at left; and the leering bourgeoisie (*center left*) looking down from an observation platform as if at a zoo.

ago. . . . It is not altogether pleasant reading. The mean part is, I felt it quite justifiable, and what is more, myself partly to blame."[13]

With Edsel Ford as his patron, Rivera was given extraordinary access to the Rouge complex, which at the time was the world's largest industrial conurbation. By 1932, the Rouge had grown into a vast, all-inclusive industrial city—a startling concentration of industrial forms. Chief among the wonders were Kahn's dramatic 1925 Open Hearth Building and the 1923 Glass Plant, a sculptural, almost futuristic design, as noted previously, set off by four freestanding smokestacks in a row like classical columns. Rivera was not the only artist mesmerized by this stupefying landscape. A couple years before Rivera's arrival, New York artist and photographer Charles Sheeler shot the complex and created his iconic paintings *American Landscape* and *Classic Landscape*, both vistas defined by the raw geometry of Kahn's industrial design.

The *Detroit Industry* murals were completed March 13, 1933. Rivera and Kahlo decamped for New York the next day. Kahlo couldn't wait to ditch what she derided as Detroit's pokiness for the glamour of New York. Three days after their departure, a group of clergymen was invited to scrutinize the murals by a public relations official volunteering at the institute, George Pierrot, who, it would turn out, had a card or two up his sleeve. (Pierrot is well known to Detroiters of a certain age. In the 1960s he hosted a long-running adventure travel show on local television.)

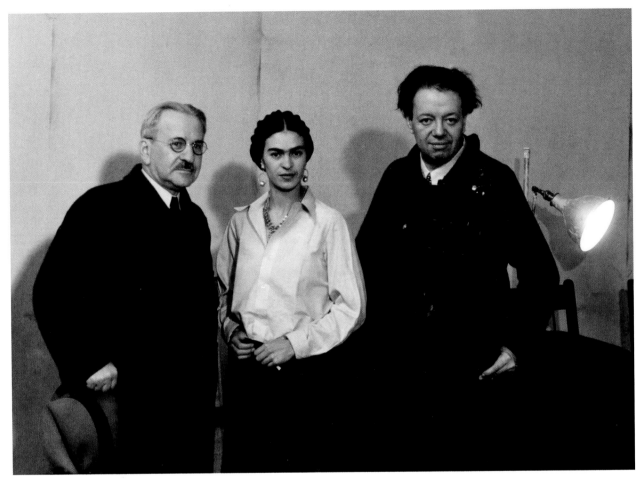

The assault on the murals began in earnest after the good men of the cloth had their peek. The Reverend H. Ralph Higgins, senior curate at St. Paul's Episcopal Cathedral, charged on March 17 that the *Vaccination Panel*, which invoked Renaissance depictions of the Holy Family, was a "caricature" bordering on blasphemy. The *Detroit News* lost no time in denouncing the murals as "un-American" and, astonishing to contemporary ears, "a slander to Detroit workingmen."[14] The newspaper called for the murals to be whitewashed, an idea subsequently taken up by city councilman William P. Bradley.[15] In his "Good Morning" column in the *Detroit Free Press* on March 23, two days after the official unveiling, Bingay accused Rivera of sneering at Detroit, pointing to the artist's foreignness as explanation: "He is not indigenous to the soil of Detroit. He cannot understand the soul aspirations of our people—he can hardly speak our language."[16] The president of Detroit's Marygrove College, Dr. George Hermann Derry, a member of the "committee of eight" opponents led by the Reverend Higgins, told the *Free Press*, "Señor Rivera has perpetrated a heartless hoax on his employer, Mr. Edsel Ford."[17] The

Albert Kahn with Frida Kahlo and Diego Rivera in 1932.

Diego Rivera's *Vaccination Panel*, part of the multipanel *Detroit Industry*, enraged local clergy for mimicking Renaissance depictions of the Holy Family.

controversy over the murals would have a long shelf life. As late as 1952, when Rivera's communist beliefs were yet again in the news, the *Free Press* worked itself into a lather over "decadent art."[18]

The public got its first glimpse on Tuesday, March 21, and as word ricocheted across town, it generated a veritable stampede to a museum that, up till then, had seen distinctly lackluster attendance. Newspapers reported that ten thousand visitors mobbed the court on the first Saturday after the murals' debut. "To many of the museum's regular visitors," wrote DIA curator Linda Bank Downs in 1999, "it was a shock to see the grimy inside of the factories so dramatically represented in the middle of their elegant temple of art. To automobile workers, who had never seen themselves depicted in a cultural institution of the city," she added, "it was a revelation."[19]

With demands for destroying the murals rising, the first voice of any consequence to defend them was that of arts commissioner Albert Kahn, who launched a blistering attack on opponents in the *Detroit News* the day after the opening. "This whole controversy is silly," Kahn said, employing the astringent tone he often used when confronted with patent foolishness. "The critics of Rivera's frescoes are simply showing themselves to be provincial and narrow-minded. The storm of criticism, and the quarters from which it is coming, is another proof of the power and originality of the work." Interestingly, Kahn wasn't afraid to tackle religious critics, mostly Christian, head-on. "Some ministers have become excited because they see in one panel what they call a caricature of the Holy Family. I do not see how anybody could find fault with that panel," he said, and then proceeded to scold the complainers: "The world has seen many examples of religious fanaticism, and always the Church has lived to be ashamed of such manifestations."[20]

In any case, the architect noted, great work is often slighted when it first appears. "If I am any prophet," Kahn said, in a prediction that turned out to be uncannily accurate, "the Detroit Institute of Arts, because of these Rivera murals, will become a sanctuary for art lovers the world over."[21] Despite Kahn's prescience, the historical literature

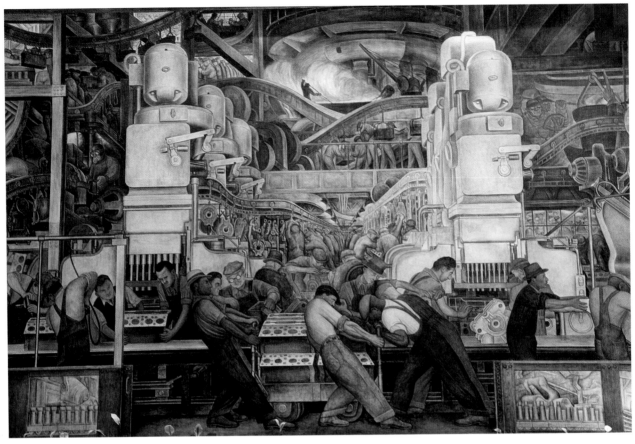

on the subject almost completely ignores his comments. Indeed, Robert Lacy asserted in *Ford: The Men and the Machine* that prior to Edsel Ford's statement endorsing the murals a month later, "[n]ot a single local public figure spoke up for the frescoes."[22]

Three weeks after Kahn's remarks, Edsel Ford told the *Detroit Times*, "I admire Rivera's spirit. I really believe he was trying to express his idea of the spirit of Detroit."[23] An unanswered question is whether Kahn's vocal defense influenced Ford's endorsement. For his part, Kahn makes no mention of it. But in the midst of a furious controversy, with the murals highly unpopular among Blue Book Detroit and much of the public at large, it's quite possible that Kahn's remarks stiffened the millionaire's spine. As Lacey noted, "Edsel Ford did not know how to stand up to his father, but to his eternal credit, he did know how to stand up to Detroit."[24] Once Ford spoke, that mostly settled the issue. Royal Oak's "radio priest" Father Charles Coughlin, a fascist sympathizer, tried to make hay out of the subject as the spring wore on, but got little traction. In May, a month after Ford's remarks, DIA assistant director E. P. Richardson wrote Valentiner to say that things had calmed down: "There are no signs of the revival of

Detail on the north wall of *Detroit Industry* at the Detroit Institute of Arts. Some say this amounts to Rivera's idealized vision of the Rouge—a rainbow coalition of men all pulling together in one great ennobling purpose.

hostility. At least," he added, in a reference to Coughlin, "the Hound of Heaven has not even yipped."[25]

Many years after Kahn's death, his daughter Lydia Winston Malbin told curator and author Linda Bank Downs that her father had been "ambivalent at best" about the sweeping changes to the Garden Court, and Kahn's actual remarks on the subject do suggest a complex view.[26] In correspondence with Valentiner, the architect complained that he didn't get the connection between the two large panels, with their epic depiction of the assembly line, and the smaller ones above and below them, adding, "More than ever do I personally object to the scale of the allegorical panels on top," referring to the reclining nudes representing the four races that crown the entire ensemble. "Saarinen and others whose judgment I value agree with me on these points," he wrote. All the same, Kahn praised Rivera's large north wall, the first to be completed. "It is turning out just as I expected," he wrote Valentiner, "perfectly magnificent, full of interest, of wonderful color, excellent in scale and thoroughly satisfactory in every way."[27]

Kahn's position on Rivera's work stands in sharp contrast to his feelings about other modernist artists, most of whom he dismissed with the same breezy contempt he applied to architectural rebels Gropius and Le Corbusier. And he could be scathing about modern architecture. In a 1928 speech to the Detroit Business Women's Club at the city's Hotel Statler, Kahn inveighed against European architects' romance with "the ultra-modern which, for mere novelty's sake, would with one fell swoop destroy all that has gone before." He went on, "I can understand this strange work no more than I can the paintings of Picasso, Utrillo and Matisse, to say nothing of the lesser lights who copy them."[28]

How is it that Picasso's modernism annoyed Kahn, while he generally admired Rivera's? One simple explanation might come down to Kahn's skills as a draftsman and freehand sketch artist. For all his stylized approach, Rivera still worked very much within the age-old framework of perspective and scale. Cubism, which violated all those rules, jarred Kahn. But Rivera painted a world Kahn recognized, and his impressive technique was something the architect, with his respect for craft, could easily admire.

Kahn's own artistic tastes generally ran to yesterday's revolutionaries—the Impressionists—whose early sufferings, before they were accepted by the artistic beau monde, he felt acutely. In a 1935 lecture at his home to members of the arty Torch Club, Kahn discussed Manet, Pissarro, Monet, Degas, Sisley, and Cassatt at length. On the walls around him as he spoke were paintings by three of the artists on the agenda—Sisley,

Degas, and Cassatt. Kahn dwelt on the scorn the Impressionists endured in their early years, especially Manet, whose classic *Le dejeuner sur l'herbe* was famously rejected by the 1863 Paris Salon. "It is difficult today to understand the violent objection to Manet's work," Kahn told his audience. "It differed from earlier work only in that it presented the everyday life colorfully and realistically, instead of somberly and with affectation." Then, in a comment that summed up his feelings about art as well as modernist architecture, he added, "Nor did [Manet] depart from the generally accepted *merely to be different or contrary*, but out of full conviction that what was being done [previously] was theatrical and artificial."[29]

"Reviled, sneered at, rejected and scorned," the architect said in conclusion, "as perhaps no other group of innovators had ever been before and probably never will be again, then accepted and admired . . . the question naturally arises: What of the modernists of today? Many contend that history is merely repeating itself. Personally," he added, one imagines with a smile, "I doubt it."[30]

Kahn's relationship with Rivera appears to have been a friendly one. The architect not only supported the *Detroit Industry* project throughout, he hosted Rivera and Kahlo for

Rivera assistant Clifford Wight, Jean Abbott Wight, Frida Kahlo, Diego Rivera, Ernestine Kahn, and Dr. Edgar Kahn pose at the Farm, the Kahns' summer house in what is now West Bloomfield. It was Edgar Kahn's thirty-second birthday.

Courtesy of Betsy Lehndorff

dinner at least once at his Mack Avenue mansion the summer they arrived. The Kahn family guest register lists Diego Rivera and "Freida" Rivera, an alternate spelling Kahlo apparently used for reasons that are unclear. (At a tea in her honor hosted by Clara Ford, Henry's wife, Kahlo played the provocateur, cheerfully dropping obscenities like "Shit on you!" into the conversation as if she was utterly unaware of what she was saying.)[31] Possible confirmation of a genuine friendship between the architect and artist might be found in what appears to be a portrait of Kahn—disguised as a cheerful assembly-line worker with glasses—on the north wall. Edgar's daughters certainly believe this. They also maintain that the scientist bending over the microscope in the famous *Vaccination Panel* is their father Edgar, the doctor who may have been called in when Kahlo had her medical crisis and miscarriage in July 1932. The daughters note the scientist has a widow's peak, just like their father. There is, to be sure, a resemblance.[32]

Albert Kahn also used his influence to get Rivera the commission for a mural in the General Motors Exhibit at the 1933–34 Century of Progress International Exposition in Chicago, which Rivera was to turn to after his work for the Rockefellers in New York.[33] The Rockefellers had commissioned *Man at the Crossroads* for the new RCA Building, which the artist wrapped up late in 1933. But when Rivera, desperate to be readmitted to the Mexican Communist Party (he was expelled in part because of his association with the rich and famous) inserted an admiring portrait of Vladimir Lenin into the mural—not in the preliminary sketch the Rockefellers approved—his patrons were outraged. The family had the mural covered with a tarp while they dithered over what to do next. Finally, they allowed the management company in charge of the Art Deco skyscraper complex to sledgehammer the fresco off the wall—an act of artistic vandalism that director Tim Robbins immortalized in his 1999 film, *Cradle Will Rock*.

The controversy quickly went viral. One immediate consequence of the New York flap was GM executives' abrupt cancellation of Rivera's contract for the upcoming World's Fair, a doleful message that fell to Kahn to deliver. Despite Kahn's earlier defense of Rivera, by the time the New York scandal erupted it seems the architect had had his fill of temperamental, self-promoting artists. And little wonder. "Mr. Kahn worked very hard to keep the General Motors contract for [Rivera]," DIA assistant director E. P. Richardson wrote Valentiner, "and even after the newspaper publicity he could have saved the situation if Rivera had supplied him with sketches to show to the General Motors executives. Rivera, however, simply ignored Kahn's messages, and finally sent

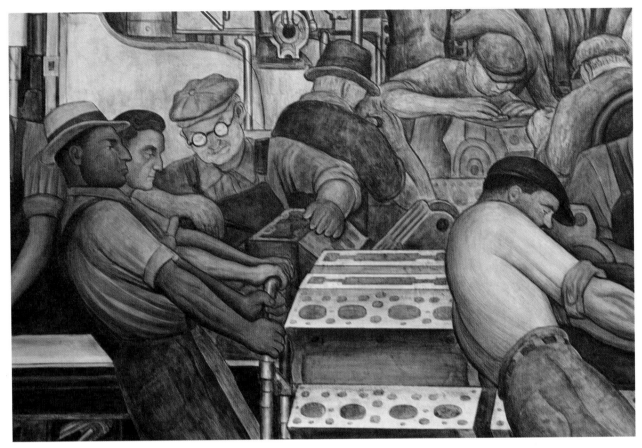

the last telegram [from Kahn, canceling the commission] to the newspapers in order to have himself seem a martyr."[34]

That strategy worked like a charm. Most Rivera biographies drag Kahn onstage just once—as hatchet man in the service of GM. In *The Fabulous Life of Diego Rivera* by Bertram D. Wolfe, published in 1963, the author framed the episode in terms that have been repeated ever since: "On May 12, [Rivera] received a wire from Albert Kahn, architect for the building: 'Have instructions from General Motors executives—discontinue with Chicago mural.'" Wolfe noted that all future work for Rivera in the United States disappeared at that time: "All the promised walls in America vanished with that telegram."[35] Thirty-five years later, Patrick Marnham repeated the same trope in *Dreaming with His Eyes Wide Open: A Life of Diego Rivera*: "Because of the public row [over the Rockefeller Center mural], Rivera lost his next public contract. On May 12 he received a telegram from Albert Kahn, who had been appointed architect of the General Motors Building at the Chicago World's Fair, cancelling Rivera's newly agreed commission to decorate that. It began to dawn on Rivera that as a painter of public

The claim has been made, including by some members of the Kahn family, that the "merry foreman" with the owlish glasses at left is actually Rivera's homage to architect Kahn. The glasses certainly fit.

murals in the United States he was finished. The process had taken less than a week."[36] Even Hayden Herrera's excellent *Frida: A Biography of Frida Kahlo* overlooked Kahn's early support for Rivera, instead going straight to the telegram, though Herrera at least dignified the architect as a "friend" to Rivera.[37] But she made no mention of Kahn's staunch defense when the murals first came under attack.

For his part, Kahn was furious in the wake of the New York uproar, doubtless feeling he'd gone out on a limb for an ungrateful artist. "Mr. Kahn came to the Arts Commission meeting last Monday sputtering with rage," DIA assistant director Richardson wrote. "I don't blame him much, because he has an enormous vacant wall in his building at the World's Fair and only about a week in which to work out a new scheme of decoration."[38] Between the collapse of the lucrative factory contracts with the Soviet Union and the difficulties dealing with a self-aggrandizing artist, Kahn—whose own politics leaned toward the Progressive Left—might be forgiven if he decided to put all communist associations behind him once and for all.[39]

9

TURBULENT THIRTIES

From 1930 on, the Kahn firm turned decisively toward industrial projects, with a rapidly shrinking percentage of commercial and residential contracts. The scale of the Kahn firm's industrial work that decade was tremendous. By 1938, the firm accounted for almost one-fifth of all new architect-designed industrial projects in the United States.[1]

At the start of the new decade, Kahn had just come off a long stretch of commercial elegance. If you jump over his Soviet work, the big commissions at the end of the 1920s were the Fisher Building and the Edsel B. and Eleanor Ford House, both design challenges where aesthetics reigned supreme. In the new decade, the first big commercial project was General Motors's 1926 Argonaut Building, enlarged in 1936—which ultimately housed the old GM Tech Center where, from his office on the top floor, the legendary Harley Earl oversaw design.[2] In the foyer just outside his door, visitors were greeted by a gleaming new General Motors product circling slowly on a giant "lazy Susan." (The building was equipped with three large, powerful freight elevators.)[3]

Kahn reached for a sharp contrast to set the Argonaut off from his neoclassical GM Building and Laboratory across the street, designing a Romanesque Revival structure in dark red brick that acts as a pleasing foil to all that limestone. The Argonaut is similar in appearance to Kahn's 1928 complex at Detroit's Herman Kiefer Hospital, which used much the same brick and Romanesque detailing—as did Kahn's Griswold Building in Capitol Park. The Argonaut had only a short run as the GM design center. By the late 1940s, the company needed more space for its designers, and abandoned the building for the gleaming, low-rise modernist complex by Eero Saarinen, Eliel's son, which at the time was way out in farm country in Warren, Michigan.

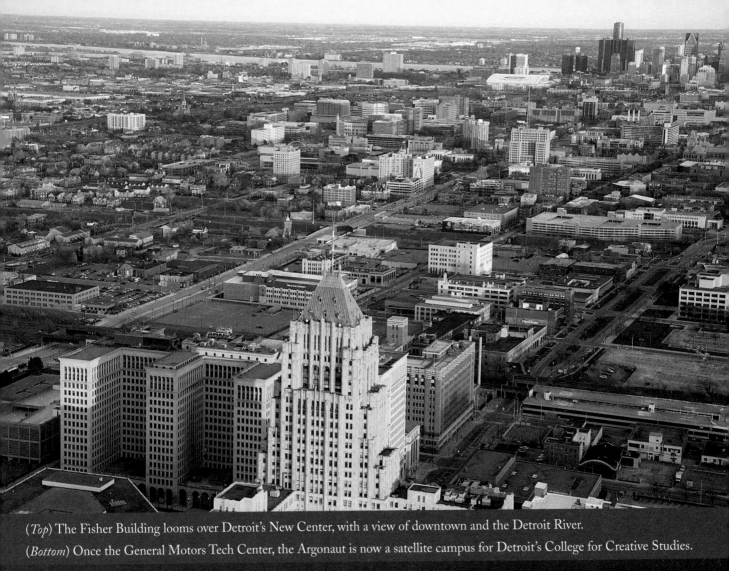

(*Top*) The Fisher Building looms over Detroit's New Center, with a view of downtown and the Detroit River.

(*Bottom*) Once the General Motors Tech Center, the Argonaut is now a satellite campus for Detroit's College for Creative Studies.

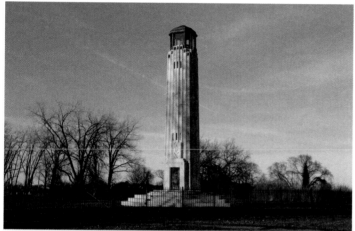

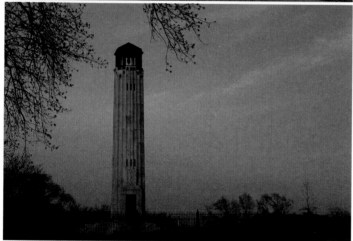

The hard-to-find Livingstone Memorial Lighthouse stands at the eastern end of Belle Isle in the Detroit River.

Emblematic of the neglect and disinterest that overtook so much of once-monumental Detroit, by the 1990s the Argonaut was padlocked and empty. But just a few years later it would morph into one of Detroit's early comeback stories. Well before the post-2010 uptick that has revolutionized the feel of downtown and midtown, GM donated the Argonaut to the College for Creative Studies, a design school a mile away. After a $145 million gut renovation in 2009 by Albert Kahn Associates, successor firm to the original, the building reopened as the high-tech A. Alfred Taubman Center for Design Education, a satellite campus with abundant state-of-the-art studio space, a three-hundred-student dormitory, classrooms, and an art-focused charter high school.[4]

Also debuting in 1930 was one of Kahn's most graceful designs, the William Livingstone Memorial Lighthouse at the east end of Belle Isle. This little-known treasure, which *AIA Detroit* called "an elegant ode to the possibilities of Art Deco applied to the tall building," is matched in delicacy only by Kahn's Renaissance Revival Clements Library at the University of Michigan.[5] The lighthouse tower, with fluted, vertical piers and a large allegorical sculpture by Géza Maróti, is fifty-eight feet tall and made of white Georgia marble. Capping it is a refined glass and copper head that originally housed an "8,600 candlepower" light that flashed every ten seconds and was visible, according to the opening-day account in the *Detroit Free Press*, for fifteen miles. The lighthouse, the article asserted, would be "a beacon for more ships than any other lighthouse in the world." To mark the event, a squadron of fifteen army pursuit planes from nearby Selfridge Field did a flyover salute to Mayor Frank Murphy and the five hundred assembled guests. (The late William Livingstone, by the way, was the president of Detroit's Dime Savings Bank and the Lake Carriers' Association, and had long lobbied for a light at that spot on the Detroit River.)[6]

By 1930, of course, economic conditions were darkening and panic had become a staple of daily life. All of which may account for a *Detroit Free Press* banner headline that topped the front page one Sunday that fall: "Fishers to Build 10-Story Edifice *at Once.*" In the go-go 1920s, with skyscrapers sprouting all over Detroit, a new ten-story building would be unlikely to land at the top of the Sunday front page, but times had changed. "By constructing such a building at this time," said Kahn, "the Messrs. Fisher are not only proving their full faith in this section of the city but in the future of the city itself. What is most important is they are doing their share toward solving the non-employment problem of today." As the article noted, the New Center Building (renamed the Albert Kahn Building in 1998) "will be conformable to the design of the present Fisher Building." While no price tag was attached at the time, expectations were that it would hit eight figures.[7] The resulting Art Deco structure is a "refined commercial building," as the AIA guide has it, a discreet complement to its more magnificent cousin kitty-corner across Second Avenue. When the New Center Building opened in 1931, Saks Fifth Avenue moved into the ground floor, and the Kahn firm, which had been

The 1930 Ford Power Plant, which supplies steam heat to the Ford Engineering Laboratory and The Henry Ford museum complex, represents an early use of the moderne design that would become typical of much of the Kahn firm's later work.

The Albert Kahn Building (originally the New Center Building) was built by the Fisher brothers out of marble intended for the mega-structure originally planned for the Fisher Building site before the Depression hit.

downtown in the Marquette Building since 1918, relocated to the new building, where it's been ever since.[8] In 2015, a development company with deep pockets acquired both the Fisher and Albert Kahn, with plans to invest $100 million in a thorough renovation. The Fisher Building will enjoy upgrades throughout but still remain an office building. By contrast, the Kahn Building is to be converted into about 160 high-end apartments, with retail on the ground floor. The architects intend to stay put.[9]

To facilitate movement between his three New Center structures, Kahn built tunnels connecting the GM Building to the Fisher and the Fisher to the New Center Building. A series of stores enlivened the subterranean Fisher-GM link. There was even a nightclub at the north end. In later years, however, both nightclub and stores vanished and the tunnels, faced in white subway tile—began to feel dated and unfashionable. In recent decades, Minneapolis-style enclosed pedestrian bridges were built to, essentially, duplicate the tunnels. (The one vaulting Second Avenue goes from the Fisher to One New Center, a nondescript building next door to the Albert Kahn Building—happily sparing the Kahn Building the indignity of having an unwanted gold plexiglas tube stapled to it.) The skywalks over both Second Avenue and Grand Boulevard are cheap looking, but the one running to the General Motors Building is both an eyesore and an obstacle. It ruins the view when you turn from Woodward Avenue onto Grand Boulevard, entering what by rights ought to be one of Detroit's great urban prospects, framed by majestic skyscrapers. The skywalk acts like an X scrawled across a painting.

The New Center Building commission was doubtless welcome in the early years of the Depression, though the Kahn firm's finances were more stable than those of most other large offices. The reason, of course, was the huge 1929–32 design project in the Soviet Union. While the first contract for the Stalingrad tractor factory was signed before the 1929 crash, the timing of the Soviet enterprise turned out to be particularly opportune, since Kahn's mainstay—the auto industry—went into a

five-year swoon starting with the 1929 crash. (Surprisingly, it would begin to revive by the mid-1930s). [10] Inevitably, there were several years of hard sledding.

Starting late in 1929, perhaps with post-crash urgency, Kahn launched a vigorous campaign to get local notables to write Andrew Mellon, secretary of the treasury, or Ferry K. Heath, assistant secretary, to demand that the Detroiter get the contract for what was variously described in correspondence as Detroit's "new federal building" or "new post office." At least fifteen top Michigan businessmen, industrialists, and publishers, including Henry Ford and George G. Booth, testified to Kahn's superior competence and cost-saving savvy. In a July 10, 1930, telegram to Mellon, Packard Motor president Alvan Macauley wrote: "Want to take the opportunity to endorse [Kahn] in the highest possible terms. STOP He has as you perhaps know designed many if not most of the outstanding public buildings in Detroit. STOP In addition, he has been our architect for more than 25 years and the relationship has been satisfactory in the extreme. STOP Mr. Kahn's appointment would meet the cordial approval of all who know beautiful and efficient architecture. STOP"[11] Kahn got the contract, the result being the 1933 moderne structure next to Detroit's now-abandoned train station that was the book depository for the Detroit Public Schools.[12]

Kahn was pessimistic about an early exit from the Depression. Writing Wilhelm Valentiner in 1932, he noted that some were predicting a quick turnaround. "I am confident that at best the change will be very, very slow and that there will still be much suffering before the return of normal conditions."[13] You can read some of this apprehension in a 1931 letter Louis Kahn wrote to George G. Booth at Cranbrook. As the firm's top administrator, he asked for help renegotiating a business contract with a real estate company Booth owned. Albert, Louis, and Julius Kahn had for years leased three properties on Michigan Avenue from the Booth Investment Corporation, subletting them to other businesses. In light of the national emergency, Louis asked Booth if he could intervene to help lower the Kahn brothers' expenses, since they'd gotten nowhere with the firm's management.[14] The newspaper publisher, sounding a bit put out, wrote back nine days later to say he was "surprised" by the request. He noted that when times were flush, the Kahns had not volunteered to give back an extra share of their profits to Booth Investment, so he hardly saw why the reverse should happen now. In any case, Booth underlined, he had nothing to do with running the firm, and wished the Kahns luck.[15] (By contrast, the Couzens family reportedly canceled a similar lease that, after the onset of the Depression, was weighing on Kahn's finances.)[16]

One year later, Albert Kahn wrote his old friend, client, and architectural collaborator to ask the same favor. This time Booth took real umbrage. "You and your associates held the property in question during years of prosperity," he wrote, "when [for us] there might have been a sale, lease or opportunity for profitable improvement; it suited your plans to hold it entirely through this period—and how you can [now] justify the repudiation of your undertakings when the days of distress come on us is beyond my understanding." Kahn's letter precipitating this has not survived, but from Booth's response we can infer that the architect was apprehensive the petition could jeopardize their relationship—not that such concerns kept him from making it. "I appreciate the friendly solicitude expressed in your letter," Booth replied, "but it seems to me there need be no concern if your agreement is carried out fairly, either as it is constituted or with such temporary easements as the Booth Invest Co. have expressed a disposition to grant. I trust you will conclude," he said in closing, "that it is along this line that a real solution of the present impasse is to be found." A final clause to that sentence was scratched out in the secretarial draft found in the Cranbrook Archives: the omitted clause read, "*which will remove all the perils you see threatening our years of friendship.*"[17]

This wasn't the only time that Kahn would risk Booth's friendship. Gregory Wittkopp, the director of the new Cranbrook Center for Collections and Research, noted in his *Saarinen House and Garden: A Total Work of Art* that the two had another dust-up in 1942 just before Kahn's death—this time over who introduced Eliel Saarinen to the newspaper magnate and baron of the Cranbrook woods. After Booth gave an interview crediting his son with bringing Saarinen to his attention, Kahn—at home suffering from a bad heart—sent Booth a long, rather tart letter that speaks to anxiety and defensiveness over his legacy. Saarinen's achievements at Cranbrook—a breathtaking series of small campuses—won plaudits throughout the design world. Having steered Saarinen to Booth would be something of a feather in Kahn's hat. Further souring Kahn's mood was the fact that Booth also left him out of a list of architects the publisher said had most influenced him.[18] In light of their fruitful collaboration over Cranbrook House and Booth's professed pride in the *Detroit News* building, this omission must have stung.

On August 27, 1942, Kahn replied to what seems to have been a conciliatory note from Booth written just days before. The architect thanked the publisher, adding that "not being counted among the many you mentioned as having stimulated your interest in architecture, I feared I had done something to displease you." Then, of course, he got down to business with something guaranteed to displease his onetime

patron—challenging Booth on the details of Cranbrook's genesis. "You are quite in error as to how [Saarinen] became associated with Cranbrook Institute," Kahn wrote. "Not that it particularly matters but let me refresh your memory." He reminded Booth that he had asked Kahn in the early 1920s to design a Memorial Hall for the foot of Woodward Avenue on the Detroit River, although it was never built. "Because of industrial work on our boards," Kahn wrote, "I had to refuse, saying however that I could get you a *better man*, namely Saarinen who had been at Ann Arbor but a short time, and was unhappy under [U-M architecture dean Emil] Lorch." Kahn also pointed out that he contributed $500 to the commission Booth would offer Saarinen, and got the local architecture society to pony up an additional $1,500. "At the time you were unacquainted with Saarinen," Kahn wrote, "but accepting my recommendation, you agreed to have me arrange with him."[19] Alas, we have no record of Booth's reaction. And four months later, Kahn was dead.

Later in life, Kahn was bedeviled by the occasional suspicion he'd been wronged by an old friend. The architect was put out when Swedish sculptor Carl Milles and his wife Olga, who lived in Bloomfield Hills, failed to get in touch with their friends the Kahns the whole summer of 1939. Again, the architect's letter has vanished, but it must have been rather pointed, given the plaintive tone of Milles's response. Acknowledging how kind the Kahns had been when he and Olga first settled in Michigan, Milles added, "Albert, it hurts me when you think we are not your friends." The sculptor apologized profusely and explained that Olga had been deathly ill most of the year, and as a consequence they had socialized with almost nobody.[20] His letter seems to have soothed Kahn's feelings, and the friendship survived. Just before he died, Kahn wrote his son Edgar, in army boot camp in Arkansas, "Last Sunday I visited at Carl Milles'. They asked after you. Too bad you didn't see his collection of Greek and Roman sculptures he purchased just before the declaration of war. It is really quite wonderful. He has it all in his living room, which looks like an antique shop."[21]

While Kahn's production, as noted, turned sharply industrial in the 1930s, he nonetheless got several opportunities to bust loose with more symbolic architecture. Chief among these were world's fair pavilions for both General Motors and Ford. His first dip into architectural fantasy came in 1933 with the Chicago World's Fair, A Century of Progress, which sprawled across 417 acres south of the Loop. Opening May 27, 1933, the fair was initially planned to shut up shop that November, but extended its run to October 31, 1934, both because of its popularity and, as the Chicago Historical Society notes, the need to retire debts associated with its construction.[22]

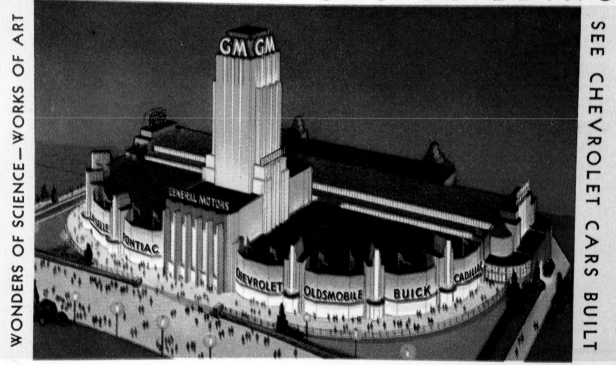

GENERAL MOTORS BUILDING

WONDERS OF SCIENCE—WORKS OF ART

SEE CHEVROLET CARS BUILT

A CENTURY OF PROGRESS—CHICAGO—MAY 27 - NOV. 1

Albert Kahn's General Motors exposition building at the 1933–34 Century of Progress World's Fair in Chicago. Henry Ford shrugged off suggestions that he build a Ford exhibition hall—until he saw how successful GM's was.

A Century of Progress, which attracted almost 40 million visitors, was meant to herald scientific achievement and the inevitability of progress, driving home "the message that cooperation between science, business, and government could pave the way to a better future," as its advertising had it.[23] Biographer Hildebrand was blunter. Its real purpose, he suggested, was "to sell the New Deal." Stylistically, both the GM and Ford buildings, he noted, were "slick modernistic efforts in the style of Norman Bel Geddes," the industrial designer who pioneered the "futuristic" streamlined style and was a consultant to the fair.[24] The GM Pavilion was housed in a streamlined Art Deco building with a tower defined by strong vertical lines, dramatically lit at night.

But it was the 1934 Ford Pavilion that would attract the most attention. Initially scornful of wasting money on a fair, Henry Ford belatedly recognized the advertising bonanza GM was reaping, and placed an order with Kahn for a pavilion built in what the *Detroit Free Press* called "the Detroit corner" of the fair, near the GM, Chrysler, and Transportation halls. "Architect Kahn has drawn his inspiration for the design of the structure from the automobile engine connecting rod," the paper noted. "At the

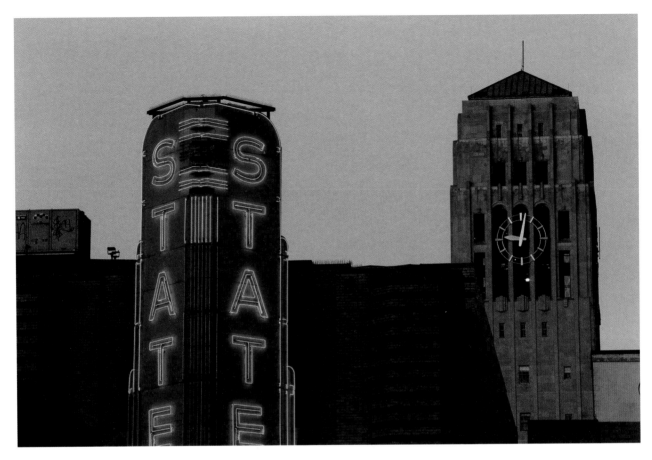

The 1936 Burton Memorial Tower dominates Ann Arbor's State Street.

south end of the building is an enormous circular rotunda in the shape of a gear." The rotunda's center was open to the sky, with a huge glass globe within that underlined "the worldwide sweep of the Ford enterprises." Along the sides of the building was an exhibit documenting humanity's inevitable progress from Roman chariot to the latest Ford coupe.[25]

In 1935, the circular portion of the hall was dismantled and moved to Dearborn, where it was reassembled and faced in more permanent Indiana limestone as the official Ford visitors' center near the Rouge plant. Inside the renamed Ford Rotunda was a theater, showroom, and a vast photographic display of the "Ford World." In back of the building were outdoor reproductions of famous "Roads of the World."[26]

The Rotunda, a much-loved Detroit landmark, was destroyed on November 9, 1962. As two workers applied tar with a blowtorch to waterproof parts of the translucent roof, a fire broke out, turning the 110-foot dome that now topped the structure, designed by Buckminster Fuller, into what the *Free Press* called "a roaring volcano." The paper added, "Forty minutes after the fire started, the majestic limestone walls of the

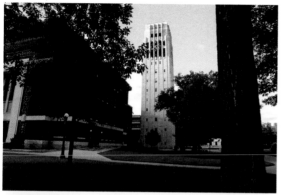

eight-sided structure fell in, sending a huge billow of orange flame skyward along with columns of black smoke." Thirty-five visitors and fifteen staffers were evacuated without serious injury, but the structure, with a "multimillion-dollar Christmas Fantasy display being readied inside," was a complete loss.[27]

The mid-1930s also saw one of the last and most prominent Kahn commissions at the University of Michigan. The 1936 Burton Memorial Tower is an iconic Art Deco limestone structure, almost resembling a machined object, that provides a ready visual reference point all around campus and downtown Ann Arbor.[28] The design initially looks to be an homage to another architect, much the way Kahn's 1924 Angell Hall gestures to the Lincoln Memorial, and the 1915 Detroit Trust Company echoes New York's 1903 Knickerbocker Trust Company by McKim, Mead, and White. (The Knickerbocker was savagely expanded in 1921, when ten new stories were added.)[29] But there's a Burton backstory. In 1925, Cranbrook's Eliel Saarinen inked plans for a U-M music school with attached carillon tower that was never built. By the mid-1930s, the university was ready to move on the tower, if not the attached school, but Saarinen was too busy to return to the project. So it went out to Kahn.[30]

Budgets in the mid-1930s, however, were much tighter than in the go-go 1920s. "There was insufficient funding to build the tower to the full height proposed by Saarinen," wrote university planner Frederick W. Mayer in his history of the Michigan campus. "So the tower was shortened by removing a portion of the top section and expanding the remainder to fit on the base."[31] Still, the spin Kahn gave Burton is distinctly his own—a gracious reinterpretation of Saarinen's design, and one that dovetails with Kahn's

architectural philosophy of borrowing and creative synthesis. His tower, typically, is heavier, simpler, and more masculine than Saarinen's, but clearly took inspiration from the initial design with its telescoping shaft, strong vertical accents, and low-slung hip roof.

All in all, it must have been a busy year for Kahn in Ann Arbor. In 1936, he also designed the Art Deco offices for the *Ann Arbor News*, his sixth newspaper building. (The others were the *Detroit News*, *Detroit Free Press*, *Detroit Times*, *Flint Journal*, and the Brooklyn offices of the *New York Times*.)

Also taking shape during the Depression were some of the Kahn firm's most innovative industrial designs, steel and glass structures whose crisp, transparent elegance approached the cathedral-like quality of great European train sheds. One of the first was the 1936 De Soto Press Shop in Detroit. "Lightweight curtain walls on a vast scale and an extraordinary purity of form have made the De Soto Press Shop of the Chrysler Corporation (1936) a classic of modern architecture," wrote Ferry. He also quoted *Architectural Forum* editor (and later design director at Herman Miller

On an icy morning, Burton Memorial Tower peeks above Hill Auditorium at the University of Michigan.

The 1938 Chrysler Half-Ton Truck plant was one of Kahn's most aggressive and modern designs—an elegant, glass-filled, industrial cathedral. Sadly, in recent decades the structure has been altered beyond recognition.

Company) George Nelson, who noted, "Conservatives may rebel at the application of architectural criteria to such structures, but the fact remains that it is precisely in such buildings that modern architecture has reached its most complete expression."[32]

De Soto was followed in 1938 by what many regard as Albert Kahn's *tour de force*, the Chrysler Half-Ton Truck plant of Warren, Michigan, just north of Detroit. Hildebrand declared it "a masterpiece of industrial architecture." He applauded the structure for "the crisp expressiveness of its form, which is seen as exemplifying a twentieth-century technological style. The plant attracts this kind of praise," he added, "because it is remarkably handsome and photogenic," with a precision that makes it "appear to have been machined."[33] Nelson called the plant "one of the Kahn firm's most-successful

designs, interestingly varied in mass and vigorous in treatment." Ferry's terms for it were "transparent and immaterial-looking."[34] The roof was unusual in that the skylight monitors didn't project above the roof line, as was typical, but "hung down below the roof level, thus projecting daylight into the heart of the plant and increasing the intensity of natural illumination."[35] The Half-Ton Truck plant was followed in 1940 by the Chrysler Tank Arsenal, "a huge glass cage three blocks long." By contrast, buildings in the Willow Run bomber plant, designed once the war was under way to run twenty-four hours a day, were artificially lit, with no windows—reflecting fears of nighttime aerial attacks.[36]

The Dodge Machine and Assembly Building in Chicago marked a return to experimenting with reinforced concrete. Virtually all auto and airplane manufacturing facilities had long ago switched from reinforced concrete to steel frame construction, but once the war started, steel was strictly reserved for military applications. With Chicago Dodge, which produced B-29 bomber aircraft engines, Kahn deftly jumped from his original steel design to a concrete-frame building with a "multi-arch thin slab concrete roof." Because of this "arch-rib" construction, the eighty-two-acre factory—larger even than its predecessor, Willow Run—cut the amount of steel necessary in reinforced concrete construction from "a customary 5.5 pounds [of steel] to 2.6 pounds. By this method," noted the *Weekly Bulletin of the Michigan Society of Architects* after the architect's death, "enough steel will be saved to build 14 destroyers or more than 600 Medium Tanks."[37]

The Richman Brothers Store Building on Detroit's Woodward Avenue is a handsome sandstone structure with gleaming metal edging. More than any other work by Kahn, the Richman Building looks as much like an object as architecture. The half-hidden glowering face on the water tower, by the way, is by artist Shepard Fairey.

THE MONSTER OF MODERNISM

Albert Kahn was almost universally described as driven but affable. Letters from corporate presidents thanking the architect for this or that splendid new headquarters invariably mentioned what a pleasure it was working with him and his entire organization. (The man had undeniable style. Kahn sent flower baskets whenever one of his major commercial buildings opened—elegant white peonies, when available.)[1] Nonetheless, the architect had a fiery side that flared at times, and on those occasions Kahn had little compunction about speaking very bluntly. This was the case, as noted previously, with his defense of the Diego Rivera murals at the Detroit Institute of Arts. When they came under right-wing attack, the architect and City of Detroit arts commissioner told the *Detroit News*, in effect, that anyone who didn't like them was a dolt.[2]

Since Kahn left so few personal papers from his mature years—no diary, and only a small handful of personal letters, mostly to family—we know almost nothing about his response to criticism of his own work, with one exception. In 1931, *Detroit Free Press* reporter Malcolm Bingay happened to catch Kahn at his office (a "miniature Pitti Palace") when the architect was in high dudgeon. The next morning's "What's Doing Today in Detroit" column opened with the marvelous tease, "Albert Kahn is boiling." It seems *Scribner's* magazine had just published an article that took swipes at "the five-and-ten-cent buildings of the Ford Motor Company" and the "soda fountain ornamentation of the Fisher." Unsurprisingly, Detroit's leading architect was furious. "Unknowing and unfair!" Kahn retorted. "Mr. Ford's buildings are models all over the world. Swedish, German and other architects cross the ocean to see them. They are his pride. He has gone to no end of bother and expense to get the best." Noting that the

writer misidentified the cladding on the Ford Engineering Laboratory (limestone, not cement), Kahn concluded, "If he doesn't know any more what he's talking about than that, I guess we can pigeon-hole the whole article."[3] It's indicative of the man's character, perhaps, that he springs to Henry Ford's defense, but—at least according to what ran in the paper—defends neither the Fisher Building nor himself.

Kahn brought the most biting critique of his career, however, to bear upon the radical new architecture springing up in Germany, Holland, and France in the years after World War I. Kahn didn't simply disagree with "Machine Age" designers like Walter Gropius, Le Corbusier, Adolf Loos, and others. He denounced them with a passion that suggests just how deeply their strange new structures offended him. (The term *International Style*, by the way, wouldn't come into use until after the 1932 Museum of Modern Art show, *Modern Architecture: International Exhibition*.) "Modernists present us with box-like forms, with windows unconventionally placed at corners or in long horizontal slots," Kahn complained, "with structures devoid of cornices, flat roofs surmounted by pipe railings, and ask us to accept those as the last word in architectural design."[4]

European modernists would have regarded the anthropomorphic figures studding the Fisher Building—typical of much Art Deco design— as hopelessly out of date and "bourgeois."

LAGOON AND ELECTRIC TOWER, WHITE CITY, CHICAGO

From Harry
6 - 2/-0 6

No. 297. V. O. HAMMON PUB. CO., CHICAGO AND MINNEAPOLIS.

The 1893 Chicago World's Fair launched a new enthusiasm for neoclassical or Beaux-Arts design that had been out of fashion for well over half a century.

Kahn was by no means alone among leading U.S. architects on this score. Frank Lloyd Wright, one of the few Americans to win praise from the transatlantic rebels (they lauded him as a sort of Ur-modernist), also dismissed European revolutionaries in a 1930 lecture at Princeton University: "Most new 'modernistic' houses manage to look as though cut from cardboard with scissors," Wright said, "the sheets of cardboard folded or bent in rectangles with an occasional curved cardboard surface added to get relief." It all amounted to, he said, "a childish attempt to make buildings resemble steamships, flying machines or locomotives."[5] And Kahn's old master, the very traditional George Mason, wrote from Hollywood in 1939 to carp about a modern, "monolithic concrete job" going up in the city, noting that some modern work "looks much better in a photograph than in reality."[6]

For his part, Kahn was scandalized by modernism's disregard, or outright contempt, for most of what preceded it, an arrogance that this talented eclecticist, who relished adapting earlier styles to his residential, commercial, and academic buildings, found insufferable. He posited an incrementalist approach to the discipline. "All good architecture is the result of cumulative effort," Kahn noted in a 1931 speech to the Maryland Academy of Sciences, the most detailed elaboration we have of his views. "If, in reemploying older forms and applying them to our newer problems, we have done wrong, then all architecture of the past is wrong, for all of it is but a development of what was done before." At the present moment, Kahn went on, "There is a trend to follow *no* style, to throw all precedent to the winds and do the utterly new and original. But," he added, "there is nothing utterly new. So, to be original, we indulge in the strange and bizarre"—two of the sharpest insults in the man's vocabulary. "All done these past fifty years," Kahn complained, "during which we believed ourselves emancipated from a periodically recurring dark age, is to go for naught, all the work we considered fine and inspiring, the work of men we believed sincere and honest—artists of the first rank—is proclaimed archeology not architecture." He was particularly incensed that the 1893 Chicago World's Fair, whose neoclassical White City was widely thought to have given American design a much-needed shot in the arm, was now written off as

doing more harm than good. "Now it is contended by some," Kahn said, "that instead of developing a purely American style, as we might have, we ever since have only copied, consulted our books on the Classics and Renaissance and pilfered what has suited our fancy."[7] (That was Chicago architect Louis Sullivan's viewpoint; he called the fair's design a form of "progressive meningitis.")[8]

Yet the very same European modernists Kahn deplored swooned over his early car factories. The severe gridwork elevations of the Packard and Ford plants, circa 1910—those utterly pragmatic, rectilinear, no-frills structures with their wide spans and gigantic windows—electrified European rebels in search of a break with a hopelessly tainted and over-ornamented past. Kahn, the mastermind behind Highland Park's Crystal Palace as well as Detroit's neoclassical and Art Deco towers, found it all a little annoying. "[Kahn] might admit that . . . his 'beautiful factories,' were inspired by the drama of industry," Hildebrand wrote, "but he is not likely to have thought of them as inspiring. Yet they did inspire."[9]

Le Corbusier himself praised the rigorously geometric, gridlike façades of early twentieth-century American factories, like Kahn's Six-Story Building at the Ford Highland Park complex.

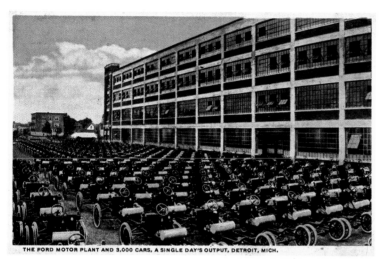

THE FORD MOTOR PLANT AND 3,000 CARS, A SINGLE DAY'S OUTPUT, DETROIT, MICH.

A smudged postmark on the back of this card of the Highland Park plant appears to date it to 1918 or 1919.

The installation that most exhilarated European proto-modernists on the eve of World War I was the Highland Park Ford plant, which manufactured the Model T from 1910 to 1927. Here was the future sculpted in groundbreaking reinforced concrete and glass, with only glancing concessions to exterior ornamentation—a brave new world. In 1913, Bauhaus founder Walter Gropius wrote in a widely circulated article, "America, the motherland of industry, possesses some majestic original constructions. . . . The newest halls of the great North American industrial trusts can almost bear comparison with the work of the ancient Egyptians in their overwhelming monumental power."[10] The very first image accompanying the article was the Highland Park Original Building, aka the Crystal Palace, in all its unadorned, highly glazed glory.

The plant pops up again in 1923 in Le Corbusier's seminal text, *Vers une architecture* (Towards an Architecture), in which he praised the "simple forms" of American factories, with their geometric "checkerboard or grid" façades. These, he declared, were "the reassuring first fruits of the new age." Amusingly, Le Corbusier altered the picture of the Highland Park Original Building for *Vers*, editing out the "bourgeois," if low-key, ornamentation on the brick towers. Unlike Gropius, he also failed to name either the architect or factory—though that may not have been meant as an insult, fitting in as it did with Le Corbusier's enthusiasm for the anonymous engineer and disdain for architects. (By way of example, he closed his chapter on American factories with the injunction, "Let us heed the advice of American engineers. But let us beware American *architects*." To drive home the point, an arrow leads from the text to a picture of an admittedly hideous office tower that bears some resemblance to the old Singer Building in New York.)[11]

It wasn't just European proto-modernists who were dazzled. The cultural impact of Highland Park, and later Kahn's Rouge complex, would likely surprise contemporary Detroiters. Both attracted a steady parade of awed visitors, domestic and foreign, all come to witness the wondrous new world. Some 157,000 took the Highland Park tour in 1925, just two years before all operations moved to the Rouge, at a time when the

plant was spitting out one Model T a minute.[12] Both Karl Neumaier, general manager of Germany's Benz Company, and Louis Renault praised the complex to the skies.[13] In John Dos Passos's *The Big Money*, one of the first things a character newly arrived in Detroit does is visit the magical installation at Highland Park.[14] Still, not all visitors were adoring. French existentialist Louis-Ferdinand Céline sketched a picture of a "Fordist" hell, visible from the street through Kahn's nearly floor-to-ceiling windows: "I saw some big squat buildings all of glass," Céline wrote in his semi-autobiographical *Journey to the End of the Night*, "inside which you could see men moving, but hardly moving, as if they were struggling against something impossible" (as concise a portrait of Taylorist scientific labor practices as you're likely to get). A bit like D. H. Lawrence's decades earlier, Céline's view of the industrial future was shot through with despair. "All around me and above me as far as the sky, the heavy, composite, muffled roar of torrents of machines—hard wheels obstinately turning, grinding, groaning, always on the point of breaking down but never breaking down. 'So this is the place!' I said to myself. 'It's not very promising.'" Once assigned to his machine, Céline's narrator reported, "We ourselves became machines, our flesh trembled in the furious din. It gripped us around our heads and in our bowels and rose up to the eyes in quick continuous jolts."[15]

Point of view, of course, was everything. In 1936, on his first visit to the United States, Le Corbusier took a tour of Kahn's futuristic Ford Rouge complex in Dearborn (and not, as is often reported, the Highland Park plant, which Ford had abandoned by then). The man behind the owlish glasses was dumbstruck. "I'm going out of the Ford workshops in Detroit [*sic*]," Le Corbusier wrote. "As an architect, I am in a kind of stupor. With Ford, everything is collaboration, unity of vision, unity of intentions, perfect convergence of the totality of thought and action"—welcome praise, perhaps, in an era when Ford's worldwide reputation as a benign visionary, four years after his security guards killed five in the Ford Hunger March, had long since crashed and burned.[16]

There were, to be sure, European industrial precedents for the development of modernism as well, particularly the AEG Turbine factory in Berlin by Peter Behrens. Sometimes called the father of European modernism, Behrens trained Gropius and Mies van der Rohe, and was an architect Kahn admired.[17] But the gigantic scale of the new industrial structures going up in America held the incipient modernists in thrall. And handsome as Behrens's AEG factory was, with its early suspended curtain wall of glass, it still made stylistic reference to a Greek temple—and was in that way softer and more backward looking than Kahn's severely functionalist designs, like Packard No. 10.

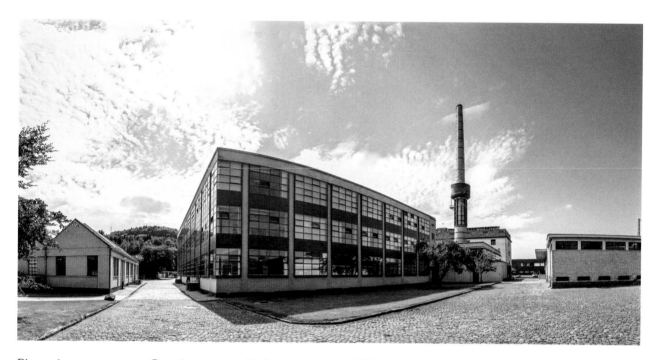

Pioneering European modernist Walter Gropius reportedly kept a picture of Albert Kahn's Highland Park complex above his drafting table while working on the Faguswerk factory in Germany. What the Gropius design lacked in practicality—and those glass corners were probably leaky—it made up for in sheer elegance.

Shutterstock

Gropius reportedly kept a picture of Highland Park on his desk while he was designing the 1910–13 Faguswerk plant, one of the most exhilarating landmarks in all of early European modernism (and now a UNESCO World Heritage site). But Highland Park wasn't the only American factory he admired. He also had a photo of engineer Ernest L. Ransome's equally forward-looking United Shoe Machinery plant in Beverly, Massachusetts, which bears considerable resemblance to Highland Park. (The United Shoe owners were investors in Faguswerk.)[18] But in terms of the factories' wider impact, there's no competition between Ransome and Kahn. The Ford name in the 1910s was still a byword for dizzying, hopeful modernity, a fame that lent Kahn's designs a visibility and—to put it bluntly—a sexiness Ransome could never match. (As an index of relative fame, in 1915 the Italian journal *L'industria* ran a big piece on Highland Park, but made no mention of United Shoe.)[19] With photos of these two plants in hand, Gropius—who, like Le Corbusier, wouldn't actually visit the United States till the 1930s—launched a wider campaign that "glorified American industrial buildings and that figured in the theoretical elaborations of the European architectural avant-garde."[20] At the very center of it all was Albert Kahn.

Gropius always called Faguswerk, with its striking office block organized around a monumentally framed doorway, an "American factory."[21] But in most respects, it was much more concerned with aesthetics and less with practicality than its American predecessor.

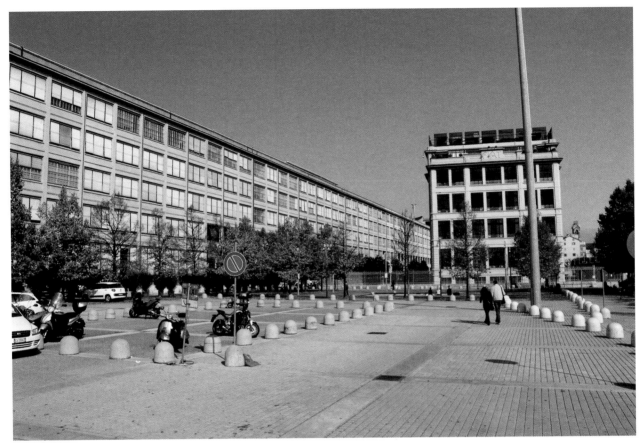

Closer in spirit to Highland Park was Giaccomo Mattè-Trucco's 1920–23 Fiat Lingotto complex in Turin, Italy. Interestingly, the plant was conceived and built years after Henry Ford decided multistory construction was inconsistent with a fully implemented moving assembly line, a judgment that rendered Highland Park obsolete by 1913. All the same, "possessed by American visions and mass-production ambitions," Fiat founder Giovanni Agnelli commissioned the Highland Park clone several years later.[22] Fiat Lingotto has no brick facing, so at first glance, the vast reinforced concrete façade looks rather different from Highland Park. But in most respects, from the wide spans between columns to the enormous steel sash windows, the plant is a kissing cousin to its Michigan predecessor. One key and telling difference, however, separates the two. Raw materials and parts entered Highland Park from the roof, and then "fell" through the four stories of the Original Building (the Crystal Palace) on gravity chutes, becoming larger and more assembled the closer to the ground floor they got. Mattè-Trucco turned this cost-saving strategy, gravity being free and all, on its head. Parts and materials entered on the ground floor, and as the vehicle took shape it rose through Lingotto's

Engineer Giaccomo Mattè-Trucco based the Fiat Lingotto plant in Turin on the Ford Highland Park plant. In recent years, architect Renzo Piano renovated the vast Lingotto complex, which is now an upscale mall boasting two hotels.

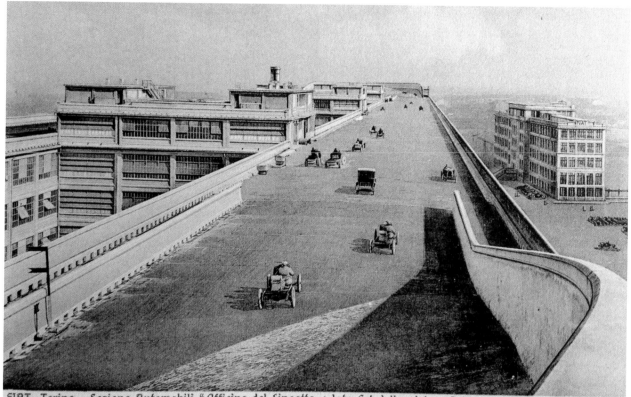

FIAT, Torino - Sezione Automobili "Officine del Lingotto": lato Est della pista e Palazzo della Direzione.
FIAT, Turin - Section Automobiles "Usines du Lingotto": côté Est de la piste et Palais de la Direction.
FIAT, Turin - Automobile Department "Lingotto Works": East side of the test track and Palace of Administration

Raw materials entered the Fiat Lingotto complex from the ground, and the car rose through the multistory structure until it emerged, fully assembled, onto the rooftop racetrack, where it was tested.

five stories, emerging fully formed on the rooftop, where it zipped around a banked racetrack before going down the engineer's truly spectacular double-helix exit ramp.

Banham dubbed Fiat Lingotto the "the most nearly Futurist building ever built," a reference to the Italian movement that worshipped speed and the machine.[23] And indeed, in pictures taken from above, there's something unquestionably snappy about this racetrack high in the sky. (Le Corbusier featured it prominently in *Vers*—one of the few factories the book identified by name and location.)[24] "This testing track/racetrack declares a rhetoric of speed, of display, inconceivable to Ford Company's modernity," Smith wrote in *Making the Modern*. "It is architectural ostentation of a high order, repellant to pragmatists who would reject it immediately because of the extra expenses of installation (compared to an orthodox roof) and expansion. . . . It is, however, a wonderfully symbolic form, expressing the purpose of an otherwise anonymous building."[25] (The rooftop racetrack still exists, and can be accessed through the Pinoteca Giovanni e Marella Agnelli, an elegant boutique art museum on the Lingotto roof, adjacent to the track.)

In an illuminating contrast between the Italian and American way of doing things, however, Highland Park today is much degraded, the revolutionary Crystal Palace demolished to make way for a garish (if useful, in a town with little commerce) low-end shopping center, and the Ford administration building in advanced decay. The endless Six-Story Building behind it is occupied, if down at the heels, and used for warehousing. By contrast, Fiat Lingotto, the last stop on Turin's spiffy new subway (built for the 2006 Winter Olympics), was sumptuously repurposed by architect Renzo Piano into an upscale mall and two hotels. (Happily, Mattè-Trucco's double-helix, spiral exit ramp is still there, though no longer in use. There's no barrier to just walking in, however. By all means crane your neck for a peek at the spectacular geometry rising floor after floor above you.)

Fiat Lingotto and Faguswerk both started with something like the template of Highland Park, but in each case aestheticized it—jazzing it up, in the former instance, with a racetrack on top, and in the latter, with startlingly elegant, highly glazed walls and dramatic corners where glass virtually meets glass. And so it went, this surprising exercise in cultural transfer whereby early twentieth-century American factories informed the emerging vision of European modernists. The transatlantic rebels, driven by a philosophy that eschewed all ornamentation as grasping, false, and "bourgeois," seized on U.S. models formed by strict economic and engineering necessity and tarted them up, often at considerable cost. It was an amusing bit of hypocrisy for a doctrine that also claimed the mantle of pure functionalism. As David Gartman noted in *From Autos to Architecture*, "Mies insisted that the steel frameworks of his buildings be revealed, but at the same time he concealed their assembly by specifying that joints be welded, not bolted, and then ground flat and painted so as to hide their connectivity."[26] Banham took much the same line with the legendary Faguswerk. "What separates it from American factory architecture, more than anything else is its tendency to be clever, original, and complicated at just those points where an American builder would have availed himself of the simplest and conventionally tested solution."[27]

Albert Kahn, we can be sure, would have chosen the most straightforward solution, and regarded Gropius and others as shamefully self-indulgent and indifferent to the cost concerns of their clients. "Kahn launched a sharp criticism of the modern European architects (Mendelsohn, Gropius, Taut, Le Corbusier and Curcat)," wrote Bucci, "who had imposed their own personal elaboration on industrial building design. Against this 'ultra-modern' approach, he leveled a technical/functional charge.

McKim, Mead, and White's 1900 People's State Bank is a neighbor to Kahn's Detroit Trust Company, just to the right.

He criticized the European architects for excessive use of glazed surfaces—not the product of precise responses of a functional nature, but motivated merely by aesthetic demands, and [which] resulted in an unjustifiable increase in heating costs."[28] By contrast, Kahn listened carefully to his clients and saw his role as carrying out their wishes—not the other way around. (As prophets of a new architectural order that was supposed to revolutionize daily life, European modernists could be a little intolerant. "No loud talk from the client allowed!" was the first commandment in their architect-client catechism, according to *From Bauhaus to Our House*, the scathing, often hilarious send-up of the men behind the International Style.)[29]

Where did Kahn's architectural heart actually lie? As with fine art, the man was drawn to yesterday's revolutionaries, though he warned against simply copying historical styles. "Slavish adherence to style, far from producing perfection in design," he said in a 1927 speech to a teachers' convention, "often proves distinctly detrimental. The models of the past serve better for inspiration than emulation."[30] In particular, he admired the revival of Beaux-Arts classicism pioneered by Chicago architect Daniel Burnham and New York's McKim, Mead, and White at the 1893 Chicago World's Fair, which reinterpreted a style that had been out of fashion for much of the nineteenth century and was widely seen as reinvigorating American design. The latter's neoclassical American Renaissance made a deep impact on Kahn, many of whose buildings, including the 1920 General Motors headquarters and the 1915 Detroit Trust Company, drew on that vocabulary. The bank appears to have been a clear homage to McKim, Mead, and White and their Knickerbocker bank in Manhattan, which was strikingly similar. Granted, most neoclassical banks in this era looked alike. But the resemblance in this case was very strong, especially before a 1926 addition tripled the size of the Detroit bank.

In any case, the similarity is unlikely to have been an accident, given the building's site. Detroit Trust sits right across Shelby Street from McKim, Mead, and White's 1900 People's State Bank, the firm's only major commission in Detroit. It's impossible to know if Kahn was awed or amused—or both—at the chance to design a knowing

reference to his heroes next to one of their signature buildings. In any case, we can be sure the gesture was meant as a salute, particularly to partner Charles F. McKim, whom the Detroiter admired above all others. In McKim's buildings, Kahn remarked in 1931, "there is displayed that fine sensibility, that restraint and orderliness, *that respect for the best traditions of the past* which marked all his work, and which found its fullest expression in the Boston Public Library and the group of Columbia College buildings."[31]

"Many call McKim a plagiarist, which is most unjust," Kahn added, delivering his philosophy of artistic continuity and the disruptive effects of revolution á la Gropius. "If profiting by the past is plagiarism, then practically all great men are guilty," he said. "[You might] as well call Beethoven a copyist of Bach for having received inspiration from him. . . . I insist that the reuse of well-tried forms when invigorated by a strong personality is not only unobjectionable but desirable, the opinion of many of our modernists to the contrary notwithstanding." Interestingly, and somewhat surprisingly, given the widespread admiration it ultimately won, Kahn was not so taken with what's generally regarded as McKim, Mead, and White's greatest accomplishment, New York's late, great Pennsylvania Station. "I fully admit," Kahn said in the same speech, "that it is not good architecture to reconstruct the Baths of Caracalla to serve as a railroad station in New York. . . . To force precedent into serving for what it was never intended is bad architecture."[32]

Kahn admired the Boston colossus of Romanesque Revival, H. H. Richardson, as well as Louis Sullivan and his onetime employee Frank Lloyd Wright—albeit with reservations. He disagreed with the widespread contention that the two Chicagoans had created a "truly American" architecture. "Theirs was not an architecture that sprang from the soil, even though hailed as such," Kahn said. "It was an individual effort which did not acquire even sufficient momentum to interest a reasonably large group, and collective effort is always necessary to form a new school." Still, he tipped his hat to Sullivan's solution for that most American of structures, the skyscraper. "Sullivan was

Kahn was a big fan of the New York firm McKim, Mead, and White. Its 1903 Knickerbocker Trust Company (*above*) appears to have inspired his Detroit Trust Company design twelve years later. Both buildings have since been considerably altered. The New York bank was stretched with a ten-story addition in 1921 and neutered beyond recognition. Kahn's Detroit Trust met with a much gentler fate with a 1927 expansion that tripled its size but still maintained the cornice line and spirit of the original composition.

Pennsylvania Station, New York.

Kahn sometimes failed to appreciate the emotional hold key New York City buildings would exercise over posterity, notably the late, lamented Pennsylvania Station, shown here, by McKim, Mead, and White, as well as William Van Alen's Chrysler Building, which the Detroiter felt tried too hard to be "strange and different." History would judge differently in each case.

the first to clearly express the steel frame within by his use of light [vertical] piers carried through straight to cornice," Kahn noted. "Practically all of the best solutions of skyscraper architecture ever since have followed this general scheme." As for Wright, Kahn praised his exhilarating Larkin Building in Buffalo, one of the landmarks in early skyscraper design. Noting that Wright had a greater following in Europe, where he was often hailed as a prophet, Kahn said, "On the whole, Wright's work, while that of genius and considered the seed of a new architecture, has failed in enlisting a great amount of interest in this country. To many of us," he added, "it appears exotic."[33] (There is a story, possibly apocryphal, that on visiting Kahn at his Detroit office, Wright observed that the two most important architects in the United States were finally in the same room together.)[34]

In contrast to the "rabid modernism" afflicting Europe, Kahn praised some modernists working in the United States, none of whom engaged in the "shaven architecture" he deplored in Germany.[35] The romantic modernism of Finnish architect Eliel Saarinen, for example, enthralled him. Saarinen designed Helsinki's monumental train station, with its two giants guarding the entryway, as well as the school campuses at Cranbrook

in suburban Detroit. In architecture circles, Saarinen, of course, was a legend before his arrival in Michigan, admired even by the most ideological European modernists for his second-place entry in the 1922 *Chicago Tribune* competition. Saarinen lost to New York's Raymond Hood, who crafted a Gothic cathedral stretched to skyscraper dimensions complete with flying buttresses. "There are many of us," Kahn said, "and I dare say Mr. Hood included, who believe Mr. Saarinen's competitive design better than that chosen."[36] (Nonetheless, for all its tapering, Art Deco modernity, the Saarinen submission wasn't nearly as hyper-modern as Gropius's, whose plan for a simple curtain-wall skyscraper could be mistaken for something Gordon Bunshaft built in 1970s New York, minus the decorative horizontal fluting.)

Kahn liked much of Hood's work, however, including his severely modern 1930 *Daily News* building in New York. "Its straightforward, vertical treatment is not only expressive of function," Kahn said, "but forms an admirable solution." He was less taken with Hood's ornamental American Radiator Building. And, shocking to contemporary ears, Kahn judged William Van Alen's Chrysler Building in Manhattan a failure. "There is ample evidence of study and earnest attempt at creating something notable," he said, "but it is just as clear that the desire to do the strange and different"—again, Kahn's terms of abuse—"was the impelling motif." The Detroiter would likely have been surprised to find the Chrysler Building would age gracefully into one of America's most beloved architectural icons. By contrast, he called Shreve, Lamb, and Harmon's Empire State Building "an imposing mass, dignified, impressive and inspiring," never mind a few quibbles about lack of attention given to the lower floors.[37]

History, as the cliché has it, is written by the victors. And nowhere was this more true than in twentieth-century architectural history when European modernists, driven from the Continent by Hitler's rise, colonized the New World for the International Style, which put down aggressive roots in the United States only after 1945.

Eliel Saarinen's submission to the 1922 international competition for the new *Chicago Tribune* building took second place, but generated more talk than any other proposal.

Cranbrook Archives/ Saarinen Family Papers

Albert Kahn's backward-looking neoclassical Detroit Trust Company (*left*) comes face-to-face with the modernist future he unintentionally helped generate (*right*).

Gropius was appointed head of architecture at Harvard, and Mies was installed at the Illinois Institute of Technology—ultimately designing much of IIT's remarkable campus. (Gropius, on the other hand, produced the bland, instantly forgettable Gropius Complex residential buildings at Harvard Law School. He did better in 1963 on New York's Pan Am Building, designed in collaboration with Pietro Belluschi, though that also drew sharp criticism.)

Traditionalists like celebrated Chicago architect Howard Van Doren Shaw, the "radical conservative" generally credited with the world's first shopping mall (Market Square in Lake Forest, Illinois), admired Kahn.[38] Shaw wrote the Detroiter in 1921 for advice on sawtooth skylights, adding, "Incidentally, I consider that your contribution to factory and commercial building easily outranks anything done toward a real American Architecture in the last decade, and find many architects of the same opinion."[39] But modernism's judgment on Kahn was savage. His outspoken opposition to the International Style, Smith noted, "was to cost him dearly as modernist historians began to take hold in U.S. museums, education, history writing and art criticism."[40] Their dismissal was two-edged: not only did Kahn design commercial work in Art Deco and revival styles, a sign of "bourgeois" artistic bankruptcy, according to the new orthodoxy, he also failed to recognize and exploit (or "universalize") the factory style he himself gave birth to. Historians didn't condemn him to the architectural dust heap simply for building in embarrassing retro styles. Kahn was written out of the canon because he failed to acknowledge his own offspring; he was blind to the aesthetic future Europeans read in his "beautiful factories."[41]

The result was a sort of architectural pile-on. In a letter to Le Corbusier, the German-born Philadelphia modernist Oscar Storonov—who designed the original UAW-Solidarity House on Detroit's East Jefferson Avenue—called Kahn an "engineering god" but a "pig architect" in every other respect.[42] Banham, never particularly

kind to the Detroiter, wrote that "as the case of Albert Kahn in Detroit shows, being close to powerful and innovative magnates like Henry Ford did nothing to break up the stylistic timidity he showed in all public buildings that were not hidden from the public eye."[43] (Apparently Kahn merely executed Ford's excellent ideas, providing no input of his own.) Going in for the kill, architectural historian H.-R. Hitchcock—who curated the 1932 MOMA *International Architecture* show with Phillip Johnson—wrote a sneering, much-noted article in 1947 that praised Wright for creating "architecture of genius" while dismissing Kahn as a mere peddler of "architecture of bureaucracy"—gifted at producing endlessly replicable buildings on the cheap, but little else. Even worse, Hitchcock suggested, this was the future of American architecture.[44]

The charge of timidity comes up time and again, suggesting that Kahn's failure to apply factory radicalism to his commercial work was some sort of character flaw. But we know a few things about the man that suggest how unlikely he was to rebel. For Kahn, the traditional architecture he learned as an apprentice was much more than just a career. Landing in George Mason's office as a teenage immigrant was a lifesaver, rescuing the lad and lifting his entire money-pressed family out of poverty. As a young man, Kahn had a living to make and dire responsibilities on his shoulders. Bear in mind that he reportedly turned down a job offer from Louis Sullivan in 1894 because, with parents and siblings depending upon him, he couldn't take the risk of an untested position. Kahn's experience as an apprentice might weigh on the question as well. If master and apprentice enjoy a sort of father-son relationship, professionally speaking, would that disincline a youngster—particularly one who was doubtless grateful for the opportunity—from bucking Dad's legacy? In any case, attributing Kahn's disinterest in pioneering a new design aesthetic to intellectual cowardice, the glib judgment in much modernist commentary, misses the point. Everything that made Kahn the man he was argued against upheaval and revolt.

As Hildebrand commented, Kahn lay outside any formal architectural movement. "In one aspect of his career he belonged to the eclectics," he wrote, "but in another he far outdistanced them. Temperamentally and therefore professionally he was at the opposite pole from the evocative architectural poetry of Wright. Yet he was not related to the Europeans either. Behrens, the Futurists, De Stijl, the Bauhaus, the International Style—all constituted a celebration of machine-age potentials at a significantly symbolic level; Kahn's work was an attempt to solve machine-age production needs at an almost exclusively operational level."[45]

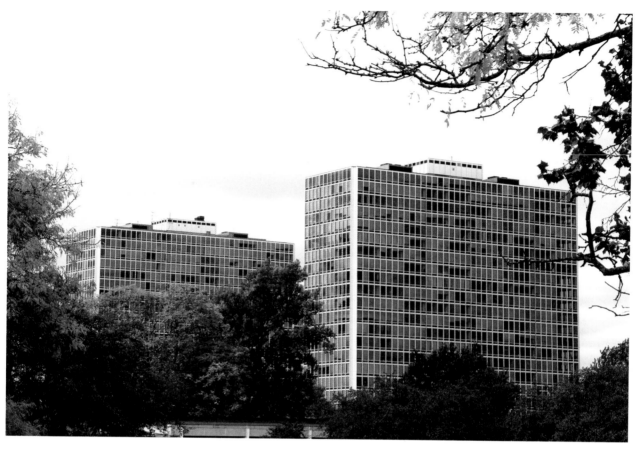

Lafayette Park in Detroit, the largest residential complex Mies van der Rohe ever built.

Historical judgment of Kahn began to shift and soften as the postwar era wore on, as a few articles and books dusted the Detroiter off for positive reappraisal after he had all but vanished. Ada Louise Huxtable, as noted earlier, wrote two articles in 1957 on Kahn factories for *Progressive Architecture in America*. Yale University architectural historian Vincent Scully picked up the baton in the late 1960s with *American Architecture and Urbanism*, referring admiringly to Kahn's "fine factories built of metal and glass." (Huxtable found it a bit much, however, when Scully located those plants on a continuum that started with the simple domestic architecture of the American colonies.)[46] "The truth," wrote historian Wayne Andrews in his 1978 *Architecture, Ambition and Americans*, "was that [Kahn's] factories were often works of art."[47]

The modernist most influenced by Kahn, according to these revisionists, was Mies van der Rohe, he of the glass curtain-wall skyscraper. In *Learning from Las Vegas*, Robert Venturi et al. wrote that Mies "looked only at the backs of Albert Kahn's factories in the Midwest, and developed his minimal vocabulary of steel T-sections framing industrial sash. The fronts of Kahn's sheds," Venturi added, "almost always contained

administrative offices, and being early twentieth century creations, were graciously Art Deco rather than historical eclectic. The plastic massing up front, characteristic of this style, grandly contradicted the skeletal behind."[48]

In another sign of partial resurrection, a picture of the Half-Ton Truck plant acts as the frontispiece for the chapter "Between the Wars" in Milton Brown et al.'s authoritative 1979 tome, *American Art*. The text made the link between Kahn and Mies explicit, noting that the latter's "industrial style of steel, glass and brick was anticipated in the numerous factories of the 1930s by the Detroit firm of Albert Kahn Associates." Conceding that Kahn suffered from the bad habit of "classicizing as well as Gothicizing" in his commercial work, Brown and his coauthors nonetheless underlined that his factories "exhibit a refined precision of architectural detail that is remarkable for the period and is surely a source for the Miesian style that would be adapted to downtown skyscrapers by 1950."[49] With that in mind, some would say it's only fitting that Mies's largest residential complex, Lafayette Park, sits just outside downtown Detroit—not so far from the auto plants that provided the original stylistic inspiration.

Ultimately, it fell to that midcentury iconoclast Eero Saarinen to bring the discussion of the International Style back to first principles. Commenting on his sleek 1956 General Motors Technical Center just north of Detroit, Saarinen noted, "It has been said that in these buildings I was very much influenced by Mies [van der Rohe]. But this architecture really carries forward the tradition of American factory-building which had its roots in the Middle West, in the early automobile factories of Albert Kahn."[50]

WAR

Dr. Edgar Kahn shipped off to England in the summer of 1942 with the rest of his University of Michigan Hospital unit, recently attached to the army. Eddie was forty-two years old and had been a neurosurgeon and professor of medicine for over twelve years. (He would rise to chief of neurosurgery shortly after the war.) His unit completed basic training in Arkansas and then embarked from New York City, where Ernestine and Albert met him at the Biltmore Hotel to say good-bye. It must have been a sober parting. "Father told me he could not sleep lying down," Edgar wrote years later in his memoir. "He did not realize this was a sign of chronic heart failure. He could hardly walk, and I knew," he added, "I would never see him again."[1]

Contemporaries of the seventy-three-year-old architect could hardly picture a decrepit Albert Kahn. His persistence and drive were legendary. People were forever telling the man to slow down, but it ran against the grain. As early as 1923, when Kahn was still a vigorous fifty-four, Henry B. Joy, chairman of Packard Motor, lectured his friend the "human steam engine" in a letter: "You'll blow up sure if you don't slow up, and then what have you left? It's time you played a little! In fact, the time is long past. No man can keep up a thousand pounds of steam forever."[2] Kahn seemed determined to prove otherwise. A jet-setter before the arrival of jets, the Detroiter was forever zipping off on overnight trains to New York City and sundry other destinations where his commercial buildings, or more likely his factories, were under construction. "I had a busy day of it [in New York]," he wrote his daughter Ruth in 1923 from a homebound train, "with Mr. Clements in the morning, with a Mr. Mayer at lunch to talk over a new temple for Brooklyn." He'd also stopped at the Japanese Fan Company, he said, as well

as one of his favorites, the lighting fixture firm of Caldwell and Company (whose work hangs in both the Fisher Building and Cranbrook House). "I pretty nearly missed [my train], for I couldn't find my ticket bought this morning," he wrote, "but all's well again. It was in one of my many pockets." He added, "It is a strenuous life, but I like it."[3]

In the early 1940s, of course, the Kahn firm—which by that point numbered about 650 employees—was buried under an immense amount of government work, not least because of the firm's reputation for coming in on time and often under budget.[4] Surviving letters testify to bureaucratic astonishment that Kahn delivered what he promised when he'd promised it. R. C. Wilson, somewhere in the Navy Department, wrote in 1941 to praise Kahn's work and carp about other architects. "The work entrusted to your care has been finished, whereas some of the other plans have *not even been started*." He added, "The Chief shares my concern about the situation and has called me to a conference for tomorrow to solve the problem. I know what the answer will be—Albert Kahn Associates will have to do some more work for the Pacific Naval Bases. Does this

The Kahn extended family gathered in the 1930s to inaugurate the gallery addition Kahn put on his Mack Avenue mansion to house his growing collection of Impressionist art. Kahn is just right of center, with his hand on the table. Ernestine is dressed in white immediately to the right of him.

Albert Kahn Family Papers, Bentley Historical Library, University of Michigan

answer your question, Mr. Kahn, as to whether or not the Contractors and the Navy are satisfied with your services?"[5]

Edgar Kahn did basic training at Camp Robinson outside Little Rock.[6] That summer his father wrote to let him know about an upcoming interview he'd given to the national CBS radio network. "Perhaps you'll have a chance to listen in," he said. Turning to the office, Kahn noted the firm was still very busy, with a Pratt & Whitney factory and a Dodge plant both still on the boards, but added that he knew all this defense work couldn't last. "I visited Louisville a couple of weeks ago to see the new Curtiss-Wright and the Palmolive-Colgate plants," he wrote. "So I was within a couple hours by airplane from you. I had a notion of calling you by phone, but thought it best not to cause the trouble of looking you up. Perhaps you were learning to march at that very time."[7]

Until his heart began to fail, Kahn's biggest health complaint was recurring back problems—a disability his son, Edgar, inherited as well. Kahn wasn't a man to complain much, but he did acknowledge in a 1924 letter to Ruth that he'd had "quite some time with my back last week. Did I tell you? I sprung that sacroiliac out of joint by pushing a car and how it did trouble me!" But his osteopath paid a visit and "went at it with determination and by Jiminie he sprang it back into place. I heard it crack, and since then I am quite comfortable again, particularly at night." He added, "And they say osteopathy is a fake."[8] His back would take an unfortunate jolt returning from William L. Clements's funeral ten years later when the car the architect was riding in was forced off the road and flipped just south of Bay City, Michigan. Kahn wasn't seriously injured, but all the same his doctors ordered him to stay in bed for several days.[9] (After reporting the accident, the *Detroit News*—apparently unwilling to let a good story die—ran a follow-up the next day headlined, "Albert Kahn Reported Improving from Hurts.")[10]

The first omen of cardiac trouble appeared in 1940, when Kahn was on a business trip to Cleveland. "On the plane, Father experienced severe chest pain," Edgar wrote. "However, he made the meeting, which lasted three hours. He later told me he had never thought so clearly, in spite of the pain." Afterward, Dr. Harold Feil, the heart specialist at Western Reserve University, examined Kahn at his hotel. "Dr. Feil told Father he had had a coronary thrombosis and was going directly to the hospital. Father said he would do nothing of the sort, but was flying back to Detroit. If that was the case, the doctor said, he was going with him. It was dangerous, as Dr. Feil knew, for an acutely ill heart patient to fly in an unpressurized cabin, and Father arrived home cyanosed and with his heart in auricular fibrillation (pulse irregular in rate and quality). He was in

Ernestine and
Albert Kahn
in 1942, some
months before his
death.

Albert Kahn Family
Papers, Bentley
Historical Library,
University of
Michigan

bed six weeks and then went right back to work." Edgar regretted never getting to meet Dr. Feil to thank him for his willingness to accompany a balky patient in flight—the doctor's reputation could have been badly damaged had Kahn died en route.[11]

You get a sense how run-down Kahn must have looked by the early 1940s from the rising chorus of voices insisting he take it easier. B. Moreel in the navy's Bureau of Yards and Docks wrote in 1940 to compliment the firm on its speedy work with the Naval Air Base program. "I hope that your health is again fully restored," he added, "and that you are not taxing your strength too greatly."[12] In a letter about work on the Todd Shipyards, E. E. Talmadge wrote, "Of much more importance to me is the utter disregard you show for your own health. . . . Your counsel and advice are of much more value to your clients and associates than the mental and manual work you do in tearing around all over the country. Therefore go a little slower and live longer."[13] In April 1941, R. C. Wilson concluded another letter by saying, "Please promise to come in late and go home early."[14] Chrysler president K. T. Keller sent photos of the just-completed Chicago Dodge plant three weeks before Kahn's death. "Proud as I am of that job," Keller wrote, "I am distressed to find you have again worked yourself [sick and] back into the house."[15]

If 1942 was in many ways a year of difficulty and decline, it also had its high points. In June, holding its national convention in Detroit, the American Institute of Architects recognized Kahn's far-flung contributions to the war effort by awarding him its Special Medal. "Exponent of organized efficiency, of disciplined energy, of broad-visioned planning," the citation read, Albert Kahn "has notably contributed to the expansion of the field of architectural practice. Master of concrete and of steel, master of space and of time, he stands today at the forefront of our profession in meeting the colossal demands of a government in its hour of need."[16]

One of the last descriptions we have of Kahn shortly before his death came from *Detroit Is My Own Home Town.* "The last time I talked with Mr. Kahn was just a few weeks before he died," Bingay wrote. "My wife and I were having dinner at L'Aiglon, in the Fisher Building, when he came bustling in from the [New] Center Building. . . . He chatted as though he never had a care in the world," and cheerfully demanded that the columnist buy him a dry martini. "I am not supposed to take anything to drink—against the doctor's orders," Kahn said. "So don't you dare tell anybody—my wife, especially. Just one! No more, no less. . . . Doctors say it is bad for my heart. You know," he added, "I have a bad heart." Like any number of friends and acquaintances, Bingay asked why he couldn't just let up on the accelerator. "I cannot slow down," Kahn replied. "There is a job to be done. We must all go sometime, Bing, and what better way is there than to keep going to the end?"[17]

The architect stood to go. He had a flight to catch for a morning conference about "another plane factory" in Connecticut. Kahn said good-bye, adding, "I'll be seeing you again—I hope." But that was not to be. "The great heart could not stand the pressure he had placed upon it," Bingay wrote. "But his spirit hovers over Detroit. His finger traced our skyline."[18]

The day before he died, Kahn—who'd been ordered to his bed weeks before—wrote a long letter to C. Howard Crane, the celebrated theater architect who got his start in 1905 in Albert Kahn's office.[19] Crane and his wife were in London, and Kahn wrote in part to ask them to call on Edgar. "Since his leaving here," Kahn said, "I personally have had a severe blow in the loss of my brother Julius—quite unexpectedly." Julius died in Cleveland on November 4, 1942—four weeks before Albert. The immensely successful engineer and inventor of the Kahn method of reinforced concrete was just sixty-eight. The cause of death, as it would be with his brother, was heart disease—an affliction that would stalk most of the Kahn men. "The blow came while I myself was somewhat

under the weather," Albert wrote, "and it knocked me for a loop. I have had to be in bed ever since, and probably several weeks more." However, he was "definitely on the mend," he assured Crane. Turning to work matters, Kahn noted, "We here have had a very strenuous two years of it, the second more so even than the first. I am very proud of what we have been able to contribute," he added, "and what is particularly justifying—we have been able to deliver and satisfy not only owners but prominent officials as well. The latter is not always easy." Kahn professed optimism about the war, noting the successful North African campaign. Acknowledging all the same that the road would be long, he wrote, "Things certainly are turning. Hitler and Mussolini will see their doom. You know, I hate Mussolini even worse than that other

beast. His double face towards especially Britain is what makes me boil. But hats off to Mr. Churchill. We all listened to his speech the other day. Wasn't it wonderful?"[20]

Dr. Edgar Kahn had been overseas just a few months when he learned his father had died. "In December of 1942, I was in England," he wrote. "One morning, Harry Towsley brought me the *London Times* and left without saying anything. It announced my father's death, at seventy-three, from heart disease."[21] Ruth's letter detailing the circumstances of their father's death wouldn't reach Edgar for several weeks. She'd stopped by the Mack Avenue house the morning of December 8, she noted, when Kahn was eating. "He was so cute and fussing about his breakfast," she wrote. "It seems they had forgotten to put the salt and pepper on his tray for his egg, and he was quite put out. He said, 'I don't ask for much service, but when I do I want it to be right.' Which was

Ruth Kahn's husband, Ed Rothman (*left*), with her brother Dr. Edgar Kahn in Cherbourg, France, shortly after its liberation in 1944. Both men were in the service.

Albert Kahn Family Papers, Bentley Historical Library, University of Michigan

so typical of his whole life. He really asked for so few material things. When Mother asked if he wasn't going to eat his egg he said, 'Sweet Girl, I've always been accustomed to eating my fruit first,' and he dove into his baked apple. I am telling you these little incidents," Ruth added, "for they show how normal everything was." After she drove home, Ruth called to wish her younger sister, Rosalie, a happy birthday. Len Lewis, a family friend, answered the phone, "and I thought I had called the wrong number," she wrote. "Then Len said, 'Your father died about an hour ago.' You can imagine the shock. I just couldn't believe it. But," she added, "what a wonderful way to go, if it had to be. He simply said he wanted to take a little rest and gave a little gasp and was gone."[22]

The funeral was held at 2 p.m. December 10 in the gallery of the Kahn family home.[23] Ruth said the large room, added for the architect's collection of Impressionist art, was "one solid mass of flowers. They even covered the paintings. Father's closed casket—the simplest walnut one we could find—was placed in the bay window. The curtains were open and in the windows was a bower of young green ferns."[24] Rabbi Leo Franklin and Dr. B. Benedict Glazer, both of Temple Beth El, conducted the service. Noting that Kahn had risen from poverty, Franklin said, "His only inheritance was a clean character. His only possession was a great genius for the beautiful, a passion for service, and an unlimited capacity for work." He added, in a simple summary that served as a fitting epitaph, "He took the ugliness out of things."[25]

Kahn was cremated, his ashes interred at White Chapel Memorial Cemetery in Troy, north of Detroit.[26] (Ernestine would join him there fifteen years later.)[27] Signing the funeral guest register were, among many others, Detroit Institute of Arts director Wilhelm Valentiner, his assistant Clyde Burroughs, museum benefactor Robert Hudson Tannahill, Detroit News publisher George G. Booth, and his son Ralph Harmon Booth.[28] Henry Ford told the Detroit News, "Albert Kahn was one of the best men I ever knew. He was a man of fine taste, the soul of integrity, a public-spirited citizen, and absolutely loyal to principle. He will be missed as a man and as the helper of great enterprises."[29]

Condolences poured in from around the globe. C. Howard Crane telegraphed from London, calling Kahn "a wonderful man and my greatest inspiration."[30] Paul Philippe Cret, whom Kahn had promoted as architect for the Detroit Institute of Arts in the 1920s, noted how grateful he'd always been for Kahn's endorsement. Calling his death a "loss to his friends and the architecture world," Cret added, in a description heard time and again, "He was so cheerful—kind to all, full of enthusiasm, and yet so modest

in spite of his great achievements."[31] Eliel Saarinen recalled the parties and dinners his family and the Kahns had shared over the years. "And although we, later on, did not see much of each other," he added, "there always was a feeling of warmth and friendship on the Saarinens' side."[32]

In the spring, the *Weekly Bulletin of the Michigan Society of Architects* devoted an entire issue to Kahn's accomplishments. Writing there, Cret said, "It was my good fortune to enjoy Albert Kahn's friendship for twenty years and our conversations revealed his constant preoccupation with design. Each new work in his office was an occasion for experimenting with new materials, or with new ways to use the old ones." Noting the influence on Kahn's work of the Germans Ludwig Hoffman and Peter Behrens as well as the New York firm McKim, Mead, and White, Cret added, "Albert Kahn was not a theorist: the 'architecture of tomorrow' had little interest for one so engrossed in creating the architecture of today." He noted that "for [architecture] he had a great, natural endowment. He possessed good taste and a clear judgment, as spring and balance wheel. Besides this, he understood other men, knew how to select competent and devoted assistants, maintained pleasant relations with clients and builders, was able to convince others, once he had seen the right road, and above all, kept to his last days an indefatigable activity devoted exclusively to his profession. Past seventy, he was still the same enthusiastic and unassuming young man who opened an office before the start of the 20th century."[33]

Mrs. Henry Bacon, widow of Kahn's 1891 European traveling buddy who went on to build the Lincoln Memorial, wrote Ernestine on December 12. "No words can express my sorrow at the passing of your noble husband Mr. Albert Kahn. He had been as a 'tower' of strength to me in my darkest hour." She explained that when her husband died, all his money was tied up in his architecture practice. Kahn organized a group of architects to buy her out, she wrote, "and he added a generous contribution which helped me to live."[34]

On December 16, the Soviet embassy in Washington, DC, forwarded a telegram to Ernestine that read: "Soviet engineers builders architects send you their sincere sympathy in connection with the death of your husband Mr. Albert Kahn who rendered us great service in designing a number of large plants and helped us to assimilate the American experience in the sphere of building industry. Soviet engineers and architects," it added, "will always warmly remember the name of the talented American engineer and architect Albert Kahn." The writer was Viktor A. Vesnin, a Constructivist

architect who'd been chairman of the Union of Soviet Architects in the 1930s.[35] The irony, of course, is that while Kahn's five-hundred-plus factories may have made the difference between national survival or defeat by the Nazis, succeeding generations, as it turned out, would not "warmly remember" his help in winning what the Kremlin called the "Great Patriotic War." Indeed, both Kahn and the entire American contribution to Soviet industrialization in 1929–32 were officially expunged from the record until very recently.[36]

<center>≜</center>

Unseen and largely unanticipated, the modern world was already in gestation but needed the skilled hands of Albert Kahn to give it form and substance. Early in the twentieth century, the experiments of Packard No. 10 and the Ford Highland Park plant unleashed a revolution that, while slow to gather strength, would by the 1950s upend the very nature of the built environment and how it shapes our lives. Today's light-filled, open interior spaces trace their origins to Kahn's early industrial lofts, with their unprecedented windows and airy, uncluttered floor plans. The merits of his mansions, hospitals, and skyscrapers aside, "[i]t was because of the factories that [Kahn] was a unique figure," biographer Hildebrand wrote. "Here his work was far from being merely tasteful," the charge often leveled against his commercial structures. "It was genuinely and boldly inventive."[37]

The fact that the architect himself did not recognize the wider potential and power of that boldness, convinced to the last that applying factory design principles to anything but factories was heresy, gives this promethean and very American life story an ironic, not to say tragic, edge. Kahn himself, of course, would snort at the idea that he had anything to regret. Still, had he built rectilinear, gridwork skyscrapers rather than, say, the General Motors or Fisher buildings, he would be acclaimed a seer and prophet by the architectural establishment.

This isn't to say Kahn lacked for acclaim. He virtually epitomized the historical figure who is famous while alive yet vanishes the minute he's in the ground. Known in his day as "the man who built Detroit," Kahn was one of the nation's most sought-after architects, particularly for industrial projects, and plaudits came from all sides. The University of Michigan granted him an honorary law degree in 1933; Syracuse University followed suit with a doctorate nine years later. In 1937, the French government invited Kahn to the Paris International Exposition of Arts and Technology, where he was made

Albert Kahn, 1869–1942.

Albert Kahn Family Papers, Bentley Historical Library, University of Michigan

a knight of the Legion of Honor for his work building bases in the First World War. At its national convention five years later in Detroit, the American Institute of Architects awarded Kahn a special medal for his firm's huge contribution to the war effort, just gearing up.

In 1975, thirty-three years after his death, Detroit's Albert Kahn Associates made an all-out push to get the AIA to grant the architect a posthumous Gold Medal, its highest honor, already conferred on Frank Lloyd Wright (1949), Eliel Saarinen (1947), and Paul Philippe Cret (1938).[38] The effort on behalf of Kahn did not succeed.[39]

However, in a development that would doubtless please the architect more than any prize, the unexpected urban revival that sprouted in Detroit following the 2008 economic collapse has meant that any number of Kahn's buildings, which enjoy considerable

cachet in the local real estate market, have suddenly seen new life. As noted above, a Spanish developer has vowed to bring the Packard plant back from the dead as a mixed-use complex. The Fisher Building and Albert Kahn Building (formerly New Center Building) in 2017 were both midway through extensive renovations, with the latter repurposed to residential use. Work was just starting as well on the *Detroit Free Press* building, one of the architect's jewels, which sat empty and forlorn for years. Even more astonishing, a developer announced big plans for the vast Romanesque Revival Herman Kiefer Hospital complex on the city's west side. You can almost see the smile on Albert Kahn's face.

NOTES

CHAPTER 1

1. Albert Kahn to C. Howard Crane, December 7, 1942, box 3, folder 7, Albert Kahn Papers, Archives of American Art (hereafter AKP-AAA), Smithsonian Institution, Washington, DC. In this letter, Kahn said the firm numbered 650 in 1942, not 450.

2. Federico Bucci, *Albert Kahn: Architect of Ford* (New York: Princeton Architectural Press, 2002), 108, citing March 17, 1941, Kahn interview by Bernard Crandell, United Press staff correspondent, which Bucci found at Albert Kahn Associates.

3. "Albert Kahn Dies; Famous Architect," *New York Times*, December 9, 1942, 27.

4. Bucci, *Albert Kahn*, 103.

5. "Albert Kahn," *Life*, October 23, 1939, 64; "Great Kahn," *Time*, May 20, 1929, 57.

6. "Industrial Buildings: Albert Kahn Inc.," *Architectural Forum*, August 1938, 90.

7. Alan Cobb, FAIA, CEO Albert Kahn Associates, interview with author, Great Lakes Coffee, Detroit, May 15, 2013; I am indebted to Alan for the observation "Kahn lived the life of five architects."

8. "Albert Kahn, Architect, Dies," *Detroit News*, December 8, 1942, 1.

CHAPTER 2

1. Albert Kahn to Rosalie Kahn, April 14, 1932, box 1, folder 53, AKP-AAA.

2. William R. Brashear, *Albert Kahn and His Family in Peace and War* (Ann Arbor: Bentley Historical Library, University of Michigan, 1985), 3.

3. Albert Kahn, handwritten application for U.S. passport dated November 10, 1890, image available on Ancestry.com.

4. Mollie Kahn Fuchs, "Memories of My Life," unpublished manuscript, 1937, 1, box 1, Albert Kahn Family Papers (hereafter AKFP), Bentley Historical Library, University of Michigan, Ann Arbor.

5. Kahn, passport, 1890.

6. Fuchs, "Memories," 1.

7. Ibid.

8. Ibid.

Angell Hall, University of Michigan.

9. Grant Hildebrand, *Designing for Industry* (Cambridge, MA: MIT Press, 1974), 8.

10. Fuchs, "Memories," 2.

11. Albert Kahn, "Tribute to George D. Mason," December 7, 1926, "Transcripts of Speeches," box 1, Albert Kahn Papers (hereafter AKP), Albert Kahn Associates, Inc., and Bentley Historical Library, University of Michigan, Ann Arbor.

12. Ibid.

13. Ibid.

14. "Poor as a Boy, Rich at 54," *Detroit Sunday Times*, March 11, 1923, 4.

15. W. Hawkins Ferry, *The Legacy of Albert Kahn* (Detroit: Wayne State University Press, 1970), 8.

16. Helen Christine Bennett, "You Can't Build Skyscrapers with Your Head in the Sky," *American Magazine*, December 1929, 121.

17. Ferry, *Legacy*, 8.

18. Bennett, "You Can't Build Skyscrapers," 121.

19. Kahn, "Tribute to George D. Mason."

20. Brashear, *Family*, 4.

21. Grant Hildebrand, "Beautiful Factories," in *Albert Kahn: Inspiration for the Modern*, ed. Brian Carter (Ann Arbor: University of Michigan Museum of Art, 2001), 17.

22. Kahn, "Tribute to George D. Mason."

23. Ibid.

24. "Poor as a Boy," 4.

25. Brashear, *Family*, 4.

26. Ferry, *Legacy*, 9.

27. Kahn, passport, 1890.

28. Hildebrand, *Designing*, 9.

29. Albert Kahn to Amy Krolik, November 9, 1902, box 1, AKFP.

30. Ibid.

31. Hildebrand, *Designing*, 9.

32. Ibid.

33. "Industrial Buildings: Albert Kahn Inc.," 49.

34. Brashear, *Family*, 6.

35. Hildebrand, "Beautiful Factories," 16.

36. Bucci, *Albert Kahn*, 143.

37. Brashear, *Family*, 6.

38. Hildebrand, *Designing*, 14.

39. George D. Mason, diary, 1891, George D. Mason Papers, box 1, Burton Historical Collection, Detroit Public Library.

40. Hildebrand, *Designing*, 14.

41. Ibid., 14–16.

42. George Nelson, *Industrial Architecture of Albert Kahn* (New York: Architectural Book Publishing, 1939), 283.

43. Hugh Morrison, *Louis Sullivan: Prophet of Modernism* (London: Norton, 1998), 245.

44. Albert Kahn, "Architectural Trend," speech given to Maryland Academy of Science, April 15, 1931, box 1, AKP.

45. Bucci, *Albert Kahn*, 28.

46. Hildebrand, *Designing*, 16.

47. Brashear, *Family*, 6.

48. Ernestine Krolik to Adolph Krolik, n.d., 1885, box 1, AKFP.

49. Ernestine Krolik to Mollie Kahn, August 14, 1894, box 1, AKFP.

50. Albert Kahn to Ernestine Krolik, n.d., in May–June 1894 folder, box 1, folder 19, AKP-AAA.

51. Albert Kahn to Ernestine Krolik, June 2, 1894, box 1, folder 19, AKP-AAA.

52. Albert Kahn to Ernestine Krolik, August 4, 1894, box 1, folder 23, AKP-AAA.

53. Ibid.

54. Albert Kahn to Ernestine Krolik, August 13, 1894, box 1, folder 26, AKP-AAA.

55. Albert Kahn to Ernestine Krolik, n.d., ca. August 1894, box 1, folder, 26, AKP-AAA.

56. Albert Kahn to Ernestine Krolik, June 18, 1895, box 1, folder 33, AKP-AAA.

57. Edgar A. Kahn, *Journal of a Neurosurgeon* (Springfield, IL: Charles C. Thomas, 1972), 149.

58. Brashear, *Family*, 6.

59. Edgar A. Kahn, *Journal*, 149.

60. "Kahn-Krolik," *Detroit Free Press*, September 20, 1896, 21.

61. Brashear, *Family*, 7

62. Albert Kahn, 1925 U.S. passport, box 1, folder 3, AKP-AAA.

63. Carol Rose Kahn, text message to author, January 10, 2016. Carol said she'd heard a recording, since lost, of an interview with her grandfather shortly after the attack on Pearl Harbor in 1941. "I was a kid," she wrote, "but in my memory the accent was slightly German."

64. Brashear, *Family*, undated family photograph, 2.

65. Hildebrand, *Designing*, 89.

66. Congregation Beth El, *1916 Yearbook* (Detroit: Congregation Beth El, 1916).

67. *Encyclopedia of Detroit* (Detroit: Detroit Historical Society, 2016), detroithistory.org.

68. Biographical Material: Membership Cards, 1932–1943, box 1, folders 15–16, AKP-AAA.

69. Albert Kahn, "Eugene Manet and the French Impressionists," lecture to Torch Club, May 14, 1935, 2–3, box 1, AKP.

70. Albert Kahn, "What Will the Future of Detroit Be Like?" speech to Vortex Club, Detroit, September 28, 1921, box 1, AKP.

71. "The Romantic Rise of Two Brothers Whose Achievements Have Worked a Revolution in the Construction Industry," *Detroit News Tribune*, September 20, 1908, 20.

72. Donald L. Brown (Pratt and Whitney Corporation) to Albert Kahn, December 10, 1929, box 1, AKP.

73. Albert Kahn to Ernestine Krolik, ca. August 1894, box 1, folder, 26, AKP-AAA.

74. Hildebrand, *Designing*, 89.

CHAPTER 3

1. David Lee Poremba, ed., *Detroit in Its World Setting: A 300-Year Chronology, 1701-2001* (Detroit: Wayne State University Press, 2001), 178–79.

2. Hildebrand, *Designing*, 18–23.

3. Brashear, *Family*, 7.

4. Ferry, *Legacy*, 7

5. Chris Meister, "Albert Kahn's Partners in Industrial Architecture," *Journal of the Society of Architectural Historians*, March 2013, 80.

6. "Lydia W. Malbin, 91, a Collector of European Art," *New York Times*, October 18, 1989.

7. Julius Kahn to Albert Kahn, January 14, 1900, box 1, AKFP.

8. Edgar A. Kahn, *Journal*, 150.

9. Fuchs, "Memories," 1–8.

Incised letters

INSCRIPTIONS IN
PANELS TO BE
DECIDED LATER
ANNO MCMXXI

Carved

Notes for a panel on Clements Library at the University of Michigan.

Albert Kahn Associates

10. Ibid., 3–4.

11. Julius Kahn to Albert Kahn, n.d., 1900, box 1, AKFP.

12. Fuchs, "Memories," 1.

13. Bennett, "You Can't Build Skyscrapers," 122.

14. Albert Kahn, "Reinforced Concrete Architecture These Past Twenty Years," 1, speech to American Concrete Institute, ca. 1924, box 1, AKP.

15. Nelson, *Industrial Architecture*, 89–90.

16. Ryan Salmon and Meghan Elliott, "The Kahn System of Reinforced Concrete: Why It Almost Mattered," *Structure Magazine*, April 2013, 12.

17. Ada Louise Huxtable, "Reinforced-Concrete Construction: The Work of Ernest L. Ransome, Engineer—1884–1957," *Progressive Architecture in America*, September 1957, 139–42.

18. Hildebrand, *Designing*, 29.

19. Huxtable, "Concrete," 139–42.

20. Hildebrand, *Designing*, 26.

21. Fuchs, "Memories," 5.

22. Salmon and Elliott, "Kahn System," 10.

23. Ada Louise Huxtable, "Factory for Packard Motor Car Company—1905," *Progressive Architecture in America*, October 1957, 121–22.

24. Bucci, *Albert Kahn*, 31.

25. Salmon and Elliott, "Kahn System," 10.

26. Hildebrand, *Designing*, 33.

27. Huxtable, "Concrete," 139–42.

28. Salmon and Elliott, "Kahn System," 11.

29. Edgar A. Kahn, *Journal*, 153.

30. Ferry, *Legacy*, 10.

31. "Henry B. Joy: Automotive Hall of Fame Inductee," www.automotivehalloffame.org/inductee/henry-b-joy/663. Packard No. 10 is often credited as the first reinforced concrete factory in Detroit, although not the first ever built. Wayne State University historian Charles K. Hyde, however, noted there's some evidence George Mason's reinforced concrete Cadillac Motor Car Company plant on Amsterdam Street may have beat No. 10 by a few months.

32. Meister, "Albert Kahn's Partners," 80–81.

33. Brashear, *Family*, 8.

34. Hildebrand, *Designing*, 28.

35. Hildebrand, "Beautiful Factories," 19.

36. Bucci, *Albert Kahn*, 67.

37. Nelson, *Industrial Architecture*, 28.

38. Huxtable, "Packard," 121–22.

39. Albert Kahn, "Putting Architecture on a Business Basis," speech to Cleveland Engineering Society, December 16, 1930, box 1, AKP.

40. Hildebrand, *Designing*, 29.

41. Reyner Banham, *A Concrete Atlantis: U.S. Industrial Building and European Modern Architecture, 1900–1925* (Cambridge, MA: MIT Press, 1989), 84–86.

42. Ibid.

43. Bucci, *Albert Kahn*, 32.

44. Huxtable, "Packard," 122.

45. Banham, *Concrete Atlantis*, 84–86.

46. Hildebrand, *Designing*, 61.

47. Banham, *Concrete Atlantis*, 89.

48. Bucci, *Albert Kahn*, 71. Bucci notes that Cass Gilbert's plan "insisted on the importance of the articulation of the volumes in industrial buildings, condemning the use of decoration extraneous to the 'direct and practical goals of such structures.'"

49. Terry Smith, *Making the Modern: Industry, Art, and Design in America* (Chicago: University of Chicago Press, 1993), 376.

50. Ada Louise Huxtable, "Factory for Ford Motor Company—1909–1914," *Progressive Architecture in America*, November 1957, 181–82.

The General Motors Building reflected in the Fisher Building entrance on Grand Boulevard.

51. Hildebrand, *Designing*, 54.

52. Malcolm W. Bingay, *Detroit Is My Own Home Town* (Indianapolis: Bobbs-Merrill, 1946), 304.

53. Henry Ford and Samuel Crowther, *My Life and Work* (Garden City, NY: Doubleday, Page, 1922), 113.

54. Smith, *Making the Modern*, 32.

CHAPTER 4

1. Hildebrand, *Designing*, 43.

2. Richard Bak, "Blueprint for Detroit," *Hour Magazine*, May 2000, 89.

3. Grant Hildebrand, email to author, January 4, 2015.

4. Sydney Bolkosky, *Harmony & Dissonance: Voices of Jewish Identity in Detroit, 1914–1967* (Detroit: Wayne State University Press, 1991), 72–73.

5. Carol Rose Kahn, email to author, August 22, 2016; Betsy Lehndorff, interview with author, December 29, 2016.

6. Robert A. Rockaway, *The Jews of Detroit* (Detroit: Wayne State University Press, 1986), 52.

7. *Temple Beth El 1926 Yearbook* (Detroit), 86.

8. The source, interviewed May 26, 2016, did not want her name used, emphasizing that this was a

memory from childhood and she couldn't swear to its accuracy. Still, it's striking that children would have told her that.

9. Albert Kahn to Ernestine Krolik, August 6, 1894, 1, box 1, folder 23, AKP-AAA.

10. Henry Ford's anti-Semitism was laced with hypocrisy. In his expansive history of Detroit, *American Odyssey* (Detroit: Wayne State University Press, 1986), Robert Conot reported that the loan that "saved the Ford Motor Co. from bankruptcy in 1903" came from the German-American Bank—a Detroit institution, as Conot drily observed, with a largely Jewish board of directors and a founder who was, as Ford might put it, "an international Jew."

11. Bolkosky, *Harmony & Dissonance*, 73.

12. Hildebrand, *Designing*, 44.

13. "Industrial Buildings: Albert Kahn, Inc.," 88.

14. Neil Baldwin, *Henry Ford and the Jews: The Mass Production of Hate* (New York: PublicAffairs, 2003), 195.

15. Bucci, *Albert Kahn*, 143.

16. Victoria Saker Woeste, *Henry Ford's War on Jews and the Legal Battle against Hate Speech* (Stanford, CA: Stanford University Press, 2012), 109.

17. Carol Rose Kahn, interview with author, February 24, 2016.

18. Bucci, *Albert Kahn*, 37.

19. Baldwin, *Ford and the Jews*, 133.

20. Bingay, *Home Town*, 308.

21. Woeste, *War on Jews*, 353n68, citing Allan Nevins and Frank Ernest Hill, *Ford: Expansion and Challenge, 1915-1933* (New York: Charles Scribner's Sons, 1954), 315.

22. Smith, *Making the Modern*, 58.

23. Banham, *Concrete Atlantis*, 68–72.

24. Hildebrand, *Designing*, 44–45.

25. Michael G. Smith, email to author, May 16, 2017, citing Fiske Kimball's *American Architecture* (Indianapolis: Bobbs-Merrill, 1928).

26. Brian Carter, "Kahn, Machines, and the Collapse of Boundaries," in *Albert Kahn: Inspiration for the Modern* (Ann Arbor: University of Michigan Museum of Art, 2001), 43.

27. "New Ford Factory," *Detroit Free Press*, July 4, 1909, 9.

28. Smith, *Making the Modern*, 72.

29. Allan Nevins and Frank Ernest Hill, *Ford: The Times, the Man, the Company* (New York: Charles Scribner's Sons, 1954), 453.

CHAPTER 5

1. Meister, "Albert Kahn's Partners," 80.

2. Henry B. Joy to Albert Kahn, March 13, 1923, box 1, AKP.

3. "A Chronology of University of Michigan Buildings, 1840–1999," Bentley Historical Library, University of Michigan, bentley.umich.edu/exhibits/campus_tour/chronology.php.

4. Hildebrand, *Designing*, 72.

5. Mason, diary, April 3–May 8, 1902.

6. Brashear, *Family*, 50.

7. Appropriately enough, the Whole Foods was planned in 2012 by Albert Kahn Associates. Alan Cobb, interview with author, Detroit, January 26, 2017.

8. Ferry, *Legacy*, 16.

9. Ibid.

10. Eric J. Hill and John Gallagher, *AIA Detroit: The American Institute of Architects Guide to Detroit Architecture* (Detroit: Wayne State University Press, 2003), 308. Detroit is lucky to have a superb AIA guide. Anyone interested in the city or its history should get a copy.

11. Albert Kahn, Toastmasters speech for George G. Booth, 1927, box 1, AKP.

12. Joy Hakanson Colby, *Art and a City: A History of the Detroit Society of Arts & Crafts* (Detroit: Wayne State University Press, 1957), 5.

13. Ferry, *Legacy*, 16.

14. Hill and Gallagher, *AIA Detroit*, 308.

15. Albert Kahn to George G. Booth, August 27, 1942, box 16, folder 21, Cranbrook Archives, Cranbrook Educational Community, Bloomfield Hills, MI.

16. Wayne Andrews, *Architecture, Ambition and Americans* (New York: Free Press, 1978), 262.

17. Ferry, *Legacy*, 17.

18. Charles K. Hyde, *The Dodge Brothers: The Men, the Motor Cars, and the Legacy* (Detroit: Wayne State University Press, 2005), 48–52.

19. Hildebrand, *Designing*, 72.

20. Ibid., 89.

21. Ibid., 81.

22. W. Hawkins Ferry, *The Buildings of Detroit: A History* (Detroit: Wayne State University Press, 1968), 188–89

23. Hildebrand, *Designing*, 73.

24. Bucci, *Albert Kahn*, 149.

25. Hildebrand, *Designing*, 73.

26. Frederick W. Mayer, *A Setting for Excellence: The Story of the Planning and Development of the Ann Arbor Campus of the University of Michigan* (Ann Arbor: University of Michigan Press, 2015), 105–6.

27. Hildebrand, *Designing*, 73, 79.

28. Radio City Music Hall, www.radiocity.com/faq.html.

29. Broadway in Detroit, www.broadwayindetroit.com/plan-your-visit/fisher-theatre.

30. Detroit Symphony Orchestra, www.dso.org/page.aspx?page id=87&AspxAutoDetectCookieSupport=1.

31. Hildebrand, *Designing*, 60.

32. Kahn, "Putting Architecture on a Business Basis."

33. Oral history interview with Corrado Parducci, March 17, 1975, 12–13, Archives of American Art, Smithsonian Institution, Washington, DC.

34. Michael G. Smith, *Designing Detroit: Wirt Rowland and the Rise of Modern American Architecture* (Detroit: Wayne State University Press, 2017), 44.

35. Hildebrand, *Designing*, 73.

36. Michael G. Smith, email to author, May 17, 2016.

37. George C. Baldwin, "The Offices of Albert Kahn, Architect, Detroit Michigan," *Architectural Forum*, November 1918, 125–30.

38. H.-R. Hitchcock, *Architecture: Nineteenth and Twentieth Centuries* (London: Penguin Books, 1977), 547.

39. Baldwin, "Offices of Albert Kahn," 125–30.

40. Wayne Andrews, *Architecture in Michigan* (Detroit: Wayne State University Press, 1982), 93.

41. "DAC Reaches 100, Marks It with Sculpture Park," *Crain's Detroit Business*, April 13, 2015, 4.

42. Hill and Gallagher, *AIA Detroit*, 50.

43. Albert Kahn, "The Detroit Athletic Club," *American Architect*, July 14, 1915, 17–21.

44. Hildebrand, *Designing*, 82.

45. Smith, *Designing Detroit*, 119.

Snow casts the red tones of the Booth mansion, or Cranbrook House, in high relief.

46. Ken Voyles, interview with author, Detroit Athletic Club, December 14, 2016.

47. Ferry, *Legacy*, 14.

48. Jeff Morrison, interview with author, Bentley Historical Library, Ann Arbor, April 8, 2017. Morrison is author of the forthcoming *Guardians of Detroit: A Pictorial Guide to Architectural Sculpture in the Motor City.*

49. George G. Booth to Albert Kahn, October 8, 1917, box 1, AKP.

50. George Mason to Albert Kahn, ca. 1927–28, box 3, folder 35, AKP-AAA.

51. Robert Sharoff and William Zbaren, *American City: Detroit Architecture, 1845–2005* (Detroit: Wayne State University Press, 2005), 38. *American City* is a gorgeously photographed, must-have resource for anyone interested in the architecture of Detroit.

52. Hildebrand, *Designing*, 133.

53. "G.M.C. Occupies New Building," *Detroit Free Press*, November 25, 1920, 15.

54. Emporis Research, www.emporis.com/buildings/118558/cadillac-place-detroit-mi-usa; Ferry, *Buildings*, 215.

55. "G.M.C. Occupies New Building," 15.

56. Bucci, *Albert Kahn*, 159–61.

57. Andrews, *Architecture in Michigan*, 96.

58. Hildebrand, *Designing*, 135.

59. Ibid., 60.

60. Laurie Lanzen Harris and Paul Ganson, *The Detroit Symphony Orchestra: Grace, Grit and Glory* (Detroit: Wayne State University Press, 2016), 50.

61. Kahn, "What Will the Future of Detroit Be Like?"

62. "Kahn and Wife Win Tax Appeal," *Detroit News*, November 14, 1928, 42.

63. Hildebrand, *Designing*, 93–99.

64. "Ford Revolutionizes Glass Making," *Michigan Architect and Engineer*, May 1930, 72.

65. Hildebrand, *Designing*, 111.

66. Jonathan Glancey, *Twentieth-Century Architecture: The Structures That Shaped the Century* (London: Carlton Books, 1998), 331.

67. Hildebrand, *Designing*, 100–101.

68. Janet Kreger, "Albert Kahn and the Design of Angell Hall," *LSA Magazine* (Spring 1998): 10–11.

69. Mayer, *Setting for Excellence*, 99.

70. Hildebrand, *Designing*, 135.

71. Ferry, *Legacy*, 20.

CHAPTER 6

1. Brashear, *Family*, 16.

2. Carol Rose Kahn, interview with author, January 7, 2017.

3. Brashear, *Family*, 16.

4. Albert Kahn to Ruth Kahn, February 7, 1923, box 2, AKFP.

5. Ernestine Kahn to Albert Kahn, February 11, 1923, box 1, AKFP.

6. Albert Kahn to Ernestine Krolik, August 31, 1894, 1, box 1, folder 29, AKP-AAA.

7. Ernestine Kahn to Albert Kahn, February 11, 1923, box 2, AKFP.

8. Lydia Kahn to Albert Kahn, February 13, 1923, box 2, AKFP.

9. Ernestine Kahn to Albert Kahn, March 20, 1923, box 2, AKFP.

10. Albert Kahn to Ruth Kahn, February 13, 1923, box 2, AKFP.

11. Marsha Miro, "A Devotion to Art, a Passion to Learn," *Detroit Free Press*, August 3, 1986, 21.

12. Brashear, *Family*, 25.

13. Edgar A. Kahn, *Journal*, 50–51.

14. Brashear, *Family*, 24.

15. Henry B. Joy to Albert Kahn, March 13, 1923, box 1, AKP.

16. Ralph Stone to Albert Kahn, May 28, 1927, box 1, AKP.

17. Kahn, "What Will the Future of Detroit Be Like?"

18. Bingay, *Home Town, 306*.

19. Albert Kahn to George G. Booth, August 27, 1942, box 16, folder 21, Cranbrook Archives.

20. For the hospital, see President's Advisory on Public Art, University of Michigan, www.public-art.umich.edu/the_collection/campus/gone/113.

21. Mardges Bacon, *Le Corbusier in America: Travels in the Land of the Timid* (Cambridge, MA: MIT Press, 2001), 262.

22. Ferry, *Buildings*, 333.

23. Mason to Kahn (ca. 1927–28), box 3, folder 35, AKP-AAA.

24. "Admit Fight on Kahn Due to Old Grudge," *Detroit News*, January 20, 1929, 1.

25. Albert Kahn to Ruth Kahn, July 30, 1926, box 2, AKFP.

26. Edgar A. Kahn, *Journal*, 155.

27. Ferry, *Legacy*, 22.

28. Hildebrand, *Designing*, 146.

29. Ferry, *Buildings*, 272.

30. Hildebrand, *Designing*, 146.

31. Ferry, *Buildings*, 272.

32. Hill and Gallagher, *AIA Detroit*, 302.

33. "Mr. Kahn Was Justly Honored," *Weekly Bulletin of the Michigan Society of Architects*, March 30, 1943, 29.

34. H. T. Brock, "The Broad Sweep of American Architecture," *New York Times*, April 21, 1929, 139.

35. Dan Austin, "Fisher Building," historicdetroit.org. This is a superb website for anyone interested in Detroit, and an indispensable online guide to the physical city. Recommended as well

One of Géza Maróti's medieval guardians adorning the Fisher Building.

is Detroit1701.org, another good historical resource. In 2000, AIA (American Institute of Architects) Michigan members voted the Fisher "the building of the century."

36. George D. Mason to Albert Kahn, February 22, 1927, box 3, folder 35, AKP-AAA.

37. "A $35,000,000 Development 'by Fisher,'" *Michigan Manufacturer and Financial Record*, January 22, 1927, 83–84.

38. Albert Kahn, "Fisher Building," *American Architect*, February 20, 1929, 212.

39. Ibid., 211.

40. Ibid.

41. Hildebrand, *Designing*, 147.

42. Albert Kahn to Ernestine Krolik, August 19, 1894, box 1, folder 27, AKP-AAA.

43. Ferry, *Buildings*, 335.

44. Albert Kahn, "Fisher Building," 216.

45. Ibid., 217.

46. "President's Advisory Committee on Public Art," University of Michigan, www.public-art.umich.edu/the_collection/campus/central/70.

47. Albert Kahn, "Fisher Building," 216, 238.

48. Cheney, quoted in Ferry, *Buildings*, 334–35.

49. www.historicdetroit.org/building/fisher-building.

50. Ferry, *Buildings*, 334.

51. Hildebrand, *Designing*, 147.

CHAPTER 7

1. "Soviet Plans Factory to Build Tractors," *New York Times*, May 5, 1929, 24.

2. Sonia Melnikova-Raich, "The Soviet Problem with Two 'Unknowns': How an American Architect and a Soviet Negotiator Jump-started the Industrialization of Russia; Part I: Albert Kahn," *Industrial Archeology* 36, no. 2 (2010), 60.

3. Anatole Senkevitch Jr., "Albert Kahn's Great Soviet Venture as Architect of the First Five-Year Plan, 1929–1932," *Dimensions* 10 (1996), 36.

4. Melnikova-Raich, "Soviet Problem: Part I," 61; "American to Build Soviet Auto Plants," *New York Times*, May 7, 1929, 14.

5. "Soviet Loses One of Its Chief Cogs in Five-Year Plan," *Christian Science Monitor*, March 29, 1932, 6.

6. Melnikova-Raich, "Soviet Problem: Part I," 61–63.

7. Sonia Melnikova-Raich, telephone interview with author, December 29, 2016.

8. Melnikova-Raich, "Soviet Problem: Part I," 57.

9. Ibid., 60.

10. Bingay, *Home Town*, 308.

11. Melnikova-Raich, "Soviet Problem: Part I," 63.

The Packard plant in Detroit.

12. Ibid. (Ford's offer and remarks were also widely reported in newspapers.)

13. Ibid., 58.

14. "American to Build Soviet Auto Plants," 14.

15. "Details of Ford Contract," *New York Times*, October 14, 1929, 12.

16. Melnikova-Raich, "Soviet Problem: Part I," 58.

17. George Mason to Albert Kahn, June 28, 1930, box 3, folder 35, AKP-AAA.

18. Melnikova-Raich, "Soviet Problem: Part I," 68; "American to Build Soviet Auto Plants," 14.

19. Melnikova-Raich, "Soviet Problem: Part I," 61.

20. "Red Workers Chafe at American 'Delay,'" *New York Times*, July 1, 1929, 5.

21. Melnikova-Raich, "Soviet Problem: Part I," 68.

22. Roy A. Medvedev, *Let History Judge: The Origins and Consequences of Stalinism* (New York: Vintage Books, 1973), 102–6.

23. Melnikova-Raich, "Soviet Problem: Part I," 62, 75.

24. Ibid., 66.

25. Ibid., 62–66.

26. Ibid., 66.

27. Edgar A. Kahn, *Journal*, 28.

28. Senkevitch, "Kahn's Great Soviet Venture," 36.

29. Melnikova-Raich, "Soviet Problem: Part I," 69–70.

30. Bingay, *Home Town*, 309–10.

31. Melnikova-Raich, "Soviet Problem: Part I," 73.

32. Alec Nove, *An Economic History of the U.S.S.R.* (Harmondsworth, UK: Pelican Books, 1972), 186.

33. "Soviet Loses One of Its Chief Cogs," 6.

34. Sonia Melnikova-Raich, "The Soviet Problem with Two 'Unknowns': How an American Architect and a Soviet Negotiator Jump-started the Industrialization of Russia; Part II: Saul G. Bron," *Industrial Archeology* 37, nos. 1–2 (2011), 19.

35. Melnikova-Raich, "Soviet Problem: Part I," 76.

36. Melnikova-Raich, "Soviet Problem: Part II," 19–20.

37. Brashear, *Family*, 97.

38. "Red Leaders Feared Victims of Clean-up," *New York Times*, November 30, 1937, 5.

39. Melnikova-Raich, "Soviet Problem: Part II," 20.

40. Ibid., 19.

41. Melnikova-Raich, "Soviet Problem: Part 1," 19–20.

42. Bucci, *Albert Kahn*, 89.

43. "Great Kahn," 57.

44. "Finds U.S. Losing Big Russian Trade," *New York Times,* July 12, 1930, 11.

45. "Soviet Trade Group Held Fountain Head of Red Propaganda," *Washington Post*, March 9, 1930, M1.

46. "Says Amtorg Agents Watch Our Defense," *New York Times*, September 28, 1930, 20.

47. Edgar A. Kahn, *Journal*, 32. An electronic search of the *Detroit Free Press* archives turns up no articles on Albert Kahn containing the word *Bolshevik*. Nor does the story appear in a *Detroit News* index of headlines from 1930. Possibly the paper in question was the late, lamented *Detroit Times*, a Hearst paper that, like its sister the *Detroit News*, was an afternoon publication.

48. Bucci, *Albert Kahn*, 90–93.

49. Melnikova-Raich, interview with author.

50. Edgar A. Kahn, *Journal*, 155.

CHAPTER 8

1. Albert Kahn to Rosalie Kahn, April 14, 1932, box 1, folder 53, AKP-AAA.

2. Ibid.

3. Ibid.

4. Linda Bank Downs, *Diego Rivera: The Detroit Industry Murals* (New York: Detroit Institute of Arts

in association with Norton, 1999), 29–34.

5. Smith, *Making the Modern*, 208.

6. Downs, *Diego Rivera*, 31.

7. "U.S. Gets Plea to Apprehend Riot Leaders," *Detroit Free Press*, March 9, 1932, 1.

8. Downs, *Diego Rivera*, 28–29.

9. "Friend and Foe Lining Up for Battle of Rivera Murals," *Detroit Free Press*, March 22, 1933, 2.

10. Downs, *Diego Rivera*, 29.

11. William H. Peck, *The Detroit Institute of Arts: A Brief History* (Detroit: Founders Society, Detroit Institute of Arts, 1991), 89.

12. Paul Philippe Cret to Albert Kahn, circa 1932–33, Central Files, Rivera Frescoes—Paul Cret, Detroit Institute of Arts (henceforth DIA).

13. Albert Kahn to Wilhelm Valentiner, December 28, 1932, Valentiner Records, 30/8, DIA.

14. Downs, *Diego Rivera*, 174–75.

15. Ibid., 175.

16. Malcolm Bingay, "Good Morning," *Detroit Free Press*, March 23, 1933, 6.

17. "Friend and Foe," *Detroit Free Press*, 1.

18. "As We See It—Rivera Murals," *Detroit Free Press*, March 23, 1952, 4B.

19. Downs, *Diego Rivera*, 175–76.

20. "Detroit Put on Art Map by Rivera, Asserts Kahn," *Detroit News*, March 22, 1933, 11.

21. Ibid.

22. Robert Lacey, *Ford: The Men and the Machine* (New York: Ballantine Books, 1986), 341.

23. Smith, *Making the Modern*, 239.

24. Lacey, *Ford*, 342.

25. E. P. Richardson (by attribution—letter is unsigned, though it sounds just like Richardson) to Wilhelm Valentiner, May 18, 1933, Linda Downs Research Collection, series: Personal Papers, box 1, DIA.

26. Downs, *Diego Rivera*, 189n1.

27. Albert Kahn to Wilhelm Valentiner, December 28, 1932, Wilhelm Valentiner Records, box 30, folder 8, DIA.

28. Albert Kahn, speech to Business Women's Club at Hotel Statler, 1928, box 1, AKP.

29. Kahn, "Eugene Manet and the French Impressionists," 2–3; emphasis added.

30. Ibid., 15.

31. Downs, *Diego Rivera*, 60.

32. Carol Rose Kahn, interview, January 7, 2017; Betsy Lehndorff, interview, December 29, 2016.

33. E. P. Richardson to Wilhelm Valentiner, May 18, 1933.

34. Ibid.

35. Bertram D. Wolfe, *The Fabulous Life of Diego Rivera* (New York: Stein & Day, 1963), 330.

36. Patrick Marnham, *Dreaming with His Eyes Wide Open: A Life of Diego Rivera* (New York: Knopf, 1998), 255–56.

The Museum of Contemporary Art Detroit (*right*) was created out of Kahn's 1907 Standard Auto Company Garage and Showroom ninety-nine years later. Here, it's partly framed by Kahn's white terra-cotta 1908–14 Garfield Building.

37. Hayden Herrera, *Frida: A Biography of Frida Kahlo* (New York: Perennial Library, 1984), 166.

38. Richardson to Valentiner, May 18, 1933.

39. Herrera, *Frida*, 166.

CHAPTER 9

1. Ferry, *Legacy*, 25.

2. Cobb, interview, January 26, 2017.

3. Ibid.

4. M. J. Galbraith, "Inside the Argonaut, Detroit's Creative Hub," November 24, 2015, modelmedia. com. Albert Kahn Associates continues to be one of the most important architecture firms in the Midwest.

5. Hill and Gallagher, *AIA Detroit*, 264.

6. "Many Attend Shaft Rites," *Detroit Free Press*, October 18, 1930, 2.

7. "Fishers to Build 10-Story Edifice at Once," *Detroit Free Press*, September 28, 1930, 1.

8. Hill and Gallagher, *AIA Detroit*, 178.

9. Peter Cummings, principal in the Platform, interview with author, Redico offices in the Fisher

Building, Detroit, November 11, 2016.

10. Hildebrand, *Designing*, 152.

11. Alvan Macauley, telegram to Secretary of Treasury Andrew W. Mellon, July 10, 1930, box 1, AKP.

12. Michael G. Smith, email to author (citing Albert Kahn Associates Job No. 1644), January 9, 2017.

13. Albert Kahn to Wilhelm Valentiner, October 18, 1932, William R. Valentiner Records, box 26, folder 1, DIA.

14. Louis Kahn to George G. Booth, December 8, 1931, George G. Booth Papers, box 16, folder 21, Cranbrook Archives.

15. George G. Booth to Louis Kahn, December 17, 1931, George G. Booth Papers, box 16, folder 21, Cranbrook Archives.

16. Edgar A. Kahn, *Journal*, 155.

17. George G. Booth to Albert Kahn, January 3, 1933, George G. Booth Papers, box 16, folder 21, Cranbrook Archives.

18. Albert Kahn to George G. Booth, August 27, 1942, George G. Booth Papers, box 16, folder 21, 1, Cranbrook Archives.

19. Ibid., 1–2.

20. Carl Milles to Albert and "Celestine" Kahn, January 30, box 3, folder 38, AKP-AAA.

21. Brashear, *Family*, 88.

22. Chicago Historical Society, "A Century of Progress," www.chicagohs.org/history/century.html.

23. Encyclopedia of Chicago, "Century of Progress Exhibition," www.encyclopedia.chicagohistory.org/pages/225.html.

24. Hildebrand, *Designing*, 206.

25. "Ford Inspects a Monument to His Genius at World Fair," *Detroit Free Press*, May 16, 1934, 1–3.

26. "Work Is Speeded on Ford Rotunda," *Detroit Free Press*, April 21, 1935.

27. "Ford Rotunda Destroyed by $16 Million Fire," *Detroit Free Press*, November 10, 1962, 1.

28. I am indebted to Angelo Pitillo, director of the University of Michigan English Language Institute, for the excellent observation that Burton Memorial Tower resembles "a machined object."

29. "Stanford White's Backdrop for the Panic of 1907," *New York Times*, March 5, 2009, RE8.

30. Mayer, *Setting for Excellence*, 114.

31. Ibid.

32. Ferry, *Legacy*, 24.

33. Hildebrand, *Designing*, 172.

34. Ferry, *Buildings*, 339.

35. Nelson, *Industrial Architecture*, 84.

36. Ferry, *Buildings*, 339.

37. "Multiple-Arch Concrete Roof Saves Steel," Albert Kahn Memorial Issue, *Weekly Bulletin of the Michigan Society of Architects*, March 30, 1943, 174–78.

The Fisher Building chandeliers were made by the Edward F. Caldwell Company.

CHAPTER 10

1. [Name illegible] to Albert Kahn, June 6, 1921, box 1, AKP. "I appreciate and thank you for the basket of white peonys [*sic*]," the Detroit Savings Bank president wrote, "received on the occasion of the opening of our new home office."

2. "Detroit Put on Art Map by Rivera," 11.

3. Malcolm Bingay, "What's Doing Today in Detroit," *Detroit Free Press*, July 16, 1931, 8.

4. Smith, *Making the Modern*, 82.

5. Bucci, *Albert Kahn,* 175.

6. George Mason to Albert Kahn, February 22, 1939, 2, AKP-AAA.

7. Kahn, "Architectural Trend," 1–2.

8. Jean-Louis Cohen, *Scenes of the World to Come: European Architecture and the American Challenge, 1893–1960* (Montreal: Canadian Centre for Architecture, 1995), 21.

9. Hildebrand, "Beautiful Factories," 17.

10. Carter, "Kahn, Machines, and the Collapse of Boundaries," 43.

11. Le Corbusier, *Towards a New Architecture* (New York: Dover, 1986), 42.

12. David L. Lewis, *The Public Image of Henry Ford* (Detroit: Wayne State University Press, 1976), 160.

13. Ibid., 53.

14. John Dos Passos, *The Big Money* (New York: New American Library, 1979), 304.

15. Céline, *Journey to the End of the Night*, 192–95.

16. Bucci, *Albert Kahn*, 164.

17. David Gartman, *From Autos to Architecture: Fordism and Architectural Aesthetics in the Twentieth Century* (New York: Princeton Architectural Press, 2009), 79.

18. Banham, *Concrete Atlantis*, 191.

19. Bucci, *Albert Kahn*, 168.

20. Ibid., 164.

21. Hildebrand, "Beautiful Factories," 20.

22. Banham, *Concrete Atlantis*, 179.

23. Banham, quoted in Smith, *Making the Modern*, 67.

24. Le Corbusier, *Towards a New Architecture*, 287.

25. Smith, *Making the Modern*, 67–69.

26. Gartman, *From Autos to Architecture*, 95.

27. Banham, *Concrete Atlantis*, 191.

28. Bucci, *Albert Kahn*, 75.

29. Tom Wolfe, *From Bauhaus to Our House* (New York: Farrar, Straus, Giroux, 1981), 17.

30. Albert Kahn, "What Are the Characteristics of Good Architecture?" speech to Teachers' Convention, October 28, 1927, box 1, AKP.

31. Kahn, "Architectural Trend," 6; emphasis added.

32. Ibid., 6–7.

33. Ibid., 9–11.

34. Sally Bund, former archivist of Kahn Papers at Bentley Historical Library, interview with author, University of Michigan, Ann Arbor, July 14, 2015.

35. Kahn, "Architectural Trend," 16.

36. Ibid., 24.

37. Ibid., 24–25.

38. Whet Moser, "How the Conservatively Radical Architect Howard Van Doren Shaw Changed the American House," *Chicago Magazine*, April 24, 2015, www.chicagomag.com/city-life/April-2015/How-the-Conservatively-Radical-Architect-Howard-Van-Doren-Shaw-Changed-the-American-House.

39. Howard Van Doren Shaw to Albert Kahn, July 22, 1921, box 1, AKP.

40. Smith, *Making the Modern*, 83.

41. Hildebrand, "Beautiful Factories," 16.

42. Cohen, *Scenes of the World to Come*, 83.

43. Banham, *Concrete Atlantis*, 54.

44. Henry-Russell Hitchcock, "The Architecture of Bureaucracy and the Architecture of Genius," *Architectural Review*, January 1947, 4.

45. Hildebrand, *Designing*, 222.

46. Vincent Scully, *American Architecture and Urbanism* (New York: Praeger, 1969), 41.

47. Andrews, *Architecture, Ambition*, 254.

48. Robert Venturi, Denise Scott Brown, and Steven Izenour, *Learning from Las Vegas* (Cambridge, MA: MIT Press, 1977), 135.

49. Milton Brown, Sam Hunter, John Jacobus, Naomi Rosenblum, and David M. Sokol, *American Art: Painting, Sculpture, Architecture, Decorative Arts & Photography* (New York: Harry N. Abrams, 1979), 419.

50. Rupert Spade, *Eero Saarinen* (New York: Simon & Schuster, 1971), 12.

CHAPTER II

1. Edgar A. Kahn, *Journal*, 88.

2. Henry B. Joy to Albert Kahn, March 13, 1923, box 1, AKP.

3. Albert Kahn to Ruth Kahn, Feb. 28, 1923, box 2, AKFP.

4. Employee numbers are from Albert Kahn to C. Howard Crane, December 7, 1942, box 3, folder 7, AKP-AAA.

5. R. C. Wilson to Albert Kahn July 8, 1941, box 1, AKP.

6. Edgar A. Kahn, *Journal*, 87.

7. Brashear, *Family*, 87.

8. Albert Kahn to Ruth Kahn, Feb. 28, 1923, box 2, AKFP.

9. "Albert Kahn at Home as a Result of Wreck," *Detroit News*, November 12, 1934, 3.

10. "Albert Kahn Reported Improving from Hurts," *Detroit News*, November 13, 1934, 12.

11. Edgar A. Kahn, *Journal*, 156–57.

12. B. Moreel to Albert Kahn, January 23, 1940, box 1, AKP.

13. E. E. Talmadge to Albert Kahn, January 22, 1941, AKP.

14. R. C. Wilson to Albert Kahn, April 3, 1941, box 1, AKP.

15. K. T. Keller to Albert Kahn, November 19, 1942, box 1, AKP.

16. "Mr. Kahn Was Justly Honored," Albert Kahn Memorial Issue, *Weekly Bulletin of the Michigan Society of Architects*, March 30, 1943, 29.

17. Bingay, *Home Town*, 305–6.

18. Ibid., 310.

19. Lisa Maria DiChiera, "The Theater Designs of C. Howard Crane" (PhD diss., University of Pennsylvania Libraries, 1992), 10–11.

20. Albert Kahn to C. Howard Crane, December 7, 1942, AKP-AAA.

21. Edgar A. Kahn, *Journal*, 157.

22. Ruth Kahn Rothman to Dr. Edgar A. Kahn, December 13, 1942, box 1, AKFP.

23. "Genius and Destiny," Albert Kahn Memorial Issue, *Weekly Bulletin of the Michigan Society of Architects*, March 30, 1943, 17.

24. Ruth Kahn Rothman to Dr. Edgar A. Kahn, December 13, 1942, box 1, AKFP.

25. Dr. Leo M. Franklin, "A Tribute to Albert Kahn," Albert Kahn Memorial Issue, *Weekly Bulletin of the Michigan Society of Architects*, March 30, 1943, 15.

26. Rothman to Kahn, December 13, 1942.

27. "Mrs. Kahn Dies," *Detroit Jewish News*, December 17, 1957.

28. Funeral Guest Register, box 4, folder 5, AKP-AAA.

29. "Genius and Destiny," *Detroit News*, December 9, 1942, 14.

30. C. Howard Crane, telegram to Ernestine Kahn, December 11, 1942, box 1, folder 70, AKP-AAA.

31. Paul Philippe Cret to Ernestine Kahn, December 9, 1942, box 1, folder 71, AKP-AAA.

32. Eliel Saarinen to Ernestine Kahn, December 21, 1942, box 2, folder 38, AKP-AAA.

33. Paul Cret, "Albert Kahn," Albert Kahn Memorial Issue, *Weekly Bulletin of the Michigan Society of Architects*, March 30, 1943, 23.

34. Mrs. Henry Bacon to Ernestine Kahn, December 12, 1942, box 1, folder 57, AKP-AAA.

35. Viktor A. Vesnin, telegram to Ernestine Kahn, December 16, 1942, box 1, folder 47, AKP-AAA.

36. Melnikova-Raich, interview.

37. Hildebrand, *Designing*, 219.

38. Cobb, interview, May 15, 2013.

39. AIA: Gold Medal, www.aia.org/awards/7046-gold-medal.

BIBLIOGRAPHY

Andrews, Wayne. *Architecture, Ambition and Americans*. New York: Free Press, 1978.

———. *Architecture in Michigan*. Detroit: Wayne State University Press, 1982.

Bacon, Mardges. *Le Corbusier in America: Travels in the Land of the Timid*. Cambridge, MA: MIT Press, 2001.

Banham, Reyner. *A Concrete Atlantis: U.S. Industrial Building and European Modern Architecture, 1900–1925*. Cambridge, MA: MIT Press, 1989.

Bingay, Malcolm W. *Detroit Is My Own Home Town*. Indianapolis: Bobbs-Merrill, 1946.

Bolkosky, Sydney. *Harmony & Dissonance: Voices of Jewish Identity in Detroit, 1914–1967*. Detroit: Wayne State University Press, 1991.

Brashear, William R. *Albert Kahn and His Family in Peace and War*. Ann Arbor: Bentley Historical Library, University of Michigan, 1985.

Brown, Milton, Sam Hunter, John Jacobus, Naomi Rosenblum, and David M. Sokol. *American Art: Painting, Sculpture, Architecture, Decorative Arts & Photography*. New York: Harry N. Abrams, 1979.

Bucci, Federico. *Albert Kahn: Architect of Ford*. New York: Princeton Architectural Press, 2002.

Carter, Brian, ed. *Albert Kahn: Inspiration for the Modern*. Ann Arbor: University of Michigan Museum of Art, 2001.

Céline, Louis-Ferdinand. *Journey to the End of the Night*. New York: Penguin, 1966.

Cohen, Jean-Louis. *Scenes of the World to Come: European Architecture and the American Challenge, 1893–1960*. Montreal: Canadian Centre for Architecture, 1995.

Colby, Joy Hakanson. *Art and a City: A History of the Detroit Society of Arts & Crafts*. Detroit: Wayne State University Press, 1957.

Congregation Beth El. *1916 Yearbook*. Detroit: Congregation Beth El, 1916.

Conot, Robert. *American Odyssey*. Detroit: Wayne State University Press, 1986.

Dos Passos, John. *The Big Money*. New York: New American Library, 1979.

Downs, Linda Bank. *Diego Rivera: The Detroit Industry Murals*. New York: Detroit Institute of Arts in association with Norton, 1999.

Encyclopedia of Detroit. Detroit: Detroit Historical Society, 2016. detroithistory.org.

Ferry, W. Hawkins. *The Buildings of Detroit: A History*. Detroit: Wayne State University Press, 1968.

———. *The Legacy of Albert Kahn*. Detroit: Wayne State University Press, 1970.

Glancey, Jonathan. *Twentieth-Century Architecture: The Structures That Shaped the Century.* London: Carlton Books, 1998.

Harris, Laurie Lanzen, and Paul Ganson. *The Detroit Symphony Orchestra: Grace, Grit and Glory.* Detroit: Wayne State University Press, 2016.

Herrera, Hayden. *Frida: A Biography of Frida Kahlo.* New York: Perennial Library, 1984.

Hildebrand, Grant. *Designing for Industry: The Architecture of Albert Kahn.* Cambridge, MA: MIT Press, 1974.

Hill, Eric J., and John Gallagher. *AIA Detroit: The American Institute of Architects Guide to Detroit Architecture.* Detroit: Wayne State University Press, 2003.

Kahn, Edgar A. *Journal of a Neurosurgeon.* Springfield, IL: Charles C. Thomas, 1972.

Lacey, Robert. *Ford: The Men and the Machine.* New York: Ballantine Books, 1986.

Le Corbusier. *Towards a New Architecture.* New York: Dover, 1986.

Lewis, David L. *The Public Image of Henry Ford.* Detroit: Wayne State University Press, 1976.

Malgrave, Henry Francis. *Modern Architectural Theory: A Historical Survey, 1673–1968.* Cambridge: Cambridge University Press, 2005.

Marnham, Patrick. *Dreaming with His Eyes Wide Open: A Life of Diego Rivera.* New York: Knopf, 1998.

Morrison, Hugh. *Louis Sullivan: Prophet of Modernism.* London: Norton, 1998.

Nelson, George. *Industrial Architecture of Albert Kahn.* New York: Architectural Book Publishing, 1939.

Nevins, Allan, and Frank Ernest Hill. *Ford: The Times, the Man, the Company.* New York: Charles Scribner's Sons, 1954.

Nove, Alec. *An Economic History of the U.S.S.R.* Harmondsworth, UK: Pelican Books, 1972.

Peck, William H. *The Detroit Institute of Arts: A Brief History.* Detroit: Founders Society, Detroit Institute of Arts, 1991.

Scully, Vincent. *American Architecture and Urbanism.* New York: Praeger, 1969.

Sharoff, Robert, and William Zbaren. *American City: Detroit Architecture, 1845–2005.* Detroit: Wayne State University Press, 2005.

Smith, Michael G. *Designing Detroit: Wirt Rowland and the Rise of Modern American Architecture.* Detroit: Wayne State University Press, 2017.

Smith, Terry. *Making the Modern: Industry, Art, and Design in America.* Chicago: University of Chicago Press, 1993.

Spade, Rupert. *Eero Saarinen.* New York: Simon & Schuster, 1971.

Venturi, Robert, Denise Scott Brown, and Steven Izenour. *Learning from Las Vegas.* Cambridge, MA: MIT Press, 1977.

Wittkopp, Gregory, ed. *Saarinen House and Garden: A Total Work of Art.* New York: Harry N. Abrams, in association with Cranbrook Academy of Art Museum, 1995.

Woeste, Victoria Saker. *Henry Ford's War on Jews and the Legal Battle against Hate Speech.* Stanford, CA: Stanford University Press, 2012.

Wolfe, Bertram D. *The Fabulous Life of Diego Rivera.* New York: Stein & Day, 1963.

Wolfe, Tom. *From Bauhaus to Our House.* New York: Farrar, Straus, Giroux, 1981.

Zimmerman, Claire. "Albert Kahn's Territories," in *OfficeUS Agenda,* ed. Eva Franch i Gilabert, Amanda Reeser Lawrence, Ana Miljacki, and Ashley Schafer, 52–63. Zurich: Lars Müllerer Publishers and PRAXIS, 2014.

———. *Albert Kahn under Construction* (exhibit). University of Michigan Museum of Art, February–July, 2016; Lawrence Technological University and Münster School of Architecture, Spring 2017 (digital version).

———. "The Labor of Albert Kahn." Aggregate Architectural History Collaborative. www.we-aggregate.org/piece/the-labor-of-albert-kahn.

———, and students of the Taubman College of Architecture and Urban Design, University of Michigan. *The Path of Kahn* (digital exhibition). www.pathofkahn.com.

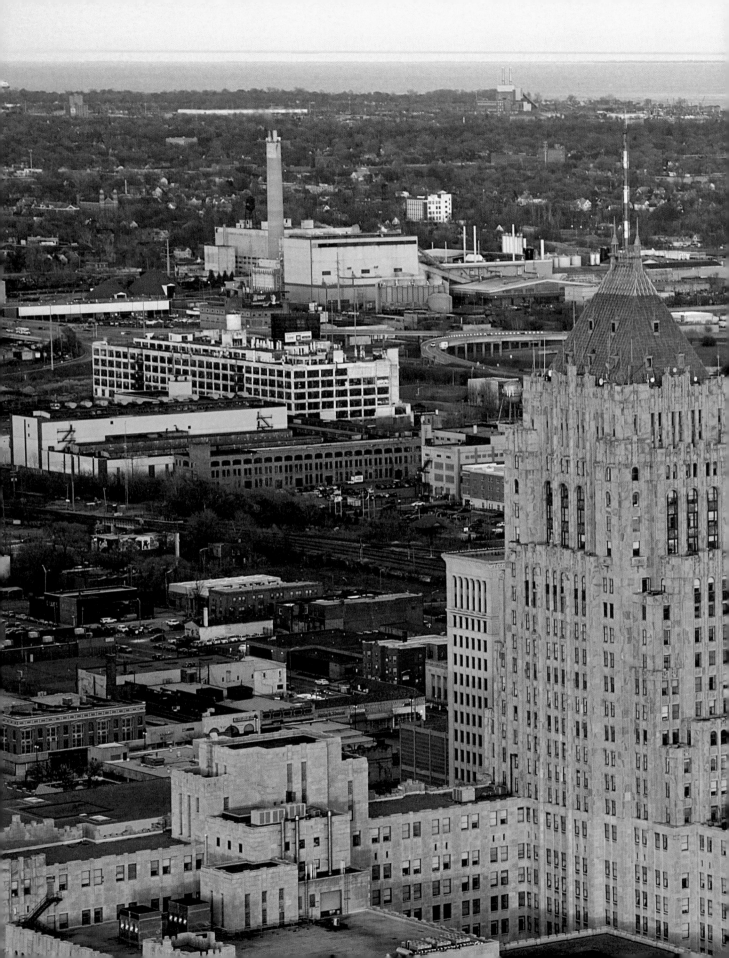

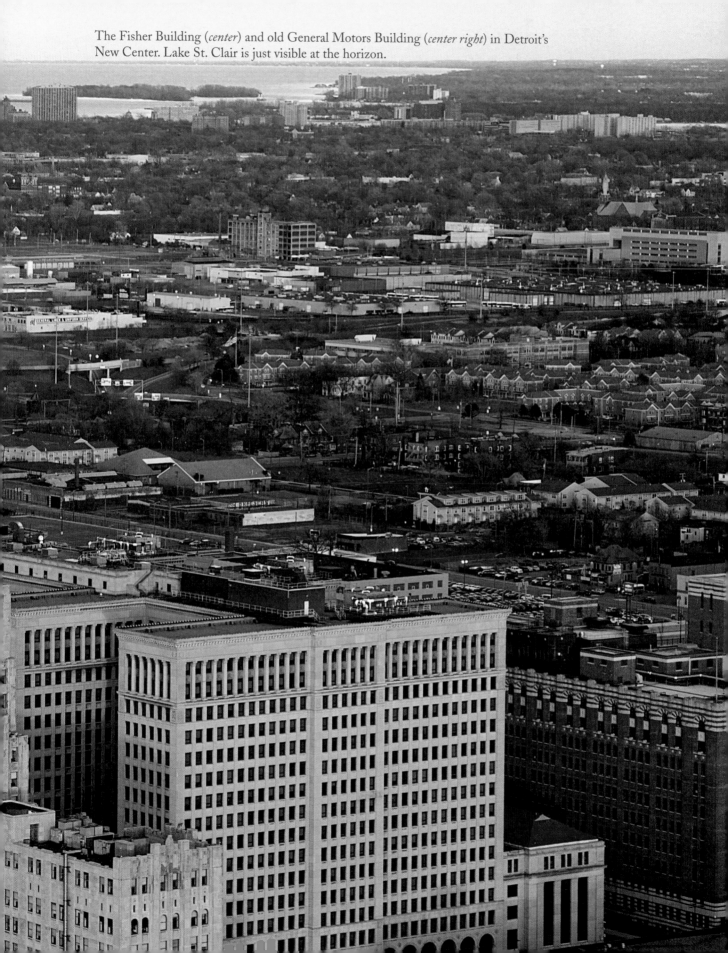

The Fisher Building (*center*) and old General Motors Building (*center right*) in Detroit's New Center. Lake St. Clair is just visible at the horizon.

INDEX

Page numbers in *italics* indicate photographs.